WITHDRAWN

Anatomy of the Grand Canyon

Panoramas of the Canyon's Geology

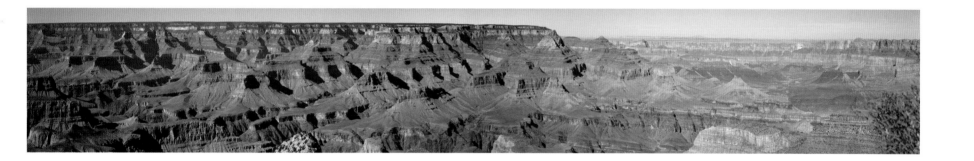

W. Kenneth Hamblin

Illustrations by Bronze Black

Grand Canyon Association
Post Office Box 399, Grand Canyon, Arizona 86023-0399
(800) 858-2808
www.grandcanyon.org

Text and Photographs copyright © 2007 by W. Kenneth Hamblin

All rights reserved. No portion of this book may be reproduced in whole or in part (with the exception of short quotations for the purpose of review), by any means without the written permission of the publisher.

Project management and editing by Frazier Enterprises, Inc., Sedona, Arizona
Diagrams, design, and production by Bronze Black, Flagstaff, Arizona
Scanning and stitching of photographs by Peter Rosenthal, Hance Partners, Flagstaff, Arizona
Printed in the United States of America by Taylor Specialty Books on recycled paper using vegetable-based inks.

First Edition 2008
ISBN-13: 978-1-934656-01-3

12 11 10 09 08 1 2 3 4 5

Library of Congress Cataloging-in-Publication Data

Hamblin, W. Kenneth (William Kenneth), 1928-
 Anatomy of the Grand Canyon / by W. Kenneth Hamblin. -- 1st ed.
 p. cm.
 Includes index.
 ISBN-13: 978-1-934656-01-3 (hardcover)
 1. Geology--Arizona--Grand Canyon. 2. Grand Canyon (Ariz.)--Pictorial works. 3. Photography, Panoramic--Arizona--Grand Canyon. I. Title.
 QE86.G73H36 2007
 557.91'32--dc22
 2008008920

The Grand Canyon Association is a nonprofit educational organization dedicated to cultivating knowledge, discovery, and stewardship for the benefit of Grand Canyon National Park and its visitors. Proceeds from the sale of this book will be used to support research and education at Grand Canyon National Park.

Marble Canyon

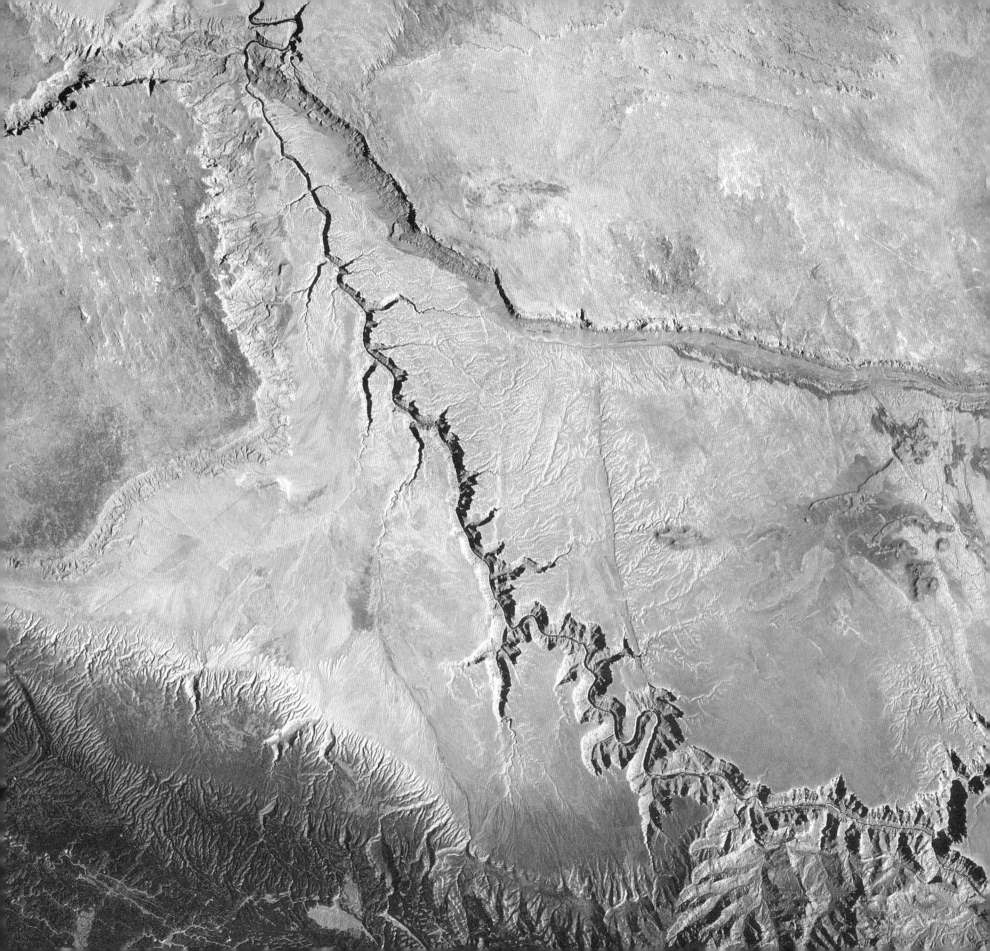

Anatomy the of Grand Canyon

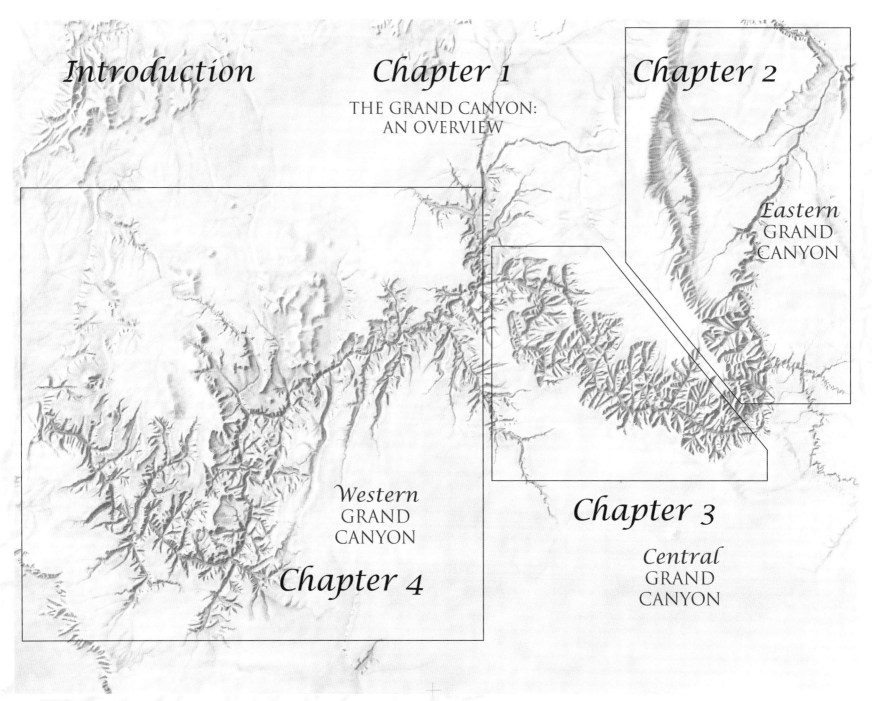

Introduction

Chapter 1
THE GRAND CANYON: AN OVERVIEW

Chapter 2
Eastern GRAND CANYON

Chapter 3
Central GRAND CANYON

Chapter 4
Western GRAND CANYON

CONTENTS

Introduction — 6
About the Photographs — 8
Photograph Index Map — 10

Chapter 1 — 12
THE GRAND CANYON: AN OVERVIEW
Colorado Plateau and Arizona Maps — 14
Grand Canyon Overview and Map — 16
The Language of Geology — 18
The Sequence of Rocks — 20
Geologic Map of the Grand Canyon — 22
Lateral Variations in Rock Formations — 24
Major Geologic Sections — 26
Structure of Grand Canyon Rocks — 30
Evolution of Tributary Canyons — 32
Erosion of the Grand Canyon — 34
Profiles of Ancient Grand Canyons — 36
Important Canyon Features — 38

Chapter 2 — 40
GRAND CANYON EAST
Marble Platform — 42
Lees Ferry — 44
Vaseys Paradise — 46
Caves in the Redwall Limestone — 48
East Kaibab Monocline — 50
Inside the Monocline — 52
Point Imperial — 54
Walhalla Plateau — 56
Cape Royal — 58
Palisades of the Desert — 60
Butte Fault — 62
PreCambrian Basalts — 64
Ochoa Point — 66

Chapter 3 — 68
GRAND CANYON CENTRAL
Navajo Point — 70
Lipan Point I — 72
Lipan Point II — 74
Grandview Point — 76
Yaki Point — 78
Yavapai Point I — 80
Yavapai Point II — 82
Upper Granite Gorge — 84
Faults and Dikes — 86
Maricopa Point I — 88
Maricopa Point II — 90
Hopi Point — 92
The Scalloped South Rim — 94
Shinumo Amphitheater — 96
Middle Granite Gorge — 98

Chapter 4 — 100
GRAND CANYON WEST
The Esplanade — 102
Kanab Point — 104
Inner Gorge — 106
Mount Sinyella — 108
Volcanoes of the North Rim — 110
Lava Dams — 112
Beneath Vulcans Throne — 114
Remnants of Lava Dams — 116
High Level Remnants of Dams — 118
Ancient Lakes in Grand Canyon — 120
Lake Deposits in Havasu Canyon — 122
Below Whitmore Wash — 124
Hurricane Fault Zone — 126
Peach Springs Canyon — 128
Shivwits Plateau — 130
Sanup Plateau — 132
Grand Canyon West — 134
Grand Wash Cliffs — 136
End of the Grand Canyon — 138

Acknowledgments — 140
Suggested Reading — 140
About the Author — 140
Glossary — 141
Index — 143

Introduction

The approach to the Grand Canyon from the south is unimpressive as you travel across the flat plateau covered with juniper and pinyon trees. Then suddenly, without warning, spread out before you is the unimaginable—a canyon ten miles (16 km) wide and one mile (1.6 km) deep, with red, gray, white, brown, and black rock formations eroded into a series of alternating cliffs and slopes, mesas, buttes, and pinnacles. After recovering from the shock of seeing the canyon for the first time questions inevitably arise. How did the canyon originate? Why is such a remarkable feature here? When did it form? Why is it so different from most other valleys?

More than a century has passed since Captain Clarence E. Dutton, one of the earliest interpreters of the Grand Canyon, spoke of the canyon as a "great innovation in modern ideas of scenery." It was "not to be comprehended in a day or a week, nor even in a month"; rather, a "special culture, requiring time and patience" was needed in order to understand it. Since then, the canyon has achieved a popular familiarity unforeseen by Dutton, and has become one of the best known of all natural phenomena.

His stipulation regarding the time and patience required to truly comprehend the canyon is as valid today as it was when first expressed. So overwhelming is the effect of the Grand Canyon on human imagination that for many people it will always remain mysterious and incomprehensible. For others, the form and color of the great chasm provide an esthetic fulfillment entirely satisfactory in itself. Yet some feel a need to pursue Dutton's "special culture" in a desire to acquaint themselves with the natural processes that have brought the

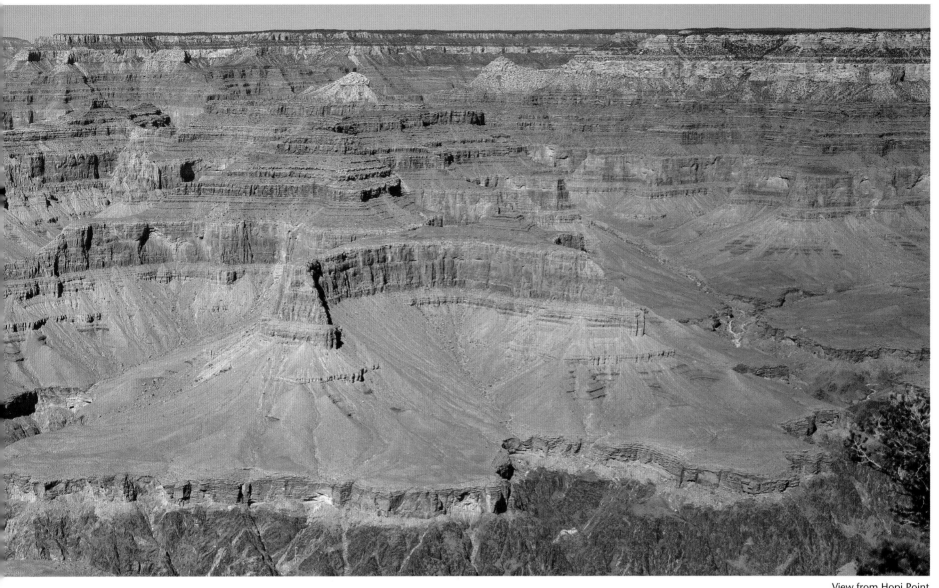

View from Hopi Point

canyon to its present spectacular appearance. They would like to know what the canyon looks like from end to end. They would like to know why the canyon changes. They would like to know how and when the canyon formed. It is for such people that this book has been prepared.

I have written from the premise that while Grand Canyon may indeed be awesome and mysterious, it is anything but incomprehensible. Equipped with an understanding of Earth's processes, the observant visitor can comprehend much of the canyon's past, and interpret many aspects of the natural forces operative today. For them the thrill of discovery awaits.

Although everyone sees the canyon in a unique way, there is one thing we can all agree upon—it is one of the most beautiful landscapes ever formed. The great attraction of the Grand Canyon is its huge size and its multicolor rock layers carved into impressive formations. The canyon is unique both in scenery and variety of geologic features so magnificently exposed. The experience of seeing the canyon is difficult to describe, but impossible to forget.

Most people see the canyon from viewpoints on the rim that provide sweeping panoramas. However, the canyon is far too large to be seen from the established rim viewpoints. Unfortunately, the canyon rim to the west is accessible only by unimproved dirt roads and trails and is therefore not easily visited. A float trip down the Colorado River provides an exciting way to see the canyon from end to end. Unlike views from the rim, a float trip through the canyon provides a series of close-up views of geologic features that can be obtained in no other way.

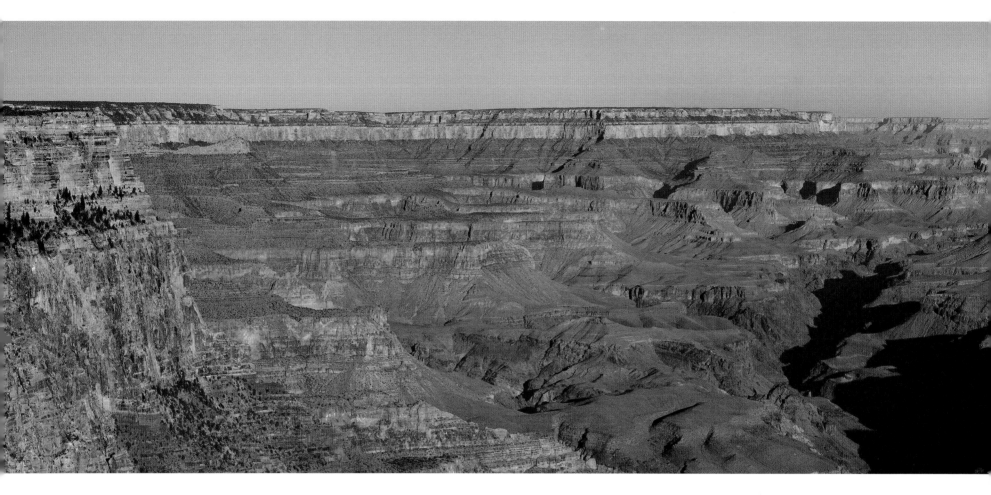

About the Photographs

This book is intended to share an appreciation and interpretation of great Grand Canyon vistas by means of panoramic photography. During many years of research and frequent field trips to the Grand Canyon with my students, I developed the compulsion to capture the majesty of the canyon on film. I quickly amassed an extensive collection of 35 mm photographs, but their small format didn't come close to portraying what I saw when I was there. Then I began to experiment with panoramic photography. The panoramic format is especially well suited to geologic illustrations in that it allows us to examine a much broader scene in new and informative ways. It has been said that the difference between conventional and panoramic photographs is comparable to looking at a city through a hotel window versus seeing it from the rooftop of a skyscraper—a vast difference in depth and breadth of information recorded.

My first efforts at panoramic photography from the ground were encouraging but not completely satisfying. There was much more to be seen than could be viewed from the ground. Photographing from a small aircraft was better, but introduced problematic vibrations for a hand-held camera. This problem was solved by using a gyro stabilizer, which is like having a tripod in the sky.

The Grand Canyon is an excellent subject for aerial panoramic photography because of its vast, open vistas. This was recognized very early by William Henry Holmes who made many panoramic sketches of the canyon in the 1870s for Clarence Dutton's pioneering work, *Tertiary History of the Grand Canyon*. Holmes sketched the canyon's geology with uncanny accuracy and his work remains unique in the annals of technical art.

With modern technology we can add a new dimension in seeing the landscape and visualizing geology. With modern panoramic cameras, fine-grained color film, and gyro stabilizers it is possible to take panoramic views from the air without distortion of foreground, curvature of the horizon, or vibrations common with a hand-held camera. There is, however, a peculiar problem inherent in photographing broad panoramic scenes that encompass more than 180

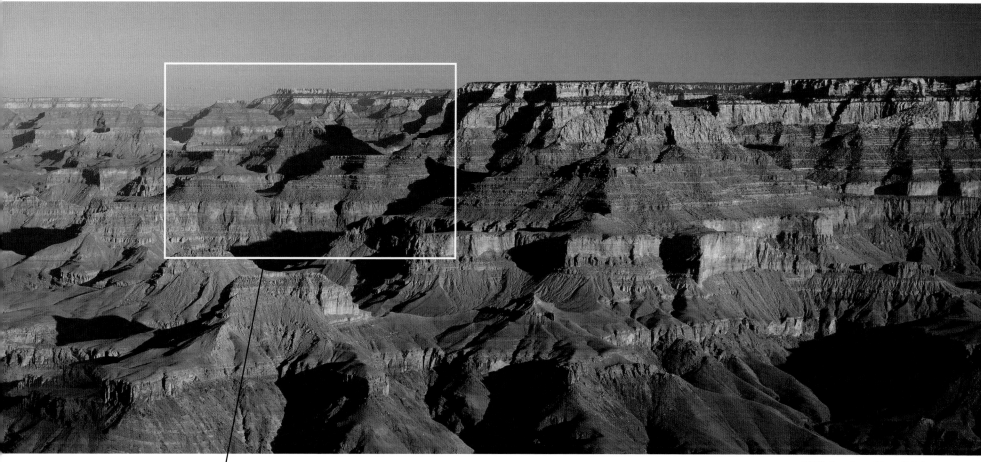

120° view from Lipan Point

The white box on the photograph shows the extent of a normal photograph taken with a standard 50 mm lens.

degrees. One side of the panorama will invariably be brighter than the other because of lighting variations across such a great expanse. Fortunately this problem can be minimized by computer enhancement.

The photographs in this book were taken from the canyon's rims, the river, and the air. They are arranged in sequence from east (upstream) to west (downstream). Photos taken from the rim or from the air may be followed with views from the river in an effort to show important details not visible from above. In some cases a single panorama was sufficient, but for many features several panoramas were stitched together by computer to make a single scene.

The panoramic photographs in this book were taken with one objective in mind: that of showing the canyon's fundamental features, the sequence of rocks, the geologic structure, and the history these features record. My photographs attempt to show important geologic information, not just esthetic beauty. Yet the canyon has its own intrinsic beauty which goes far beyond mood or artistic charm. In a way, the canyon's real beauty is like the beauty of language—a word or a sentence may have a pleasant sound, but it is only when the words are put together into meaningful combinations and understood that the true beauty of literature can be appreciated.

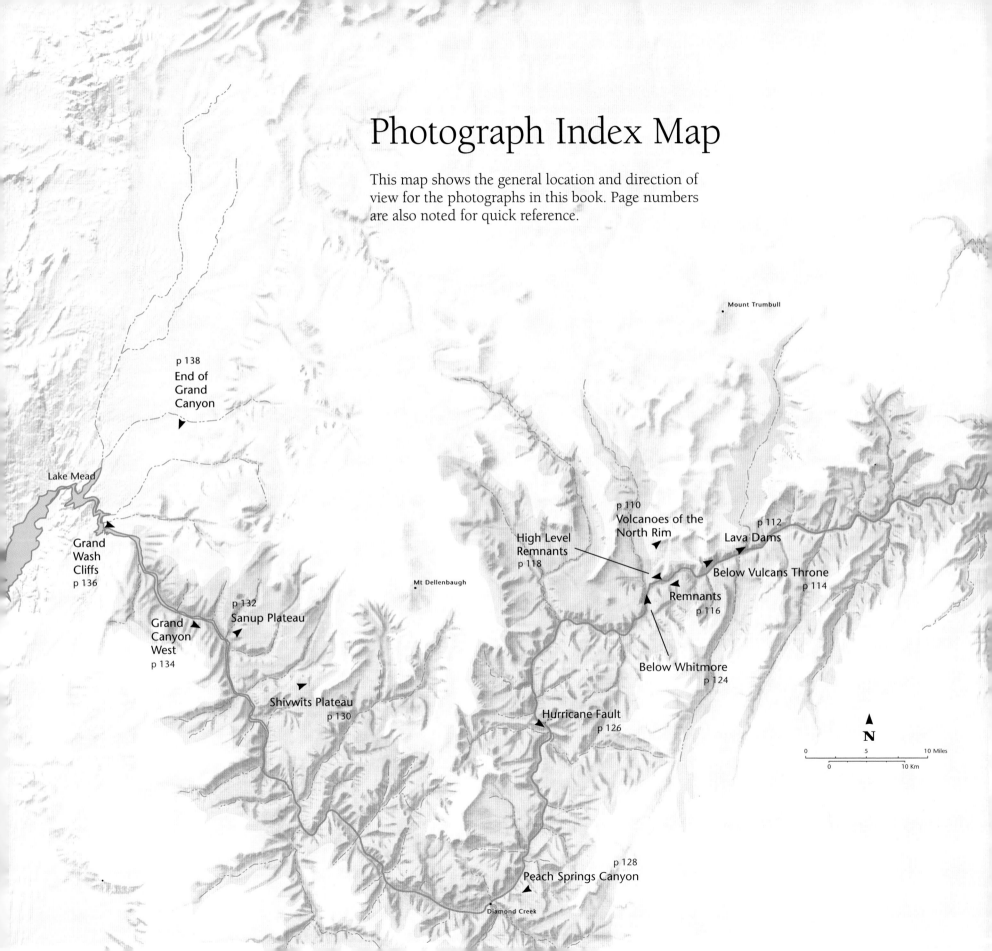

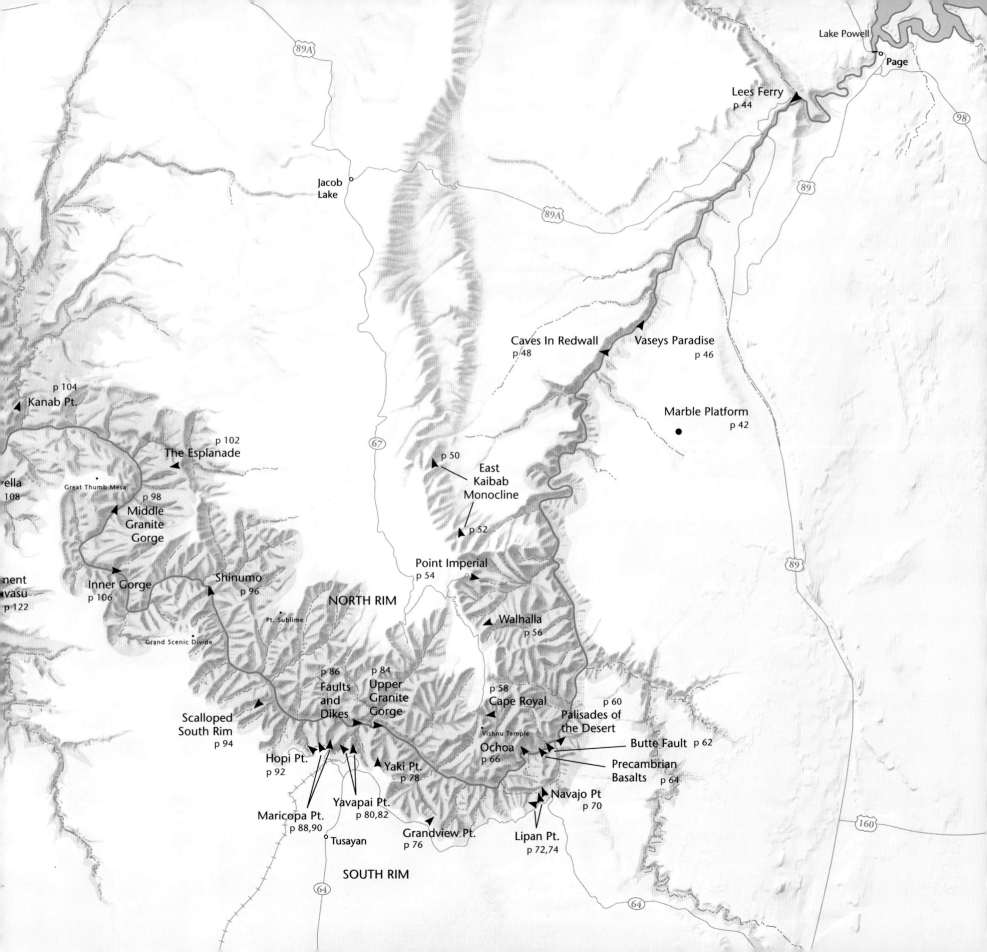

Chapter 1

THE GRAND CANYON
An Overview

Colorado Plateau and Arizona Maps	14
Grand Canyon Overview and Map	16
The Language of Geology	18
The Sequence of Rocks	20
Geologic Map of the Grand Canyon	22
Lateral Variations in Rock Formations	24
Major Geologic Sections	26
Structure of Grand Canyon Rocks	30
Evolution of Tributary Canyons	32
Erosion of the Grand Canyon	34
Profiles of Ancient Grand Canyons	36
Important Canyon Features	38

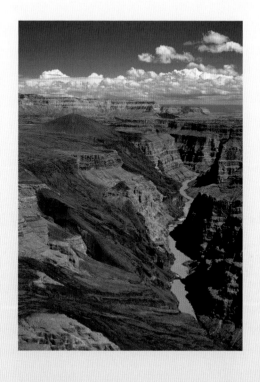
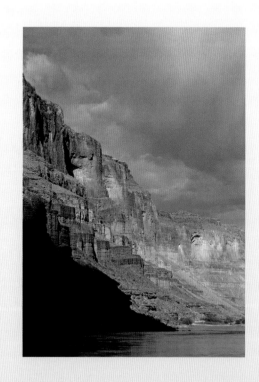

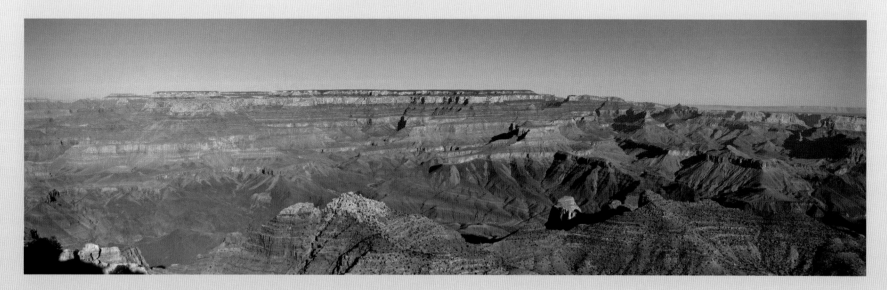

Colorado Plateau

The Colorado Plateau is a geologic province of remarkable presence and dynamic history. Bordered by the Rocky Mountains on the east and the Basin and Range on the west, the plateau encompasses 130,000 square miles in the Four Corners region of the American Southwest, where Arizona, Utah, Colorado, and New Mexico meet. One of the last areas to be mapped in the contiguous United States, it is known for its high peaks, vast plateaus, and formidable canyons.

The regions surrounding the plateau have been faulted and deformed by movement of the earth's crust, but the rock layers of the Colorado Plateau have been preserved in the horizontal orientation in which they were laid down. Approximately 40 million years ago these layers were uplifted, providing the steep gradient needed for the Colorado River system to carve deep canyons across the landscape and whittle the otherworldly rock formations for which the plateau is widely known.

From its headwaters in the Rocky Mountains, the Colorado River flows 1,450 miles across the plateau to empty into the Gulf of California. It is joined by the Green River near Moab, Utah, and the combined waters of these rivers and their tributaries have shaped the incredible scenery of the American Southwest, including its crown jewel, the Grand Canyon.

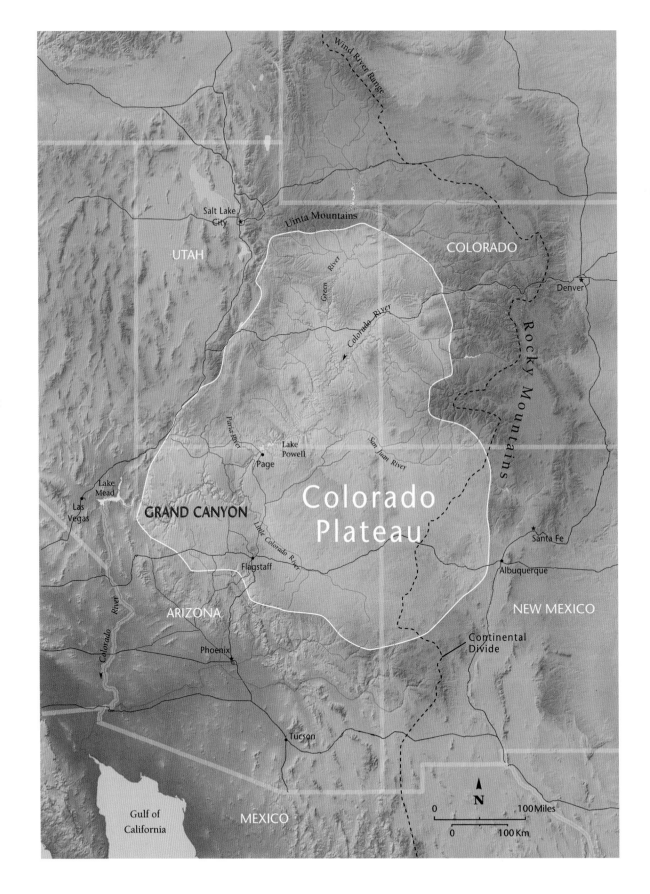

Arizona

Arizona is a land of contrasts, from its low deserts to its mountain forests. It is divided into three geologic areas: the deserts of the Basin and Range, the Central Highlands, and the Colorado Plateau. Of these three, this book focuses on the Colorado Plateau and its most dramatic feature, the Grand Canyon.

By studying the Grand Canyon and the geologic forces that shaped it, we can learn a great deal about the origins of landscape and the dynamic earth upon which we live. In our lifetimes we capture but an instant in geologic time as the earth continues to reshape itself.

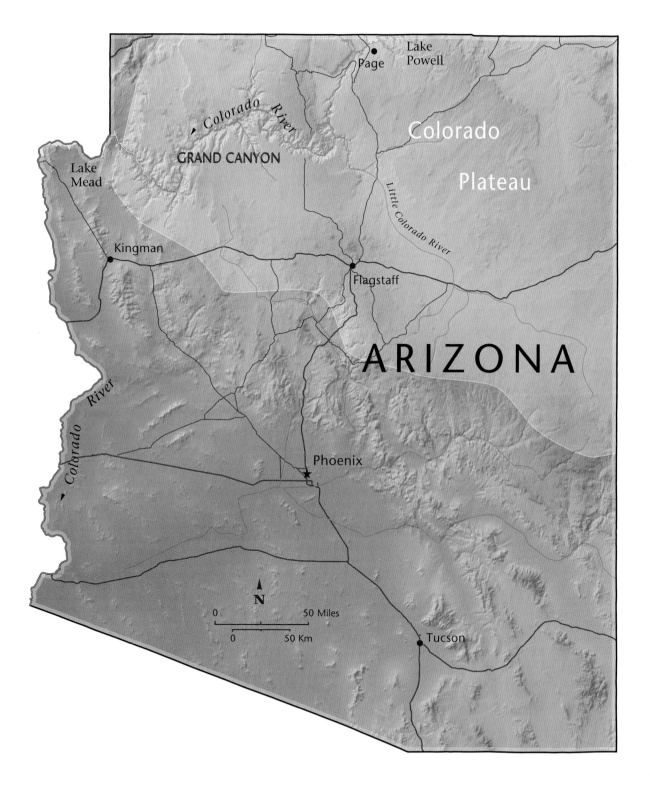

The Grand Canyon: An Overview

With satellite imagery and digital shaded-relief maps, we can now see the Grand Canyon in a way that was impossible only a few decades ago. These images enable us to see the entire canyon in one synoptic view, permitting us to examine details of the canyon's rims, tributary systems, and structures such as faults, fractures, and folds. We can see how the canyon changes from east to west and get some idea about the processes that influenced its origin and evolution. A far better concept of the canyon's form and features can be gained by studying this physiographic map than by reading whole volumes of verbal descriptions.

The map presented here is intended to guide your examination of the map so that you will become familiar with the canyon as a whole. It is a digital shaded relief map derived from thousands of measured elevation points with a resolution of ten feet (3 m). From this regional perspective the canyon looks like a giant centipede winding its way across northern Arizona, its huge head at the Grand Wash Cliffs, two long arms near the center of its body, and a long, narrow tail extending from the Kaibab Plateau to Lees Ferry. If you take a few moments to study this map you will gain an appreciation of the canyon that is not otherwise available.

The Grand Canyon is easily the most famous canyon in the world. It extends from Lees Ferry to the Grand Wash Cliffs, a river distance of 277 miles (446 km). A straight line between these two points is 140 miles (225 km). The land surrounding the canyon is like a huge layered cake, roughly 150 miles (240 km) in diameter, sliced through by a deep canyon. The "cake" however, is somewhat deformed, being tilted slightly downward to the east, fractured by several north-south fault systems, and locally deformed by a large fold (a monocline).

As is apparent on the map, the Grand Canyon is divisible into six sections separated by faults or folds. From east to west they are: the Marble Platform, the Kaibab Plateau, the Kanab–Coconino Plateau, the Uinkaret Plateau, and the Shivwits–Hualapai Plateau. The width of the canyon averages eight miles (13 km) but ranges from a few hundred yards below Lees Ferry to more than fifteen miles (24 km) in the Shivwits–Hualapai section. The canyon's maximum depth is 6,000 feet (1,900 m) measured from rim to the river. The highest point is 8,803 feet (2,683 m) at Point Imperial on the North Rim, and the lowest point is 1,200 feet (370 m) on the canyon floor at the head of Lake Mead.

One of the many striking features shown on the relief map is the erosional pattern of canyon walls. Every system of tributary streams is clearly visible. It may seem a little strange, but only three major tributaries flow into the Colorado River in the Grand Canyon area: the Little Colorado River, Kanab Creek, and Havasu (Cataract) Creek.

Note that the walls of canyon are not symmetrical. The North Rim has eroded back more than eight miles (13 km) from the river and is dissected by numerous relatively long tributary canyons. The South Rim, in contrast, is only two to three miles (3 to 5 km) from the river and is relatively undissected. Westward, the canyon's asymmetry is the result of erosion of tributary streams along faults, first on one side, then on another.

The asymmetry of tributaries and canyon walls extends throughout the canyon, yet the nature of this asymmetry shifts from one side of the river to the other depending upon the extent of uplift and the Kaibab Plateau's regional slope. In the Kaibab Plateau section the upwarp is much higher on the north and tilts downward toward the south. Water falling on the north side of the canyon follows this tilt and flows into the canyon, aiding headward erosion. Consequently, tributaries are much longer on the north side of the river and dissection of the north wall is much more pronounced. Rain falling on the south side of the canyon also follows the tilt, flowing away from the canyon. The south wall is hardly dissected at all and the canyon wall is simply carved into a series of alcoves.

In the Kanab–Coconino Plateau section, the downward slope of the landscape is to the north and the longer tributaries are on the south side of the river. The Hurricane and Toroweap faults in the Uinkaret Plateau have controlled the development of Prospect, Toroweap, and Whitmore valleys, all of which are more than twenty miles (32 km) long, but are unique in that they are filled with lava up to the rim of the Inner Gorge.

In the Shivwits section the river flows southward at first, parallel to the Hurricane fault zone, and then turns abruptly and flows to the northwest. The landscape in this area is further complicated by the lava-capped plateau on which Mount Dellenbaugh rests.

The canyon's asymmetry is most extreme in the Hualapai Plateau section where upper Paleozoic rocks on the south and west sides of the canyon have been completely stripped away and the typical rim rock found elsewhere (the limestone of the Kaibab Formation) is not preserved. On the south side of the canyon the rim is basically the rim of the Esplanade Platform.

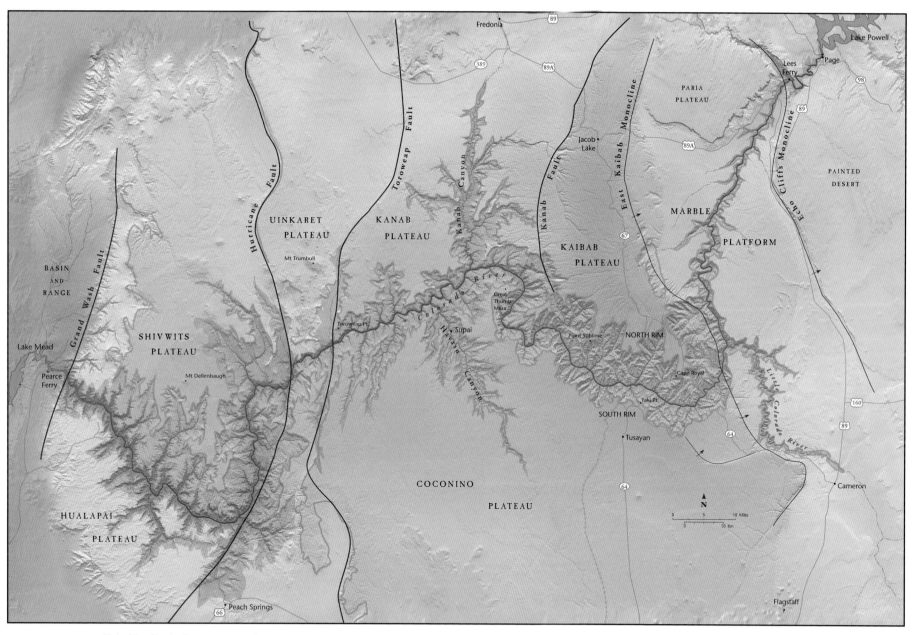

Grand Canyon map showing important regional features

Light blue line indicates canyon rims

The Language of Geology

Standard Geologic Timeline and Column of Grand Canyon Rocks

Rocks in their myriad forms are the great attraction of Grand Canyon National Park. They produce a remarkable range of color and landforms that change from day to day, even from hour to hour. More importantly, the layered sequence of rocks provides a fascinating record of the remarkable history of the earth during the last two billion years. Rocks are not simply aggregates of minerals; they are documents of history, records of what happened in this part of the world long before the canyon formed. To understand the canyon you must first understand something about the sequence of rock layers exposed in the canyon's walls. This involves becoming familiar with the language of geology.

Earth's crust is complex and is made up of thousands of different rock bodies. For example, in North America alone there are hundreds of different rock types and thousands of different rock bodies (formations). When someone is first introduced to geology it may appear to be a complex assemblage of meaningless words and one can soon become confused and discouraged by a blizzard of strange, empty names. This often smothers the desire to learn more about geology. Actually there is a sound historical and theoretical basis for geologic nomenclature. It is not arbitrary but systematic and it plays an important role in understanding and communication. Its justification is real. When a geologist says "Mesozoic" he or she is attempting to communicate a rather large and complex parcel of information in one word. The term refers to a period of geologic time during which a specific sequence of geologic events occurred and a distinctive assemblage of life forms existed.

Similarly, "Kaibab Formation" signifies a specific body of rock with a distinctive composition, texture, internal structure, color, mode of origin, and age. The rock body referred to as the Kaibab Formation extends through a specific area, has a specific thickness, and was deformed by tectonic forces during a specific period of time. Each formation name such as Supai, Redwall, Bright Angel, and so forth, conveys similar specific information and is named for a geographic location where the rock body is well exposed. The Navajo Sandstone was named for its geographic location near the Navajo Indian Reservation, the Kaibab Formation for the Kaibab Plateau, and the Supai for Supai Village.

The problem of nomenclature is simplified by utilizing graphic representation, such as cross sections similar to those shown on the following pages. Here a graphic representation of the canyon is shown along with the major formations and their topographic expression (cliff, slope, etc.). This is the standard nomenclature used in discussing the anatomy and scenery of the Grand Canyon. Repeated reference to the diagrams will help you understand the panoramic photographs and the geologic relationships they display.

THE STANDARD GEOLOGIC COLUMN

Extensive geologic studies over many years have resulted in unraveling the chronological sequence of rocks throughout every continent on the globe. From this work geologists have constructed a standard geologic timescale, similar in many respects to our yearly calendar. Most of the original work was done in Europe. The terms that may appear strange and unfamiliar to us were named after geographic areas where the rocks are well exposed. Thus terms like Cambrian, Ordovician, Silurian, and Devonian are named after locations in the United Kingdom where the large divisions of rocks are exposed. The rocks are distinguished from one another by major changes in rock types, major unconformities, and different fossil assemblages. Radiometric dating methods permit geologists to precisely date many parts of the column that serve as benchmarks from which the date of any rock can be interpolated. The standard geologic column is shown here together with the age of the formations important in Grand Canyon's geology.

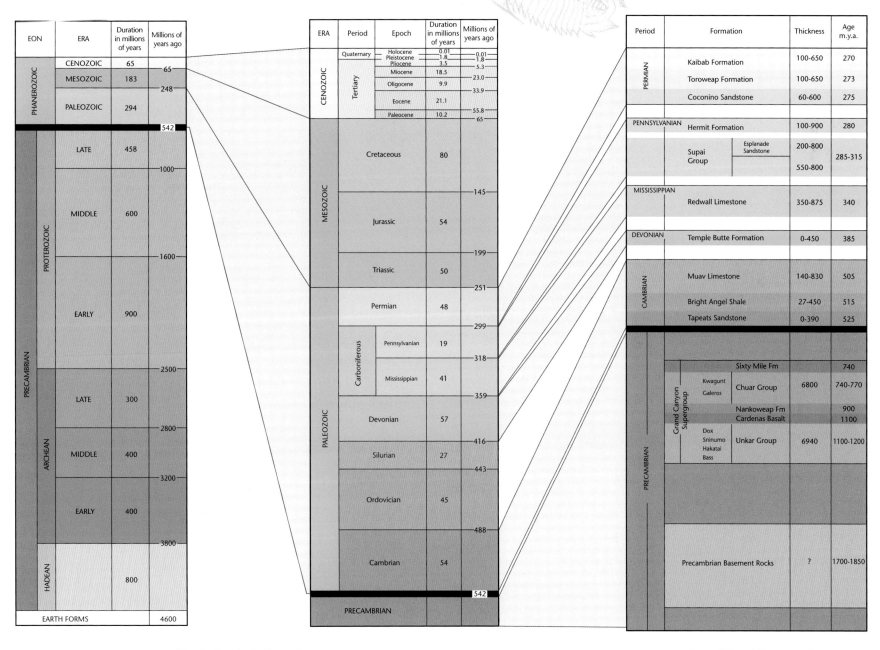

Standard geologic timescales

Ages of Grand Canyon rocks

The Sequence of Rocks

The skeletal framework of the canyon's anatomy is the sequence of rock bodies into which the canyon is eroded. Geologists have recognized the different layers since they first studied the canyon more than 150 years ago. As they studied the rocks in detail they gave each major rock body a name corresponding to the area where it was well exposed. Thus, in order to understand something about the canyon, you must first know something about the sequence of rocks that comprise it. Frequent reference to the diagram shown here and the brief description of each formation will help you recognize the formations exposed in the canyon and the landforms they produce. They are described here from top (youngest) to bottom (oldest).

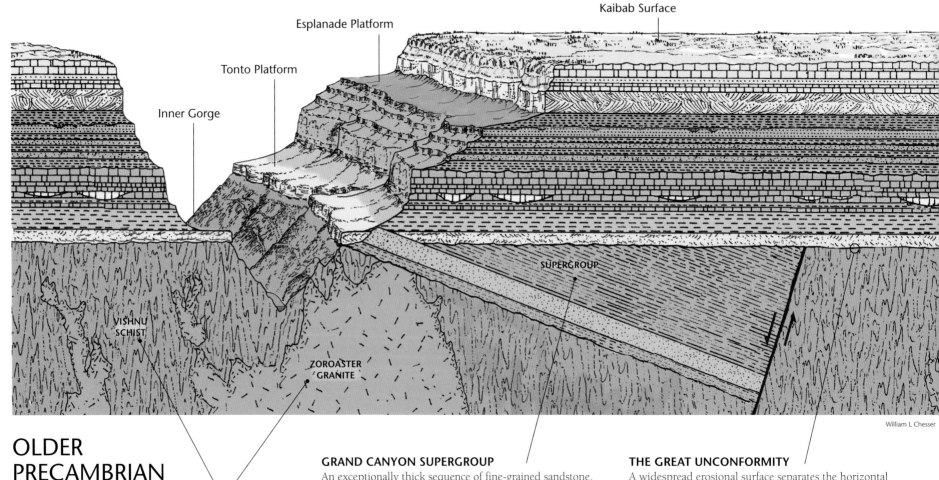

William L Chesser

OLDER PRECAMBRIAN ROCKS

OLDEST PRECAMBRIAN ROCKS

The oldest rocks within the Grand Canyon are dense, hard, crystalline granite and metamorphic rocks exposed in the bottom of the canyon. These rocks typically erode to form a steep, rugged, V-shaped gorge. The dark-colored rocks have a prominent vertical structure and have been highly deformed and altered by intense heat and pressure. Numerous pink granitic dikes have intruded into the metamorphic rocks. Radiometric dates indicate that these rocks range in age from 1.68 billion to 1.84 billion years.

GRAND CANYON SUPERGROUP

An exceptionally thick sequence of fine-grained sandstone, siltstones, and shale, tilted at angles of up to fifteen degrees, is exposed in isolated wedged-shaped bodies in the eastern part of the canyon. These rocks are referred to as the Grand Canyon Supergroup and they stand out in contrast to the overlying horizontal Paleozoic strata. The Grand Canyon Supergroup is remarkable in that it represents an accumulation of sediment and minor volcanic flows more than 12,000 feet (370 m) thick that is separated from the overlying horizontal rocks (Tapeats through Kaibab) and the underlying granites and metamorphic rocks. Radiometric dates indicate that this group of rocks range in age from 740 million years for the uppermost units to 1.25 billion years for the lowest units.

THE GREAT UNCONFORMITY

A widespread erosional surface separates the horizontal Paleozoic strata from the older underlying Precambrian basement rocks and represents a major event in Grand Canyon's geologic history. This surface between the basement rocks below and the horizontal layers above represents a period of 1.2 billion years during which the earth's crust was lifted; towering mountains were formed and then flattened by erosion. This huge gap in the rock record is known as the Great Unconformity. Indeed, it is one of the best displays of an unconformity in the world.

YOUNGER PALEOZOIC ROCKS

KAIBAB AND TOROWEAP FORMATIONS
The Kaibab and Toroweap formations comprise the uppermost 500 to 700 feet (150 to 200 m) of strata exposed in the canyon's walls, and constitute the surface of the Kaibab Plateau on the north side of the Colorado River and the Coconino Plateau on the south. They form the two uppermost cliffs and are the most widely exposed formations in the Grand Canyon region. The Kaibab and Toroweap limestones are light tan in color. More than eighty genera of invertebrate fossils have been found in these formations including large brachiopods, corals, snails, clams, and sponges, as well as a few fossil fish teeth.

COCONINO SANDSTONE
The Coconino Sandstone is composed of fine quartz sand grains that are frosted and show excellent sorting, indicating an active environment of deposition. It is characterized by well developed, large-scale cross stratification, which is interpreted to have formed in sand dunes in an ancient desert similar to the present-day Sahara Desert in Africa.

HERMIT FORMATION
The Hermit Formation is composed of red shale and siltstone. It is 200 feet (60 m) thick in the east but thickens to more than 900 feet (275 m) in the west where it plays an important role in developing the Esplanade Platform.

SUPAI GROUP
Below the Hermit Formation is a thick sequence of interbedded red sandstone and shale called the Supai Group. These rocks erode into a great series of steps with the sandstone beds forming vertical ledges and the interbedded shale forming more gentle slopes or terraces. The lowest part of the Supai Group, however, contains significant limestone beds. These rocks are responsible for most of the red color seen in the middle canyon walls. In the western part of the canyon, the thick sandstone in the upper portion of the Supai Group forms the great Esplanade Platform.

SURPRISE CANYON FORMATION
The Surprise Canyon Formation occurs as isolated lenses (a mixture of sandstone, limestone, and mudstone) that fill erosional valleys cut into the Redwall Limestone. It is found mostly in the western part of the canyon and is the least visible of all the formations because of its discontinuous nature.

REDWALL LIMESTONE
The Redwall Limestone is 500 feet (150 m) thick and forms an unbroken vertical cliff almost midway between the river and the canyon rim. The Redwall Limestone has a red color, but a very peculiar one. The rock is actually not red at all, but is light gray or tan in color. Only the surface of the limestone is red as a result of stain brought down from the red Supai above it. The Redwall Limestone is responsible for many of the majestic alcoves, mesas, and buttes that contribute to the scenic splendor of the canyon. It is susceptible to considerable solution activity by groundwater, which results in the formation of numerous caves, caverns, arches, and springs.

TEMPLE BUTTE FORMATION
The Temple Butte Formation varies considerably in thickness (from zero to 400 feet/120 m) and is hardly apparent from viewpoints on the North and South rims because it occurs only as small lenses at the base of the Redwall cliff. It thickens westward, however, where it forms a prominent vertical cliff beneath the Redwall Limestone.

MUAV LIMESTONE
The Muav Limestone consists of a sequence of alternating gray limestone and greenish-gray calcareous siltstone. In the eastern canyon it characteristically erodes into three units: a cliff above the Bright Angel Shale overlain by a sequence of small ledges, which in turn are overlain by an upper cliff member. Westward, the Muav thickens and becomes a prominent cliff-forming unit.

BRIGHT ANGEL SHALE
The Bright Angel Shale is a sequence of light green sandy silt and shale about 300 to 450 feet (90 to 140 m) thick. The shale is easily eroded to form a broad terrace on the underlying Tapeats Sandstone, known as the Tonto Platform. This terrace is one of the most prominent topographic features seen in the canyon. It lies approximately 3,000 feet (900 m) below the rim and ranges up to three miles (5 km) in width. The Bright Angel slope and the Tonto Platform thus stand out in marked contrast to the narrow, V-shaped Inner Gorge below.

TAPEATS SANDSTONE
The Tapeats Sandstone is the lowest Paleozoic formation in the Grand Canyon. It is 200 to 300 feet (60 to 90 m) thick and is easily recognized by its weathered golden-brown cliff. The Tapeats Sandstone extends throughout the canyon, although it is locally thin and pinches out over ancient Precambrian hills. Throughout most of the canyon it forms a striking vertical cliff on top of the V-shaped Inner Gorge.

Geologic Map of the Grand Canyon

A geologic map is a special kind of map showing much more than the location and distribution of rivers, mountains, roads, towns, etc. A geologic map shows the surface exposures of rock formations, faults, folds, and other geologic information, including the age relationships of the rock bodies and their relationship to the landscape. If all of the soil and vegetation were removed, each formation painted a different color, and a photograph taken from space, the results would be a geologic map. (Actually, this situation is closely approached with satellite imagery of many desert regions where there is little soil and vegetation to cover the rock outcrops.) A geologic map is, in a very real sense, a scale model of the structure of the earth's surface, and is a fundamental tool for understanding and interpreting the geology of a given region.

The geologic map shown here is a simplified version of a much more detailed geologic map prepared from the field work of hundreds of geologists over a period of more than 150 years. Studying this map is an excellent way to become acquainted with the canyon and the history of events involved in its formation.

Even a brief study of the map can yield much understanding. For example, notice the light blue color that shows the extent of the Kaibab Formation, which comprises the Grand Canyon as well as the surface of a large portion of the region. Note the dull green color representing Mesozoic rocks that have receded from the Grand Canyon area altogether.

One can also quickly grasp other concepts such as how different rock types can be recognized by distinctive patterns on the map. Note the burnt orange areas that represent volcanoes and lava flows; the blue isolated pockets near river level depicting the Grand Canyon Supergroup; and the slender brown regions that depict the oldest rocks; the metamorphic basement rocks, of the Granite Gorges.

Also note the series of parallel bands representing the sedimentary Paleozoic rocks within the Grand Canyon itself, and how the Esplanade Platform (the pale tan) has a larger extent in the western Grand Canyon.

These patterns can explain a great deal about the geologic makeup of the Grand Canyon region in a very short time and relationships to geography as well.

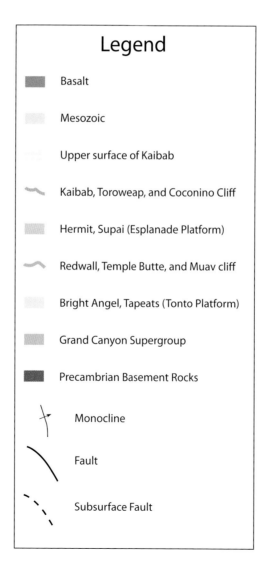

Legend

- Basalt
- Mesozoic
- Upper surface of Kaibab
- Kaibab, Toroweap, and Coconino Cliff
- Hermit, Supai (Esplanade Platform)
- Redwall, Temple Butte, and Muav cliff
- Bright Angel, Tapeats (Tonto Platform)
- Grand Canyon Supergroup
- Precambrian Basement Rocks
- Monocline
- Fault
- Subsurface Fault

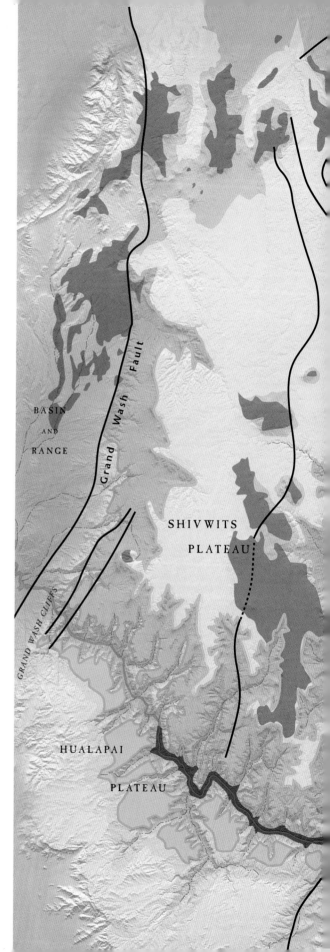

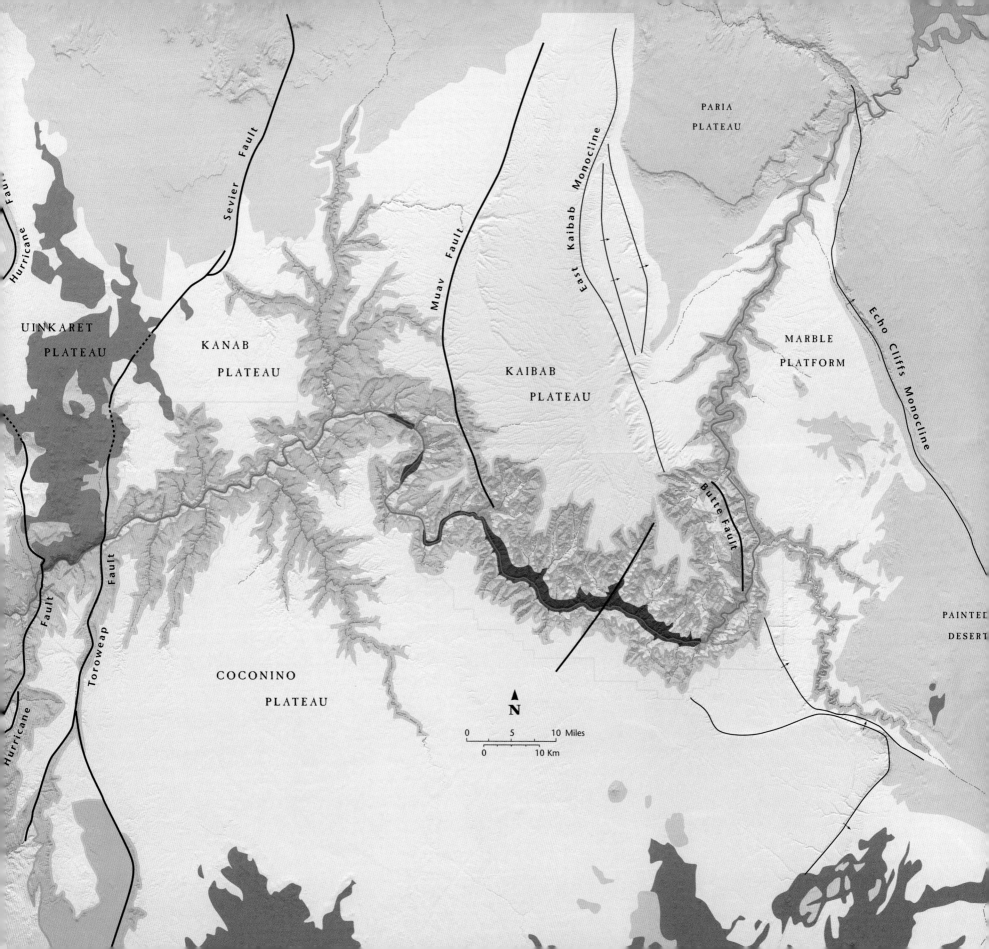

Lateral Variations in Rock Formations

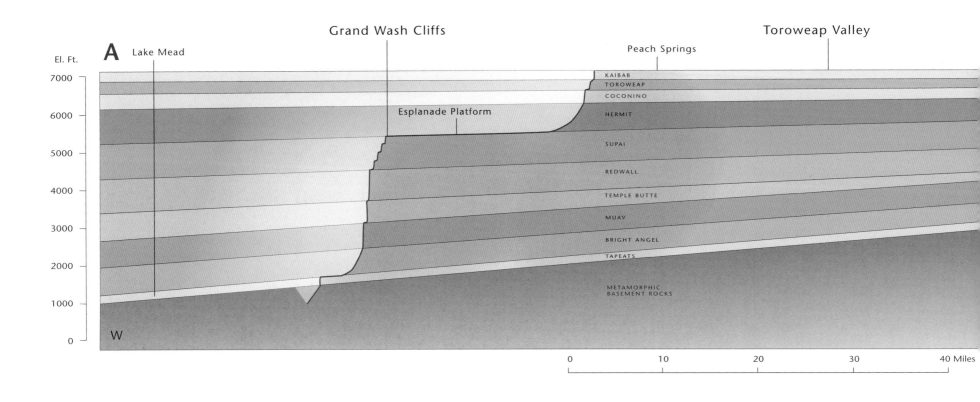

One of the most important factors controlling variations in the characteristic Grand Canyon landscape is the lateral changes in the nature of rock bodies. For example, some formations become thicker when traced laterally, whereas others gradually become thinner and disappear entirely. Sandstone commonly grades laterally into shale, and shale may grade into limestone. All of these changes occur in the Grand Canyon, mostly in an east-to-west direction, and the landscape of the canyon changes as a result. As resistant sandstones and limestones become thicker, the cliffs formed by them become higher. As nonresistant shales become thicker, the terraces formed by them become wider. Thus, the canyon profile in one area may be completely different from that in another.

The diagram above shows the major changes in Grand Canyon's formations from east to west. Although lateral variations occur in all formations, the most dramatic changes occur in the lower rock units: Bright Angel Shale, Muav Limestone, Temple Butte Formation, Supai Group, and Hermit Formation. All of these formations become significantly thicker to the west and influence the canyon profile in many striking ways. The Muav Limestone, for example, not only becomes thicker to the west but also changes from interbedded shale and limestone into massive limestone units. The Temple Butte Formation, which occurs only as thin, discontinuous lenses in the eastern part of the canyon, also becomes progressively thicker to the west. Both of these layers form vertical cliffs that rival the Redwall Limestone cliff. These two thick limestone formations (Muav and Temple Butte) are overlain by the massive Redwall Limestone, which also thickens westward. The three formations combine to form a single huge vertical cliff as much as 3,000 feet (900 m) high, giving the western canyon a very distinctive profile.

The Supai Group and Hermit Formation also undergo dramatic changes from east to west. In the eastern part of the canyon, the red rocks of the Supai Group consist of cycles of relatively thin sandstone

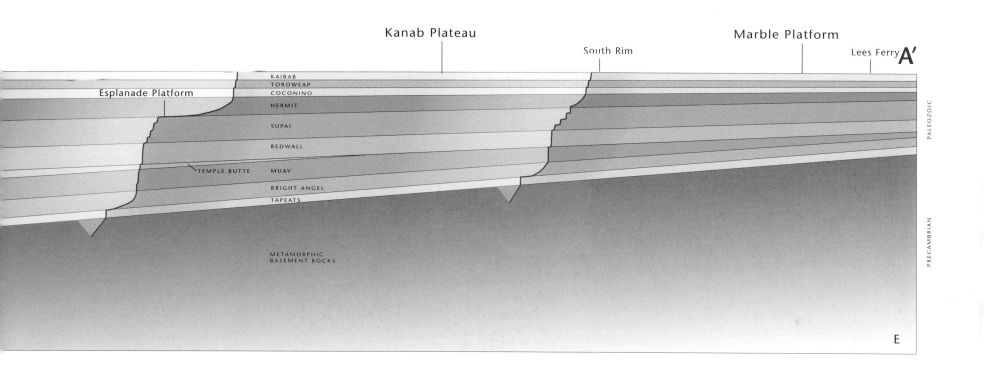

and shale that form alternating low cliffs and slopes resulting in a stair-step topography. Westward, several of the sandstone beds become much thicker and merge to form a single massive sandstone unit 400 feet (120 m) thick. The uppermost red shale (the Hermit) also becomes thicker to the west and has eroded back from the top of the sandstone bed to form a broad terrace known as the Esplanade Platform—the most striking feature in the western Grand Canyon. Thus, as can be seen in the diagram above, the canyon profiles in eastern and central Grand Canyon are distinct and dramatically different from the profiles in the west.

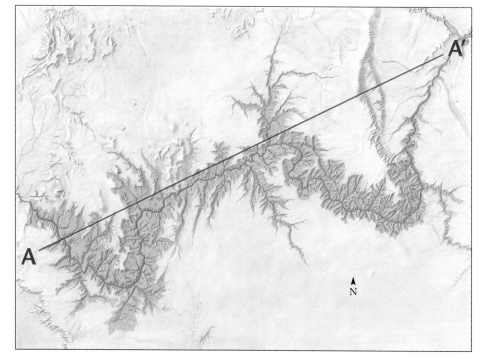

Idealized section showing variations in rock formation along A–A′, a distance of approximately 140 miles

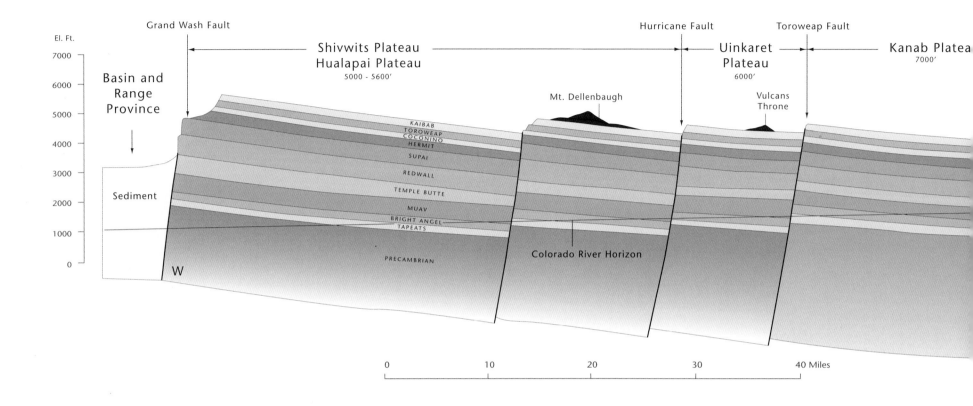

Major Geologic Sections

The Grand Canyon area can be divided into several major sections based largely on structure, elevation, and rock exposed at the surface. The western part of the region is divided into a series of blocks by the northerly trending Grand Wash, Hurricane, and Toroweap faults. Along each of these faults the blocks to the west have dropped downward relative to the blocks in the east. In general the rocks in these fault blocks dip to the northeast. The eastern part of the region is controlled by the flexing of monoclines, large asymmetrical upwarps.

MARBLE PLATFORM

The Marble Platform extends from Lees Ferry on the north to the Little Colorado River on the south, a distance of approximately fifty miles (80 km). It is a relatively flat area in which the surface is inclined toward the northeast approximately 100 feet per mile (30 m/1.6 km). Here, for a short distance near the mouth of the Paria River at Lees Ferry, there is no canyon. The river simply flows across the top of the Kaibab Formation. Then, less than a mile (1.6 km) downstream, the river suddenly begins incising the rocks and forms Marble Canyon. This is the beginning of the Grand Canyon. As the river slowly cuts downward through the strata, Marble Canyon gradually becomes deeper and at a distance of sixty-five miles (105 km) downstream from Lees Ferry it is 3,000 feet (900 m) deep.

The Marble Platform is best described as a "stripped surface" on which the overlying nonresistant Mesozoic rocks have been completely eroded away from the Kaibab Formation. As a result, the tributaries that subsequently developed on the Marble Platform flow to the northeast, down the dipping surface of the Kaibab layer.

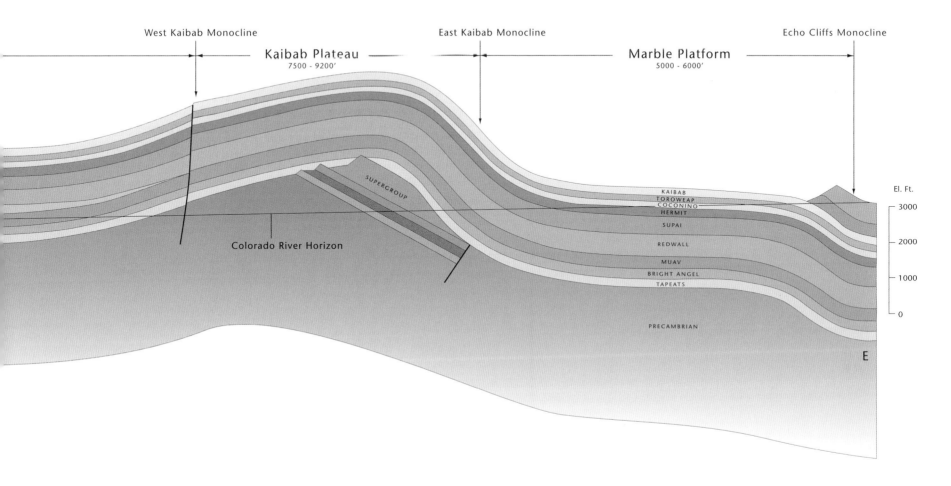

KAIBAB PLATEAU

The Kaibab Plateau section results from a large flexure in the earth's crust in which the sequence of rocks arches up nearly 5,000 feet (1,500 m) above the Marble Platform to an elevation of 7,500 to 9,300 feet (2,300 to 2,800 m). The Colorado River cuts across the toe of the upwarp in a large horseshoe-shaped bend, eroding the deepest and widest part of the Grand Canyon. This is the part of the canyon seen by most visitors, and to many it is the most scenic area of the canyon. The great attraction of the Kaibab Plateau section is that the river cuts through a far more diverse section of rocks than in other sections. As a result, it contains a multitude of colorful landforms that are either absent or less developed elsewhere. All of the major rock groups are magnificently exposed and they display a history of the canyon that is easily read. In the Kaibab Plateau section the soft Bright Angel Shale is well above river level and has eroded back from the more resistant Tapeats Sandstone to expose the Tonto Platform, one of the more prominent landforms in this part of the canyon. The cross section of the canyon in the Kaibab Plateau region shows the classic Grand Canyon profile extending up from the rugged Granite Gorge, across the Tonto Platform, and up through the Redwall cliff as well as the younger cliffs and slopes of the Supai, Hermit, Coconino, Toroweap, and Kaibab formations.

KANAB PLATEAU

The Kanab Plateau is a broad, almost flat, surface between the Toroweap and Kanab faults. It is a simple, monotonous expanse with little to note except for the magnificent, deep tributary canyon carved by Kanab Creek, which cuts southward through its center and opens into the heart of the Grand Canyon. Kanab Creek is the best hiking route out of the central part of the canyon and was used by early geologists such as Major Powell and Charles Walcott during their studies in the late 1800s.

In the Kanab section the form of the canyon changes in several significant ways. The Tonto Platform becomes smaller and then disappears. At the same time, another shelf comes into prominence some 2,000 feet (610 m) higher, the Esplanade

Platform, a magnificent bench more than five miles (8 km) wide that lies approximately 2,000 feet (610 m) below the canyon rim. In addition, the Bright Angel, Muav, Redwall, and Temple Butte formations are much thicker here than they are to the east and form a vertical-walled Inner Gorge beneath the Esplanade Platform. The cross-section of the canyon across the Kanab region is therefore relatively straightforward but quite unlike that seen from Grand Canyon Village to the east.

South of the Colorado River a broad area known as the Coconino Plateau is simply a southern continuation of the Kanab Plateau. Here the rocks are nearly horizontal but form a broad, shallow basin. Kanab Creek and Havasu Creek flow from opposite sides of the Colorado River down the axis of this depression. Havasu (Cataract) Creek, is almost the mirror image of Kanab Creek. It is unique, however, in that it is partially filled with silt and mud that likely was deposited when temporary lakes formed behind the geologically recent lava dams created by volcanic eruptions downstream at Toroweap. A series of magnificent waterfalls cascades over what may be the preserved shorelines of several of these lakes.

UINKARET PLATEAU

The Uinkaret Plateau section is a small but interesting part of the canyon situated between the Toroweap and Hurricane faults. It has been the scene of repeated volcanic eruptions that have had a major effect on the recent history of the entire Grand Canyon. What makes this part of the canyon unique is that the three major tributaries (Whitmore Wash, Toroweap Valley, and Prospect Canyon), as well as several minor tributaries, are filled with lava to the level of the Esplanade. The maximum thickness of lava filling Prospect and Toroweap valleys is nearly 3,000 feet (900 m). The valley floors, formed on the upper surface of the lava flows, are broad and flat, making it possible to drive down these valleys to the very rim of the Inner Gorge. Numerous spectacular lava flows that were extruded onto the high outer rim, flowed down into the valleys and out across the Esplanade, and then cascaded into the deep abyss of the Inner Gorge. The lava flows and cinder cones in the Uinkaret volcanic field range in age from 10,000 to 630,000 years old.

In terms of the recent history of the canyon, the most significant features in the Inner Gorge of the Uinkaret section are remnants of at least thirteen older lava dams adhering to the walls of the Inner Gorge. These dams sometimes formed temporary lakes in the canyon, some extending far upstream beyond today's Lake Powell. As the waterfalls migrated headward they became higher—some were roughly ten times higher than Niagara Falls. The highest dam was more than 2,300 feet (700 m) high. This indeed is one of the most spectacular displays of the interplay of volcanism and stream erosion in the world.

SHIVWITS PLATEAU

The western part of the Grand Canyon is largely inaccessible. It is the part of the canyon that few people know. The Shivwits Plateau section extends from the Hurricane fault to the Grand Wash Cliffs. Here the Colorado River flows southward, parallel to the Hurricane fault, for a distance of about twenty miles (32 km). It then makes a horseshoe turn and flows to the northwest, and exits the canyon at the Grand Wash Cliffs, entering the Basin and Range Province.

The surface of the Shivwits Plateau is unique in several ways. Basalt flows cap a number of scattered mesas and buttes north of the canyon rim, the largest of which is the mesa upon which Mount Dellenbaugh rests. In addition, a number of minor faults dissect the plateau surface into smaller blocks north of the canyon. A significant change in the thickness of the Hermit, Supai, Redwall, Temple Butte, and Muav rock units occurs in the Shivwits area. All continue to thicken westward and appear to merge to form a single high cliff that dominates the canyon profile.

HUALAPAI PLATEAU

The Hualapai Plateau section is south of the Colorado River and here the upper formations of the canyon (Kaibab, Toroweap, Coconino, Hermit, and upper Supai) have been completely eroded away so that the beveled edges of the Redwall form the upper surface of the Esplanade. Here the top of the Supai is, in essence, the rim of the canyon.

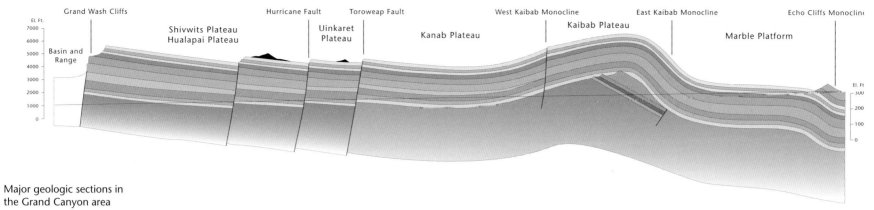

Major geologic sections in the Grand Canyon area

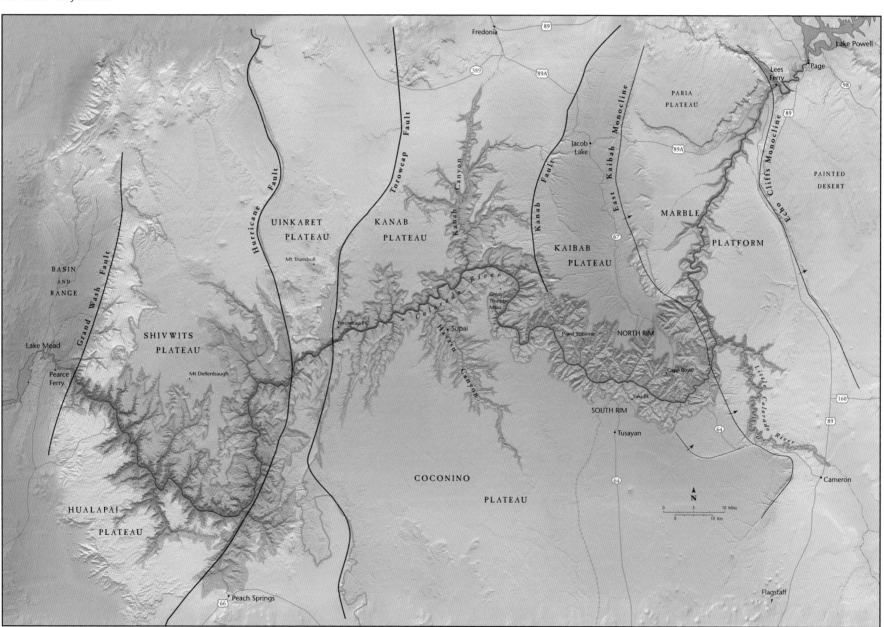

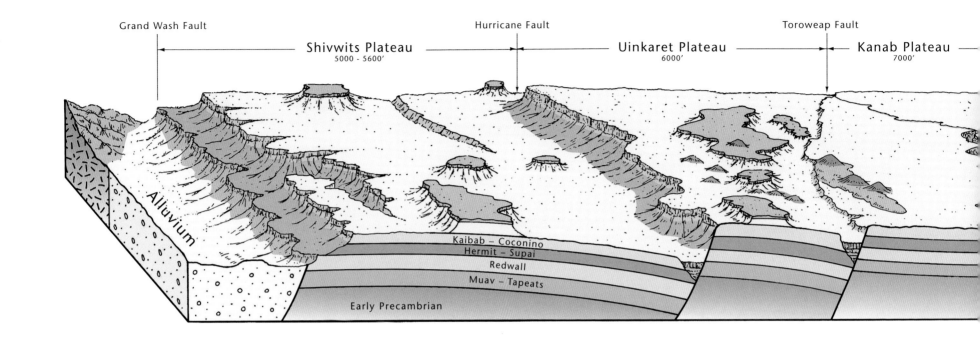

Structure of Grand Canyon Rocks

A rock formation extends over hundreds of square miles and may be tilted, folded, and displaced by faulting. To properly interpret the geology of an area one must understand something about the structure or configuration of the rock bodies. The fundamental tool for studying the structure of a region is the structural contour map, which shows the surface configuration of a formation in reference to sea level. These data have been utilized to construct a block diagram, such as the one shown here, to illustrate in perspective the regional relationships of the structure and topography. On a regional basis, the structure of the rocks in the Grand Canyon area is therefore relatively straightforward. The crust has simply been uplifted and tilted slightly downward in the east. In the western part of the canyon (the Grand Wash Cliffs area) the Kaibab Formation would once have been uplifted to an elevation of 11,400 feet (3,475 m). At Lees Ferry, the easternmost part of the Grand Canyon, the elevation of the Kaibab is only 3,100 feet (950 m) today—a difference of nearly 8,300 feet (2,500 m). Two major structural features interrupt this regional tilt and cause significant variations in the canyon. One is a zone of north-south trending faults (the Hurricane and Toroweap faults) in the western Grand Canyon, which displace the strata by 500 to as much as 1,500 feet (150 to 450 m). The other is a large fold, the East Kaibab monocline, which elevates the rocks as much as 5,000 feet (1,500 m) to form the Kaibab Plateau, reaching an elevation of nearly 9,000 feet (2,750 m). Between the faults and the Kaibab upwarp, the Kanab Plateau forms a broad, structural depression where the general elevation is only 5,600 feet (1,700 m).

The most significant effect of structure upon the development of the Grand Canyon is that the depth to which the canyon is cut is directly dependent on the amount of uplift. The greater the uplift; the greater the canyon depth. This is beautifully expressed in the Marble Canyon area where the Colorado River flows at the surface of the Kaibab Formation at Lees Ferry, but cuts a canyon progressively deeper and deeper as it flows toward the

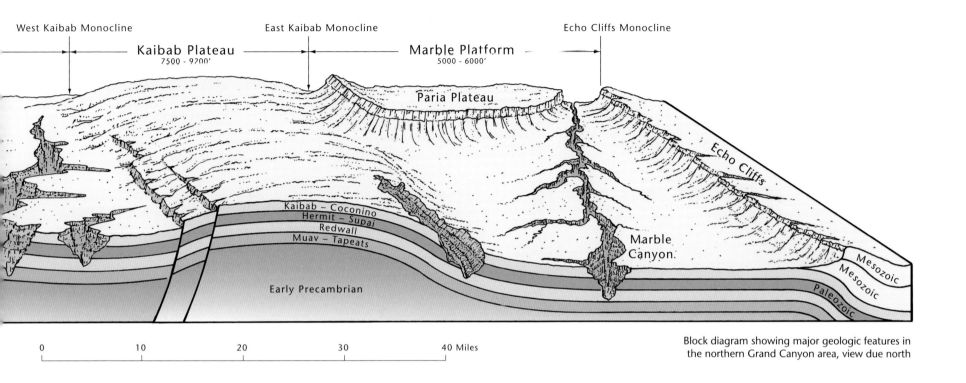

Block diagram showing major geologic features in the northern Grand Canyon area, view due north

southwest across the regional tilt of the strata. The canyon thus becomes progressively deeper as the river cuts through the area of higher uplift.

The single most significant structural feature in the Grand Canyon is the East Kaibab monocline, which has raised the surface of the Kaibab Plateau as much as 5,000 feet (1,500 m) above Marble Canyon. This is an asymmetrical fold in which the west flank of the flexure is inclined to the west at a gentle angle, and the east flank dips steeply to the east and then abruptly flattens out to form the Marble Platform.

An important, but much less impressive, structure is a broad, shallow depression that extends westward from the western flank of the Kaibab upwarp. This depression is approximately forty miles (64 km) wide and extends from the Vermilion Cliffs on the north to the headwaters of Havasu Creek on the south. Two major tributaries to the Colorado River, Kanab and Havasu (Cataract) creeks, follow the axis of this depression. Except for the Little Colorado River, these are the largest drainages within the Grand Canyon area. It would appear that both streams originated as strike-valley streams along the flank of the Kaibab upwarp very early in the evolution of the Grand Canyon.

West of the Kanab section, the structure of the Uinkaret Plateau is complicated by faulting and associated local tilting of the strata. This section is very narrow (only eight miles/13 km wide) and is bounded by the Toroweap and Hurricane faults. Both faults form zones of weakness along which headward erosion has developed long tributary canyons. Toroweap Valley, on the north side of the Colorado River, is twenty-five miles (40 km) long and Prospect Valley, on the opposite side of the river, is twenty-two miles (35 km) long; Whitmore Valley, eroded along the Hurricane fault, is sixteen miles (26 km) long. These are the longest tributaries in the area. The most distinctive feature in the Uinkaret Plateau, however, is the large volcanic field formed between the Toroweap and Hurricane faults.

Evolution of Tributary Canyons

The Grand Canyon's walls are sculpted into a seemingly random maze of mesas, buttes, pinnacles, and tributary canyons that produce panoramas of unparalleled scenic beauty. However, these landscape features originate in a very systematic way that is determined by tributary streams and how those streams evolved over time. Size, shape, and orientation of the tributaries (and thus the landscape) are the result of three key elements: structure, headward erosion, and stream capture.

The major structural control in the evolution of canyon features is the uplift and tilt of the stripped surface that forms the top of the Kaibab Formation. The drainage patterns in the headwaters of most tributary streams (that is, the segments of the stream that are beyond the canyon rim) are not controlled by the Colorado River. Rather, they are formed by surface runoff flowing down the regional slope (dip slope) of the Kaibab's surface.

The lower courses of tributaries are different. They flow essentially perpendicular to the Colorado River. The gradient of this segment of the streams is very steep, therefore headward erosion is accelerated. Soon these intra-canyon tributaries erode back (headward) and intersect (capture) the streams flowing on the tilted surface of the Kaibab Formation beyond the canyon rim. Indeed, stream capture can be seen in almost every tributary. We will consider only a few of the more spectacular examples.

MARBLE PLATFORM

The tributary streams on the Marble Platform constitute one of the most striking examples of stream capture in the world. The remarkable feature of this drainage pattern is that while the main trunk stream (the Colorado River) flows to the southwest, all of its tributaries flow in the opposite direction.

This pattern is exactly opposite a normal dendritic pattern developed by most stream systems. Careful study of the landscape in this area clearly indicates that the upper segments of the tributaries originated as consequent streams flowing down the regional dip slope on the stripped surface of the Kaibab, and were subsequently captured by the tributaries that formed on the canyon walls. At the point of capture the upper segment of the tributaries make a right-angle bend before entering the Colorado River, which forms the "barbed" pattern.

KAIBAB PLATEAU

The tributary system in the Kaibab Plateau area is strikingly asymmetrical. On the south side of the canyon, all of the tributaries are short, rarely more than five miles (8 km) long. This is because the surface on the Kaibab Formation slopes southward. Most of the runoff on the South Rim, therefore, does not flow into the Colorado River, but rather flows southward away from the canyon. Headward erosion and stream capture is minimal and growth of these tributaries is greatly limited. As a result, the southern canyon walls are not cut back by long tributary canyons but are simply serrated into a series of scalloped alcoves, or steep embayments. The South Rim is, therefore, quite close to the Colorado River.

Tributaries on the north side of the canyon follow the same slope southward toward the canyon. This has aided headward erosion, carving long, narrow canyons into the wall of the Kaibab Plateau—some more than fifteen miles (24 km) long. As a result, the North Rim of the canyon has eroded back seven to ten miles (11 to 16 km) from the river. Numerous mesas, buttes, and temples have formed on the ridges between the tributaries. Visitors to the South Rim (looking north) see an elaborately sculpted canyon landscape.

KANAB CREEK

Kanab Creek is one of the major tributaries to the Colorado River in the Grand Canyon. Its headwaters are far to the north on the high plateaus of Utah, near Bryce Canyon. From here they flow almost due south for seventy-two miles (116 km) and cut across all the cliffs of the Grand Staircase. Throughout this distance there are numerous dramatic examples of stream capture, especially where Kanab Creek cuts a deep canyon through the surface of the Kaibab Formation on the Arizona Strip.

The headwaters of tributary streams on the west side of Kanab Creek flow eastward down the sloping surface of the Kaibab Formation. On the east side the tributaries flow westward down the sloping surface of the Kanab Plateau. Essentially all of the tributaries to Kanab Creek were captured and abruptly turn 180 degrees before they enter the main channel. Thus the drainage pattern of Kanab Creek looks more like the dendritic pattern of a weeping willow than that of a typical oak tree.

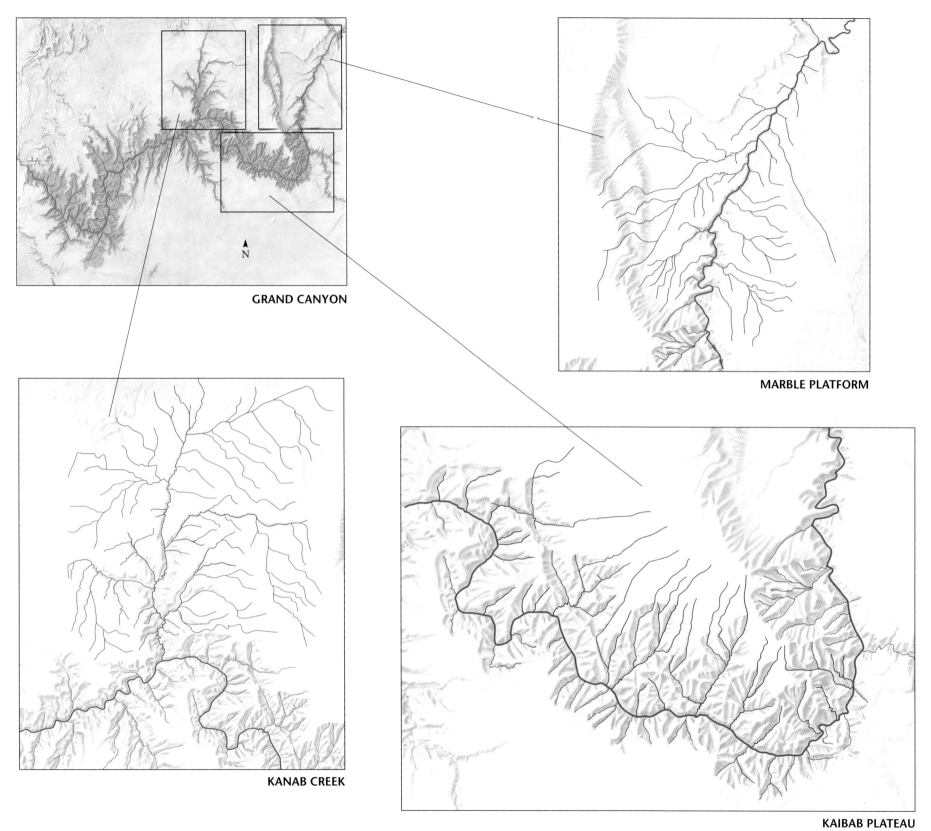

Erosion of the Grand Canyon

As you look down into the Grand Canyon, that great gash more than a mile (1.6 km) deep and eight miles (13 km) wide, and see the Colorado River as a tiny ribbon of green or brown, myriad questions inevitably arise. Did the earth split open and create the canyon in one catastrophic event? Did the Colorado River simply flow down a preexisting canyon? Geology tells us that the canyon was eroded by the Colorado River slowly, over several millions of years, but for many this is hard to believe. How could such a small river, barely one hundred yards (90 m) wide, erode such a huge canyon—in places more than fifteen miles (24 km) wide? Did great floods once flow through the canyon? What was the rate of erosion? How old is the Grand Canyon?

In order to answer these and other questions about the origin of the Grand Canyon one must first understand something about the processes of stream erosion. A river is not simply a stream of flowing water; it is a system of flowing water and sediment. This fact is vividly illustrated by motion pictures of recent floods where, in some cases, the volume of sediment was greater than the volume of water. This system of flowing water and sediment functions like a huge wire saw commonly used in quarrying operations. The flowing water drags the sediment along the channel floor, and as it does so, the sand, mud, and gravel abrade the bedrock on the channel floor. The system is extremely efficient. A wire saw can cut through a block of granite six feet (1.8 m) thick in a matter of a few hours. Likewise, a river system is capable of cutting through most any rock body in a geologic instant. Indeed, when the more than thirteen successive lava dams (having a cumulative vertical thickness of three miles/5 km) intermittently formed in the western part of the Grand Canyon during the last 630,000 years, they were rapidly cut through by the Colorado River. The radiometric dates of these dams indicate that the Colorado River cut through this cumulative three-mile (5-km) thickness of solid rock in fewer than 250,000 years!

A river, however, can only erode down to sea level. Rivers, therefore, rapidly develop a longitudinal profile that is inclined toward the sea at an angle just steep enough to maintain a gradient down which water can flow. This is called a profile of equilibrium. The gradient, or profile, of the stream channel rapidly reaches a balance point at which the least amount of energy is expended, and neither large-scale erosion nor deposition occurs. Most rivers soon develop this profile of equilibrium along their entire length. Thus, the Colorado River is not continually eroding its channel. Large scale (significant) erosion occurs only

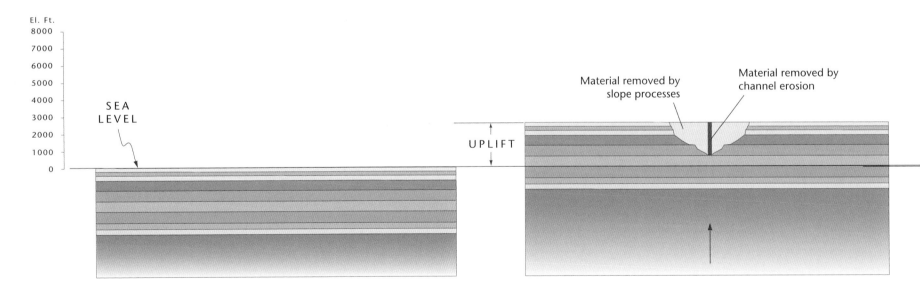

The original, undissected surface was a flat, stripped surface on the horizontal Kaibab Formation. Underlying beds contain a sequence of alternating resistant and nonresistant rocks.

Initial dissection and slope retreat occur as a result of crustal uplift or down-dropping. Slope retreat causes nonresistant rocks to recede from the river so that a terrace is left on the underlying resistant rock layer.

as a result of uplift of the crust (faulting or tilting) or tectonic lowering of areas downstream.

Regional uplift is slow and intermittent, and movement along faults at any given time is limited to only a few yards. For example, where the Colorado River crosses the Hurricane and Toroweap faults, displacement along the faults ranges from 800 to 1,500 feet (250 to 450 m), yet there are no waterfalls or rapids across the faults—none at all. Thus, it is clear that when uplift or faulting occurs, the river is able to erode its channel in a geologic instant and reestablish a profile of equilibrium. Erosion of the Grand Canyon therefore occurs in a series of short pulses corresponding to recurrent uplift or down-dropping.

The question of how long it took for the river to cut the Grand Canyon is not the fundamental question since the rate of canyon erosion is dependent on the rate of uplift or down-dropping. More significant questions to be asking are: When and how fast does structural shift occur? When did uplift begin? What is the history of uplift? Did uplift occur across the entire region all at the same time? Was uplift the result of displacement along faults? Was uplift greater in some areas than in others? Or, was the perceived uplift actually the differential resulting from down-dropping of the adjacent Basin and Range Province? The question is not how fast did the Colorado River erode the Grand Canyon, but how fast was the crust shifted either up or down.

Downcutting by stream abrasion produces a vertical gorge the width of the stream channel, but the Grand Canyon is more than eight miles (13 km) wide in many places. How did the canyon become so wide? The answer: by a combination of erosion by the numerous tributary streams and by mass movement of rock debris downslope by the pull of gravity (rock falls, landslides, debris flows, and creep).

Computer models of Grand Canyon erosion show the nature of changes that have occurred since the Colorado River began eroding into the Kaibab Plateau. Thousands of profiles were calculated and animated to simulate the development of the canyon through time. Four of the profiles are shown here. This model shows that erosion was neither gradual nor uniformly slow or fast, but rather that erosion occurred in a series of pulses that were largely a function of recurrent plateau uplift or down-dropping of the Basin and Range Province to the west. During periods of uplift or down-dropping, erosion was correspondingly faster, but the Colorado River maintained its profile of equilibrium with a smooth, gently curving longitudinal slope toward the sea.

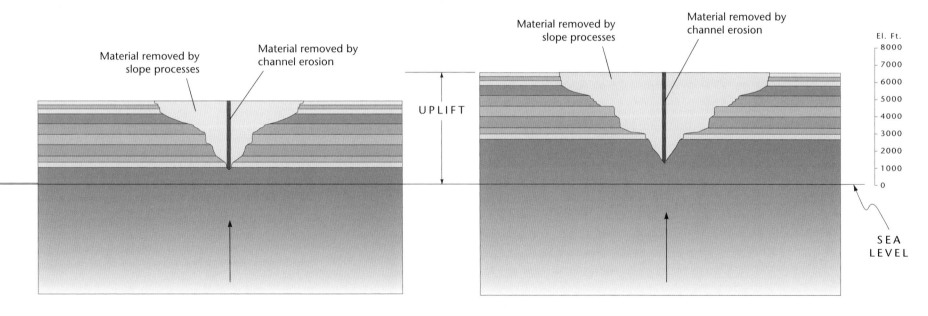

With renewed shifts in the plane of the surface, downcutting saws through the underlying rocks.

Downcutting continues as a result of uplift or down-dropping. Slope retreat produces alternating cliffs and terraces. Note that the erosion of the river channel produces a vertical gorge, whereas mass movement and erosion along tributary streams widen the canyon and produce the profile we see today.

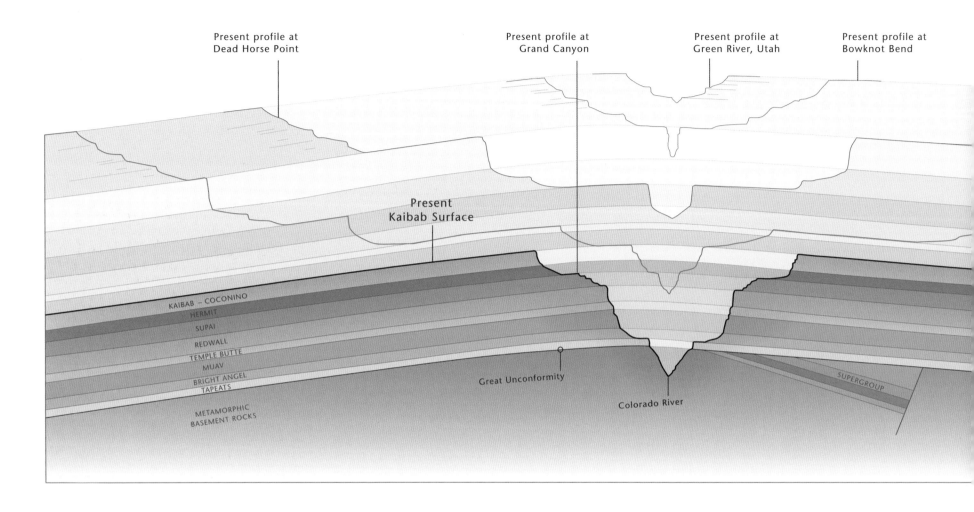

Profiles of Ancient Grand Canyons

As you stand on the rim of the Grand Canyon and look at the surrounding plateau, nothing rises above you and it seems as if nothing ever did. You feel as though you are on the top of the world, looking into the depths of Earth exposed in the canyon below. Yet the erosion of the canyon did not begin as the Colorado River cut into the Kaibab Plateau upon which you stand.

Younger rock layers and ancestral Grand Canyons once existed above you. The Colorado River flowing along the bottom of the Grand Canyon once flowed across much younger rocks higher in the sequence, and cut through them as the region was uplifted. These earlier canyons evolved over time, producing a series of canyons that were, in some ways, more spectacular than the canyon we see today. As much as two vertical miles (3 km) of rock have been removed from above the present canyon rims, and as they eroded away, a series of canyons developed with various profiles, each of which was controlled by the nature of the rock encountered by the erosive forces. Vestiges of these canyons still exist in the form of the Grand Staircase, fifty miles (80 km) to the north in Utah. South and east of the canyon a number of remnants can also be found, the largest being in the Echo Cliffs, the Painted Desert, Petrified Forest, and in the mountains around Las Vegas, Nevada (Valley of Fire, Rainbow Gardens, and Spring Mountain).

The cross section above shows a reconstruction of the general form of the canyons that evolved

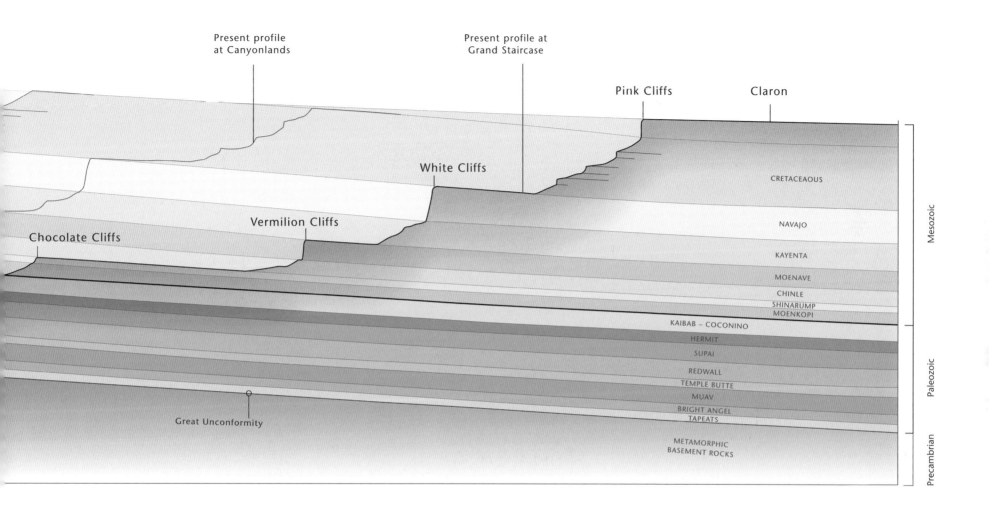

prior to the present Grand Canyon. The profile is based largely on the sequence of rocks in the Grand Staircase and other remnants south of the canyon. It is, of course, highly idealized and many details are a matter of conjecture. Its value lies in helping us to visualize the evolution of the canyon prior to what we see today.

Additional insight into the nature of the ancient canyons can be gained by studying the series of Colorado River canyons upstream from the Grand Canyon where, uplift has been less and the river channel is still eroding into the younger sequence of rocks.

At Green River, Utah, the canyon of the Colorado River is wide and shallow, being eroded through the soft Cretaceous shales (oldest canyon at the top of the diagram). Downstream, where the river cuts down into the resistant Navajo Sandstone (in the area of Bowknot Bend and Glen Canyon), the canyon is a narrow, steep-walled inner gorge with the nonresistant shales above it being eroded far back from the river to form a broad terrace. Farther downstream, where uplift has permitted the river to cut deeper into the sequence of less resistant Mesozoic rocks, a broad, open canyon is produced, characterized by a series of alternating cliffs and slopes, similar to the canyon at Dead Horse Point. Thus, to appreciate the real history of the Grand Canyon we must consider the profiles of canyons that preceded the present one.

Important Canyon Features

Much of the majesty of the Grand Canyon emanates from the variety of landforms seen between the canyon's rims. They are the result of differential erosion (resistant versus nonresistant beds) and headward erosion of tributary streams flowing into the Colorado River. Although the landscape of the canyon varies from one area to the next, the Grand Canyon has a distinctive anatomy consisting of cliffs, slopes, alcoves, plateaus, mesas and buttes, terraces and platforms, and the deeply incised Inner Gorge. Take a moment to examine each scene in the panoramas throughout this book and try to identify the rock formations and the landforms they produce.

CLIFFS AND SLOPES

The fundamental landform in the Grand Canyon is a series of cliffs and slopes produced on alternating resistant and nonresistant rock layers. This type of landscape exists on all scales ranging from high cliffs of the Redwall Limestone and the slope of the Bright Angel Shale to small-scale steps and ledges formed on individual beds.

REDWALL CLIFF

The Redwall Limestone forms a vertical wall 550 feet (170 m) high located approximately midway between the canyon rim and the river. The cliff is almost continuous and can be traced zigzagging around majestic buttes and alcoves throughout the canyon from east to west; it is one of the most conspicuous topographic features in the canyon. Another prominent cliff is that formed on the light tan Coconino Sandstone, which, like the Redwall, can be traced from one end of the canyon to the other, although it is locally absent near Kanab Creek. The resistant cliff is maintained by constant undermining of the weak shale beneath it.

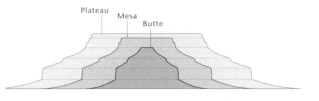

PLATEAUS, MESAS, AND BUTTES

Headward erosion along tributary streams produces peninsula-like promontories extending out into the canyon from the main plateau. An excellent example is Walhalla Plateau which is connected to the main plateau by a narrow isthmus at the head of Bright Angel Creek. With continued erosion, a peninsula will become completely separated from the main plateau. Powell Plateau is at this stage of development today; it is completely cut off from the main Kaibab Plateau as a result of erosion along the Muav fault zone.

The new detached plateau is bounded on all sides by cliffs that continue to recede due to wastage and slope retreat of the surrounding cliffs, effectively shrinking the plateau. As it becomes smaller it assumes the form of a flat-topped hill called a butte. In the Grand Canyon these isolated buttes are commonly referred to as "temples." Further erosion will reduce the butte to an isolated pyramid or pinnacle. Ultimately the resistant cap rock will be completely removed. The underlying weak shale is then quickly eroded away and a new cap rock is formed on the next lower resistant formation. An excellent example is Cheops Pyramid, west of Phantom Ranch, which is capped by the Redwall Limestone, not the Coconino or Kaibab, like so many buttes closer to the North Rim.

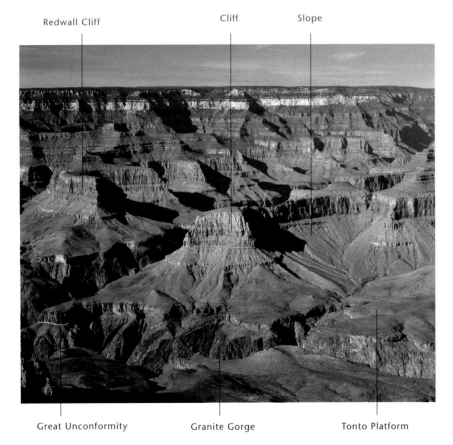

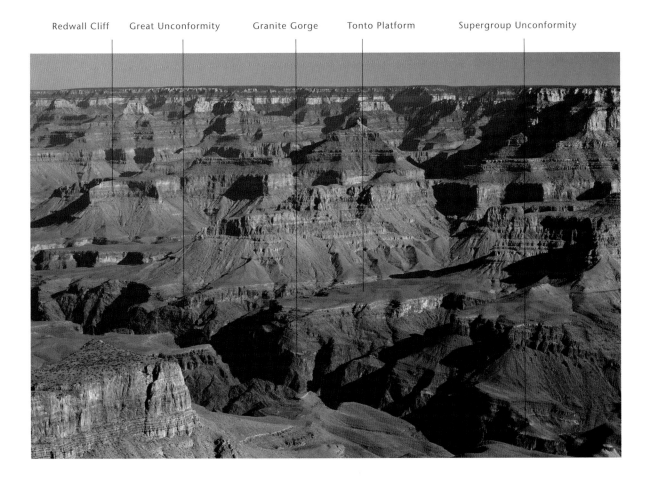

Redwall Cliff Great Unconformity Granite Gorge Tonto Platform Supergroup Unconformity

TERRACES AND PLATFORMS

Where a resistant sandstone or limestone is overlain by thick, nonresistant shale, the shale is rapidly eroded back, leaving in its wake a platform or terrace on the more resistant formation below, which may be several miles wide. The Tonto Platform is a good example. It is formed on the Tapeats Sandstone 3,000 feet (900 m) below the canyon rim. The terrace is more than a mile (1.6 km) wide and extends throughout most of the Kaibab section of the canyon. The great Esplanade Platform to the west developed in a similar way where the Hermit Formation thickens to the west and is eroded back from the underlying, resistant Supai Sandstone.

THE GRANITE GORGE

The Upper Granite Gorge (river mile 77–116) is a narrow V-shaped gorge in the bottom of the canyon formed as the Colorado River cut into the resistant Precambrian igneous and metamorphic rocks. It extends from Grandview Point downstream to the vicinity of Powell Plateau, a distance of forty miles (60 km). The Upper Granite Gorge is up to 1,300 feet (400 m) deep and is characteristically a dark, somber gray. The gorge erodes into ragged, steep slopes and thus stands out in marked contrast to the alternating steps of cliffs and slopes that form the higher canyon features. The Middle Granite Gorge is farther downstream (river mile 127–130 and 134–136) and west of Powell Plateau. In the western Grand Canyon the Lower Granite Gorge is more than forty miles (64 km) long and extends almost to the Grand Wash Cliffs from river mile 216 to 258.

Note: The terms Inner Gorge and Granite Gorge are often used interchangeably when referring to the deeply incised gorge that cuts through the metamorphic "basement rocks" at the bottom of the Grand Canyon. In this book, Inner Gorge is used throughout unless we are referring to a specific named portion of the gorge, such as Upper, Middle, or Lower Granite Gorge. In these discontinuous locations the walls of the Inner Gorge are literally composed of schist and granite, whereas the walls elsewhere are not.

UNCONFORMITIES

One of the most important boundaries between rock formations in the Grand Canyon is the Great Unconformity, the boundary between the Tapeats Sandstone and the underlying Precambrian rocks. The unconformity is not a major topographic feature, and it may escape detection by those who simply glance at the scenery. From a geologic perspective, however, the unconformity is an extremely important feature, and a feature of great geologic beauty. The Great Unconformity is an ancient erosional surface that represents 1.2 billion years of missing time—time not recorded in the canyon's rock formations. This is more than twice the length of time that has passed since the first horizontal Paleozoic rocks were deposited, and vastly longer than it has taken to erode the Grand Canyon.

Another important unconformity separates the upper Precambrian–Grand Canyon Supergroup from the underlying lower Precambrian metamorphic and igneous rocks. Physically it is similar to the Great Unconformity but it was formed much earlier and exposures in the Grand Canyon are limited.

Chapter 2

Eastern GRAND CANYON

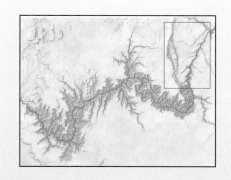

Marble Platform	42
Lees Ferry	44
Vaseys Paradise	46
Caves in the Redwall Limestone	48
East Kaibab Monocline	50
Inside the Monocline	52
Point Imperial	54
Walhalla Plateau	56
Cape Royal	58
Palisades of the Desert	60
Butte Fault	62
Precambrian Basalts	64
Ochoa Point	66

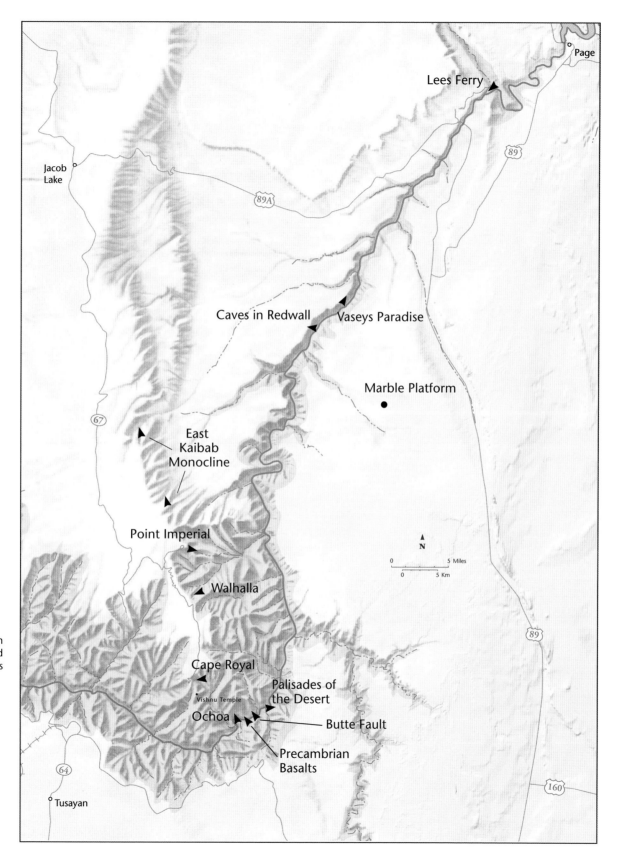

Map of eastern Grand Canyon showing locations and direction of photographs

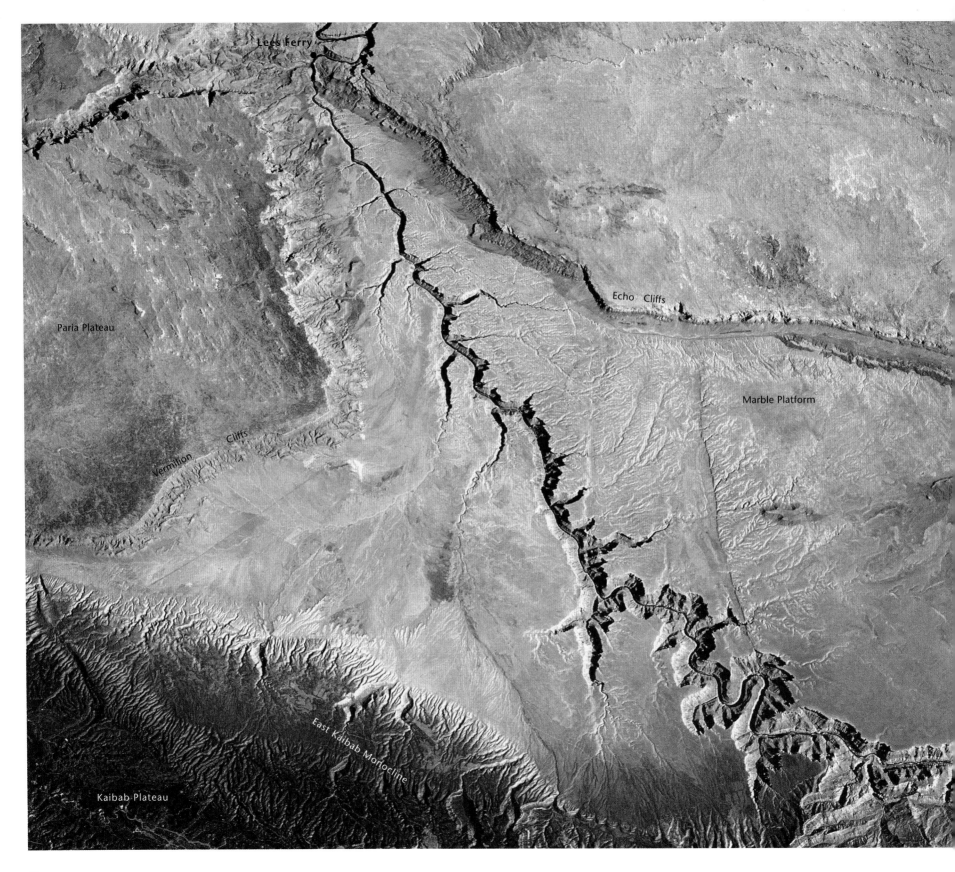

Painted Desert

The Marble Platform

Satellite imagery provides a remarkable view of the distinctive characteristics of the Marble Platform and the canyon cut into it by the Colorado River. The location of Lees Ferry, where the Grand Canyon officially begins, is visible in the upper left. The Vermilion and Echo cliffs flanking it are composed of the same sequence of rocks that once extended across the entire area but have since eroded from the surface of the underlying, resistant Kaibab Formation. A striking apron of red landslides and erosional debris flares out around their bases. The cliffs resulted from a monocline flexure that is marked by a high, steep cliff with a stripe of darker red Mesozoic shale below. In the lower left corner the Kaibab upwarp is visible; being higher, it is covered with vegetation.

The Marble Platform is a "stripped surface" where the nonresistant Moenkopi Shale has eroded from the underlying resistant Kaibab Formation. Secondary streams that developed on the Marble Platform simply flow down the tilted surface of the Kaibab Formation. In contrast, the Colorado River flows diagonally across the Marble Platform cutting into the uplifted rock layers so that the canyon becomes progressively deeper downstream. Where the river encounters the East Kaibab monocline, the canyon is 3,000 feet (900 m) deep.

Throughout its course across the Marble Platform, the Colorado River has developed a series of short tributaries that run roughly perpendicular to the main channel of the Colorado River. As these young tributaries grow headward, an extremely important change occurs. They intersect and capture the older streams flowing toward the northeast down the regional slope of the Marble Platform. This develops a pattern commonly known as a "barbed drainage" because the tributaries enter the main stream in a pattern similar to a fishhook or barb. This drainage pattern is one of the most distinctive landform features of the area. It is exactly what you would expect if the Colorado River were flowing in the opposite direction. Indeed, some geologists have considered this pattern to be an indication that the Colorado River once flowed in the opposite direction (what is upstream today). Look closely at the stream pattern. Which direction do you think the Colorado River is flowing?

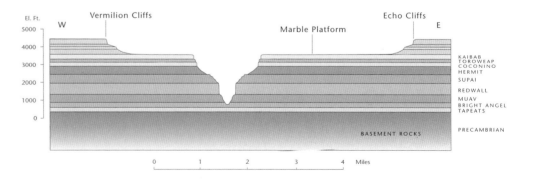

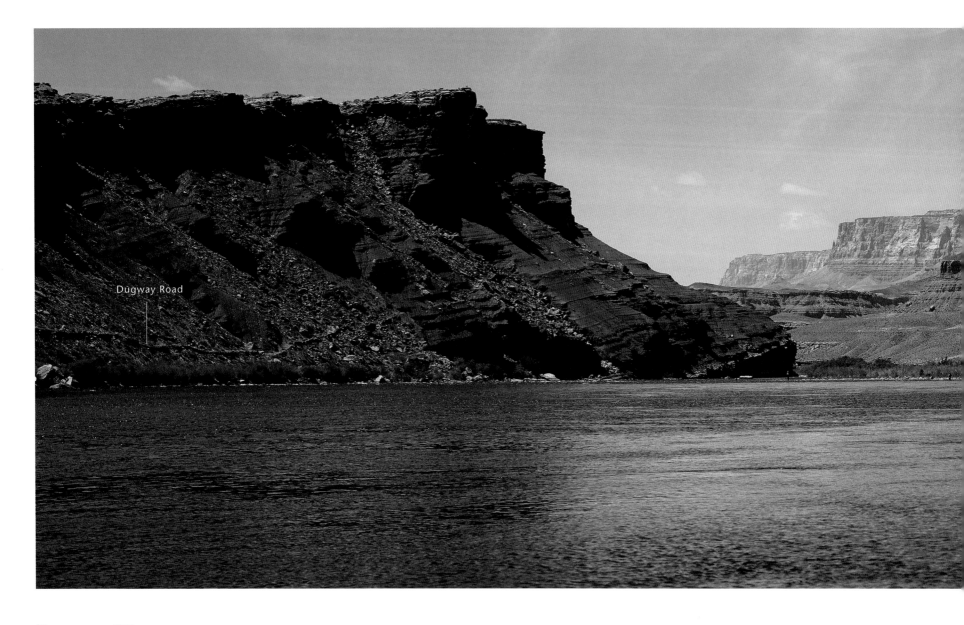

Lees Ferry *View downstream, river mile 0*

The Grand Canyon officially begins at Lees Ferry, the place where the Colorado River simply exits one canyon (Glen) and immediately flows into another. It is one of only two places in the Grand Canyon where it is possible to reach the river in a wheeled vehicle. Access to Lees Ferry is made possible by the flexure of the Echo Cliffs monocline, which brings the soft Moenkopi shale down to river level so that there is a brief lowland here, resting on the erosional terrace of the Marble Platform, instead of a deep canyon.

Although the channel of the Colorado River is on the surface at Lees Ferry, the Vermilion and Echo cliffs that flank it constitute high escarpments close by so that, in a sense, Lees Ferry is down in a canyon. The cliffs, composed of Mesozoic sandstones, could therefore be considered the rim of the Grand Canyon in this area. Soft, purple Chinle Shale forms a slope below the cliffs. Moenkopi Shale forms the low terrace on both sides of the river atop the relatively thin, resistant sandstone beds.

Major John Wesley Powell, the first geologist to

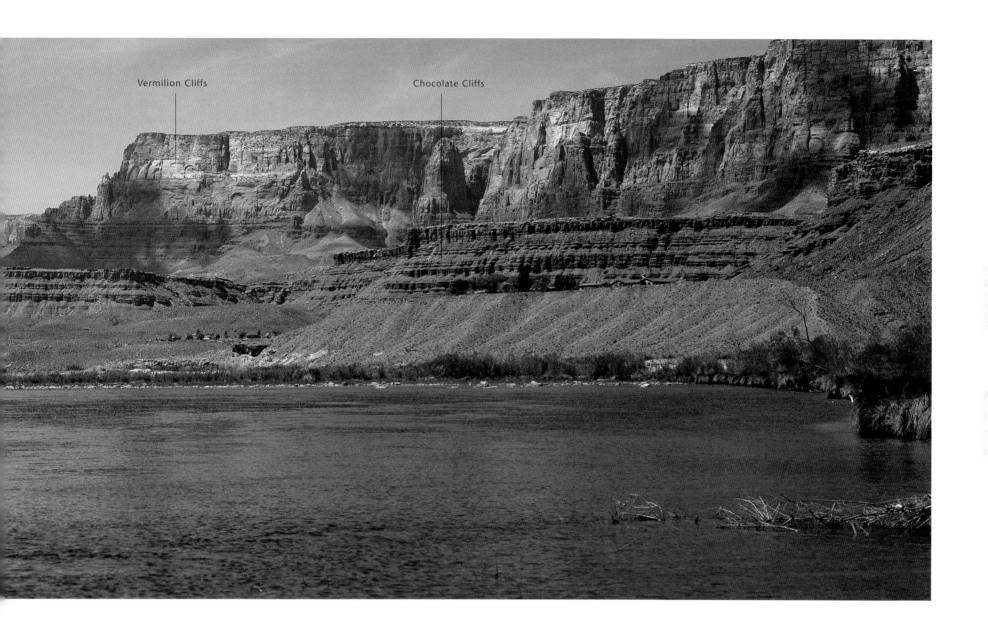

explore and map the canyon, considered Lees Ferry to be the head of the Grand Canyon, river mile zero. From here the sequence of rocks dips to the northeast so that as the river flows southwestward it cuts progressively deeper into the inclined rock layers to form Marble Canyon.

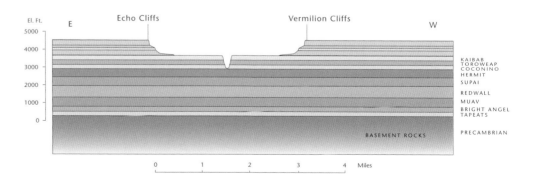

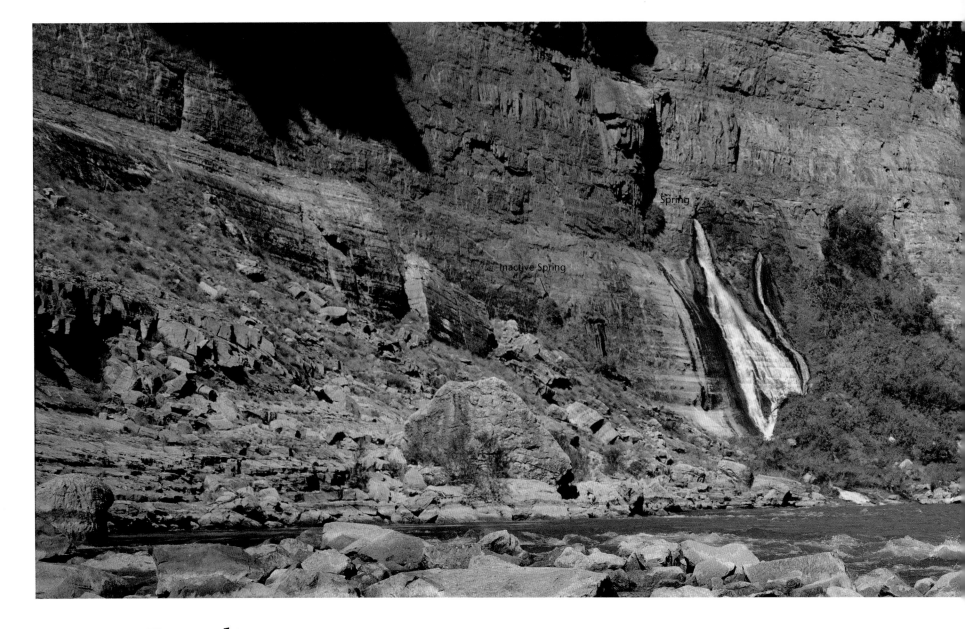

Vaseys Paradise *View upstream from river mile 32*

Each of the Paleozoic rock formations exposed in the walls of the Grand Canyon can be seen in sequence from top to bottom as the river cuts deeper and deeper into the Marble Platform. A float trip through Marble Canyon is like taking an elevator down from the rim to the bottom of the Grand Canyon. Here we first see the vertical walls of the Kaibab, Toroweap, Coconino, and then the Redwall Limestone. Marble Canyon was named for limestones polished by the river to form walls that resemble marble.

The Redwall Limestone, like most other limestone bodies, is susceptible to solution by groundwater, which develops a system of caves, springs, and collapse structures. Here at Vaseys Paradise, the process is shown in a spectacular way. Springs gush from the canyon walls and lush growth of vegetation clings high upon the cliffs as well as on the gentle slopes below. The amount of water flowing from the springs fluctuates greatly depending upon the season and the amount of rainfall, but most of the time a number of springs are flowing. Upwards of several thousand gallons per minute have been seen issuing from the cliff face. Very seldom, if ever, are they completely dry.

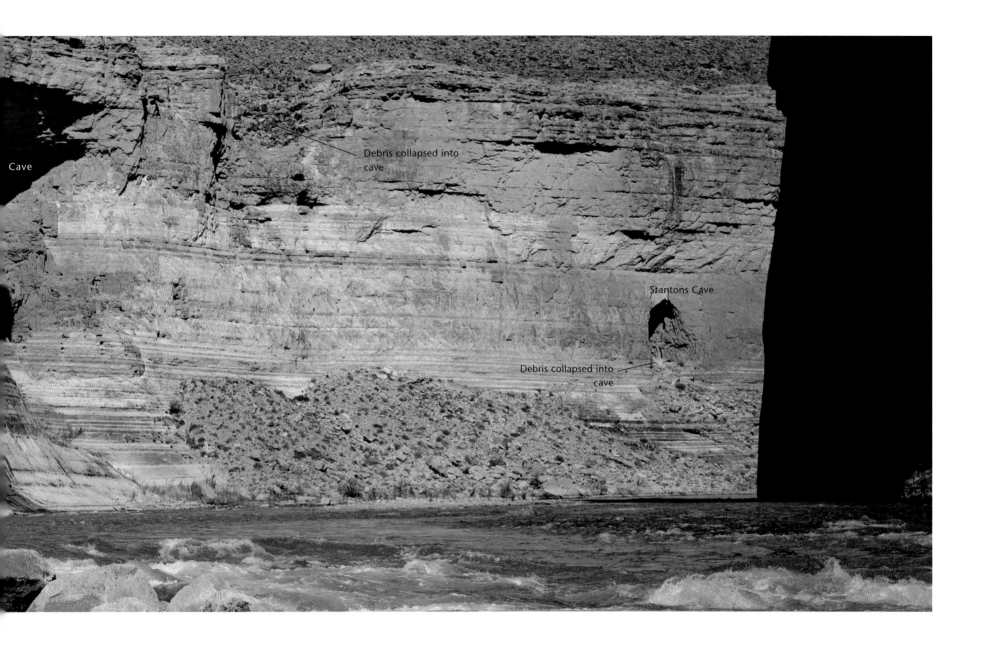

Major Powell was impressed with the beauty of this area and described it as follows:

Riding down a short distance, a beautiful view is presented. The river turns sharply to the east, and seems inclosed [sic] by a wall, set with a million brilliant gems. What can it mean? Every eye is engaged, every one wonders. On coming nearer, we find fountains bursting from the rock, high overhead, and the spray in the sunshine forms the gems which bedeck the wall. The rocks below the fountain are covered with mosses, and ferns, and many beautiful flowering plants. We name it Vasey's Paradise in honor of the botanist who traveled with us last year.

Note Stantons Cave (a dry spring) near the right margin of the photograph, at approximately the same stratigraphic horizon as the flowing springs of Vaseys Paradise. Another large cave, mostly filled with collapsed debris, is shaped by a large fracture that is located near Vaseys Paradise. A huge slab of rock in its ceiling separated along the bedding plane and fell to the floor.

Caves in the Redwall Limestone *Near river mile 35*

A short distance downstream from Vaseys Paradise, at river mile 35, a cross section of the Redwall cliff reveals a series of large caves that are characteristic of the honeycomb nature of its interior. This view of the Redwall Limestone presents the finest expression of solution activity to be seen in the entire canyon. The major factors that control solution activity are fractures and composition of beds. Both are displayed here exceptionally well. Fractures provide vertical, permeable channels through which water can easily move downward through the rock body and, as a result, solution activity has enlarged the fractures so that they now appear to be a wide-open slice through the cliffs. Some individual beds within the Redwall are more susceptible to solution activity than others; a series of caves forms along these beds. In time, solution activity enlarges the fractures and bedding planes, resulting in a complex subterranean network of caves that can extend for many miles through the rock body as shown in the block diagram.

In this area, literally hundreds of caves, both large and small, are exposed on the canyon wall, presenting a picture of what the Redwall Limestone is like below the surface throughout the extent of the formation. Many of the caves have filled with collapsed debris whereas others are only partly filled or empty. With a system of caves such as these in the Redwall Limestone, it is easy to understand the origin of large springs such as Vaseys Paradise and Roaring Springs in Bright Angel Canyon to the west. (Water flowing from Roaring Springs is pumped to the North and South rims, providing the main source of water for the park's developed areas.)

The Redwall Limestone is one of the most distinctive and prominent formations in the canyon. It characteristically weathers into an unbroken vertical cliff more than 500 feet (150 m) high. The rock is really a gray to tan color but its surface is stained red by the colored material washing down from the overlying Supai and Hermit formations. The Redwall Limestone can be seen from practically any viewpoint on either rim, but its true nature is best seen from the river.

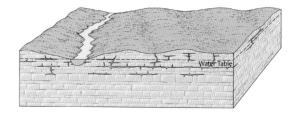
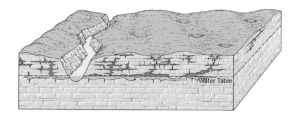
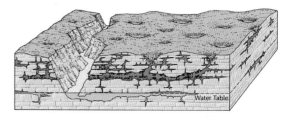

Evolution of Caves

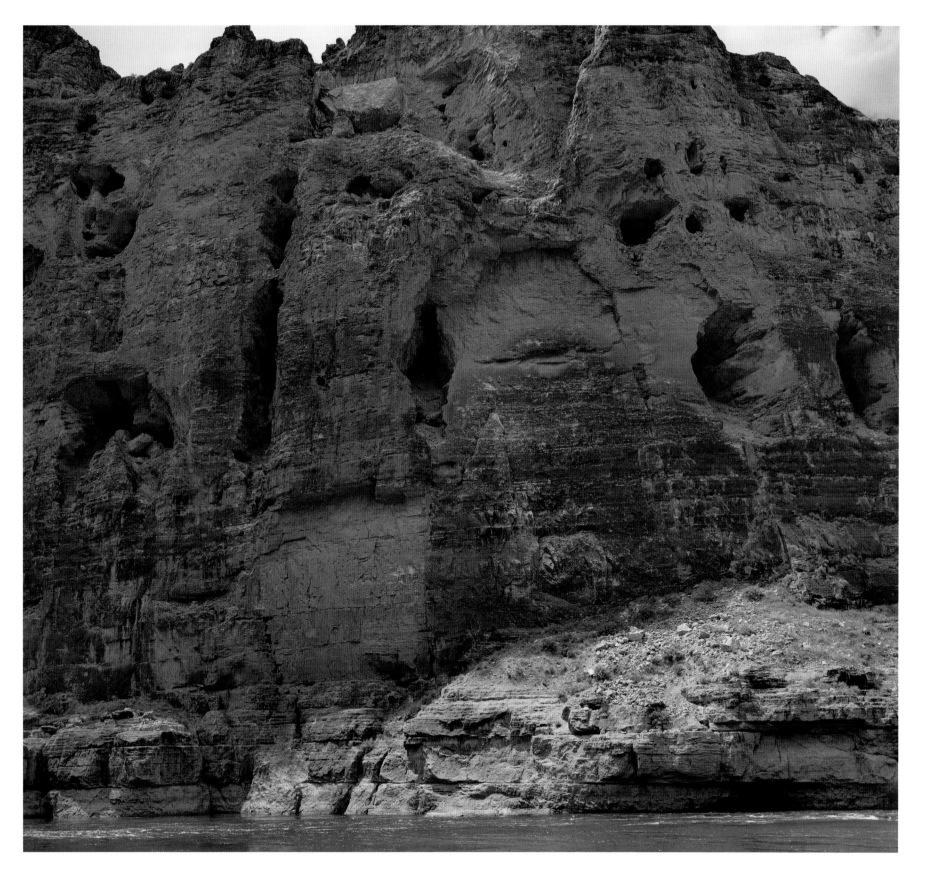

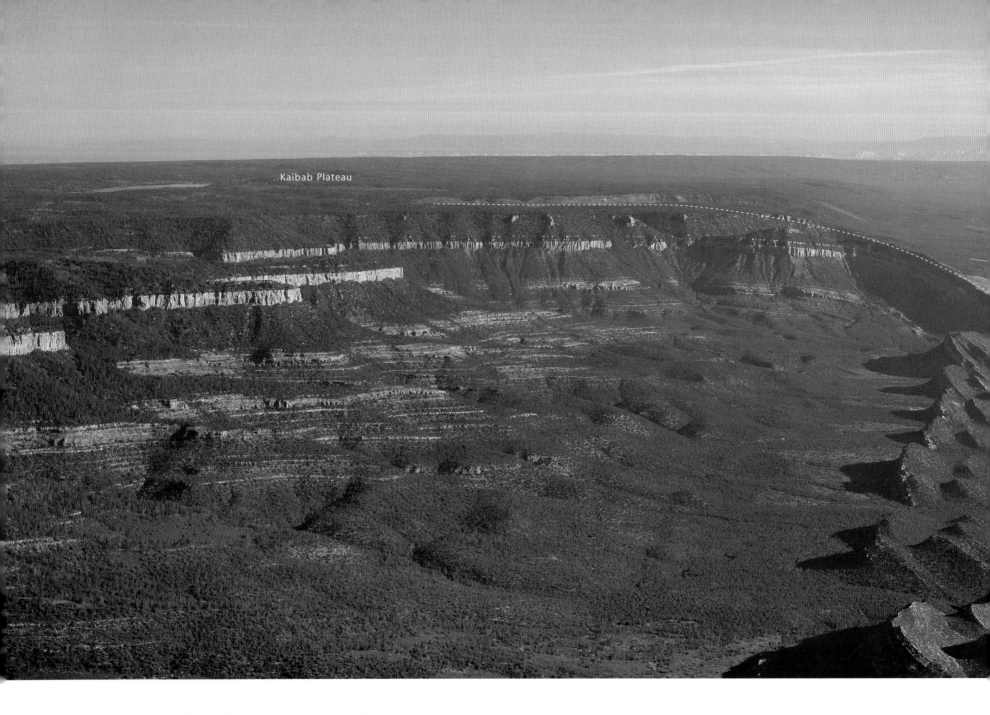

East Kaibab Monocline *View north*

The East Kaibab monocline is the most significant structural feature in the Grand Canyon area. It extends from Bryce Canyon, Utah, southward nearly to Flagstaff, Arizona—a distance of approximately 150 miles (240 km). This flexure has lifted the sequence of rocks 3,000 feet (900 m) above the adjacent Marble Platform, producing the highest area in the Grand Canyon region. In the central foreground the crest of the fold has been breached by erosion and the east limb of the fold is expressed by a sharp ridge formed on the eroded, upturned edges of the Kaibab Formation.

In this aerial view looking north, the flexure of the monocline is apparent in the distant background of the right part of the photograph, where the plateau's top rock layers bend downward in a sweeping arc toward the Marble Platform. The Vermilion Cliffs form the ridge in the background at far right.

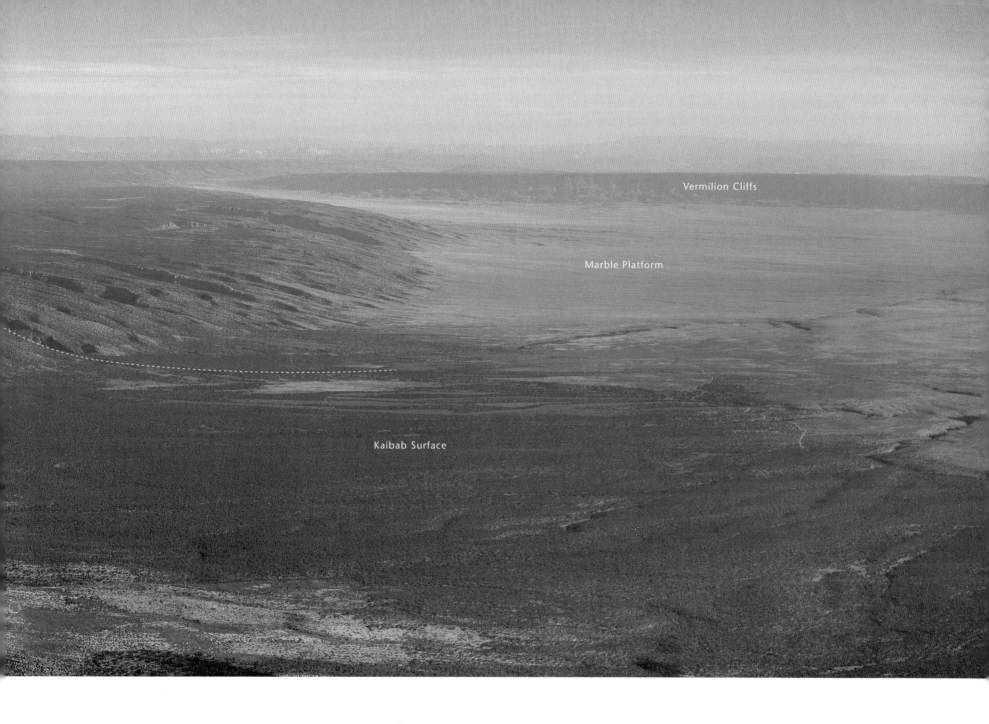

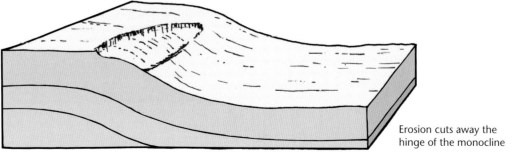

Erosion cuts away the hinge of the monocline

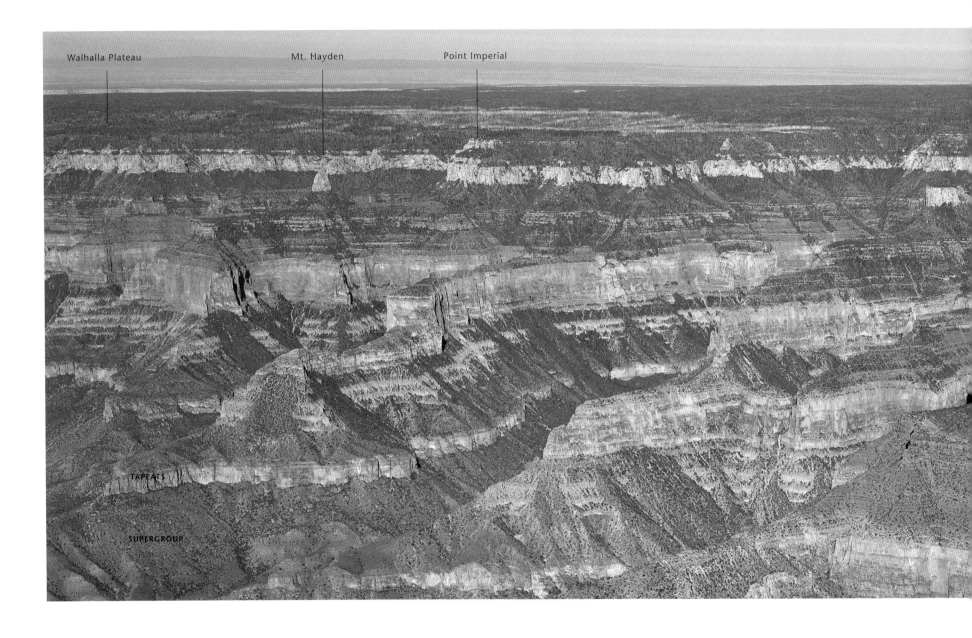

Inside the Monocline *View west toward Point Imperial*

Throughout most of the Grand Canyon area the East Kaibab monocline has been breached by erosion so that much of the fold's interior is exposed. Here erosion has cut through the crest of the fold to form a large basin in which the sequence of older rocks is exposed. The complete sequence of Paleozoic rocks forms a series of cliffs and slopes: the Kaibab Formation forming the highest cliff and the surface of the Kaibab Plateau, and the Tapeats Sandstone forming the lowest cliff. Mount Hayden rests on the red Supai and Redwall platform. The flexure of the East Kaibab monocline is most apparent in the right half of the panorama where the uppermost rocks of the plateau are bent down in a large, sweeping curve that flattens out to form the Marble Platform. Note the exposures of the upper Grand Canyon Supergroup in the bottom left of the photograph.

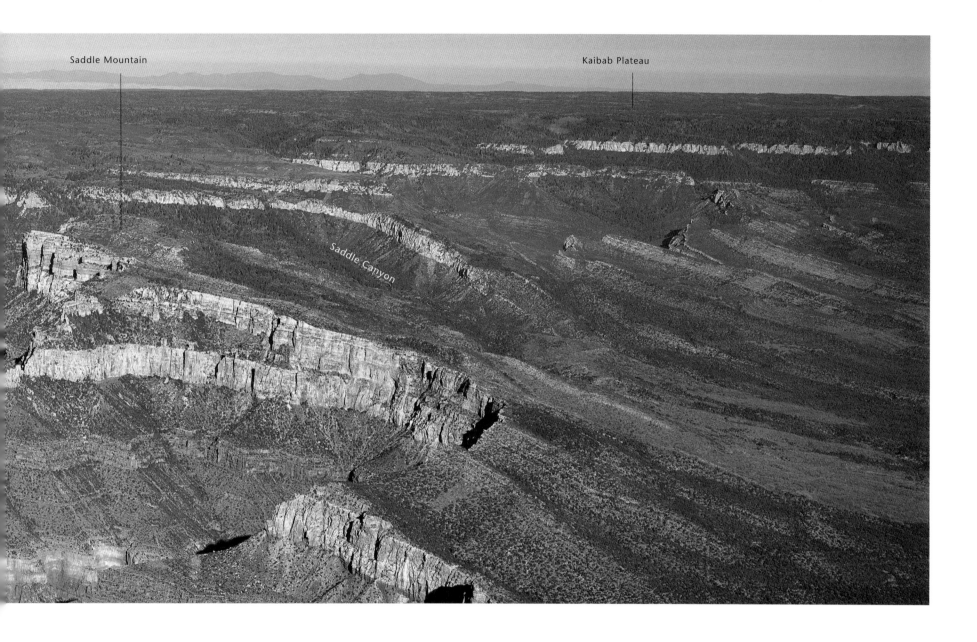
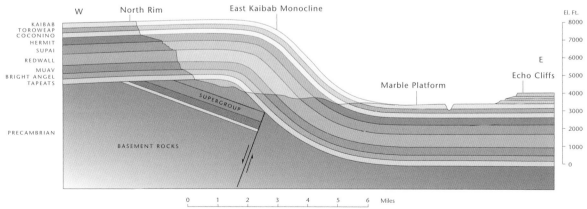

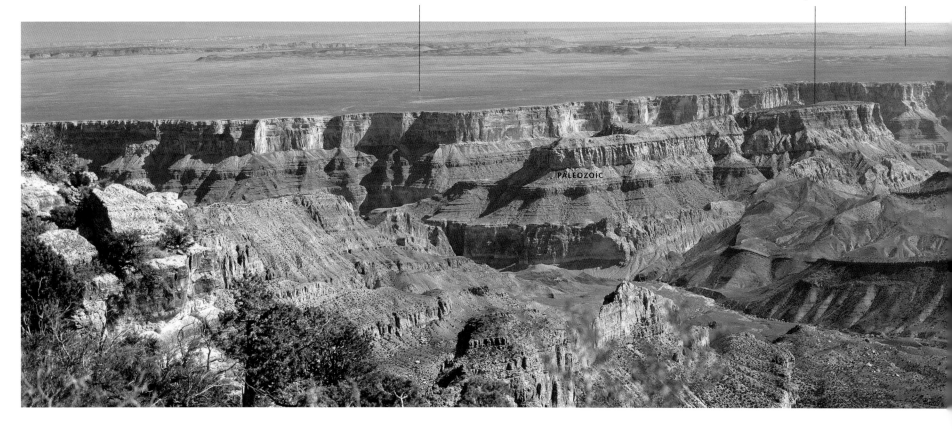

Point Imperial *View southeast across Marble Canyon*

In order to understand the landscape seen from Point Imperial you must first become familiar with the geologic setting of this unique viewpoint. Point Imperial is located on the crest of the East Kaibab monocline at an elevation of 8,803 feet (250 m) —the highest viewpoint in the Grand Canyon. This photograph looks southeast across the basin eroded into the crest of the monocline. The rocks are bent down into a tight fold, but rapidly become horizontal again within a short distance to form the Marble Platform. Tributaries to the Colorado River (Nankoweap and Kwagunt creeks) have breached the crest of the fold to form the large topographic basin spread out before you.

This is an unusual part of the canyon. The far rim drops off abruptly to form a vertical wall 3,000 feet (900 m) high, called The Desert Façade. Here the canyon rim is only three-quarters of a mile (1 km) back from the river. Beyond the canyon is the vast, nearly featureless surface of the Marble Platform. This surface is the top of the resistant Kaibab Formation, which slopes gently to the east. On a clear day many prominent topographic features of north central Arizona can be seen. To the northwest (not seen in this image) are the Vermilion Cliffs, Lees Ferry, Echo Cliffs, and segments of Marble Canyon.

The foreground of the Point Imperial area is eroded on the arched side of the monoclinal fold and exposes the Paleozoic formations and their typical landforms of alternating cliffs and slopes. The Kaibab and Toroweap formations constitute the upper gray cliffs and the Coconino Sandstone forms the striking light cliff below. Mount Hayden, a large pinnacle of Coconino Sandstone, rests on the underlying red Hermit Formation.

In contrast to the scenery at most viewpoints, the section of canyon seen at Point Imperial appears to be a little unusual. The colors of the canyon are muted or blurred. This gives rise to a strong illusion. The rocks may look gray, even black. The lines of stratification, so prominent in most views of the canyon may be dimly seen in one place, but are entirely gone in

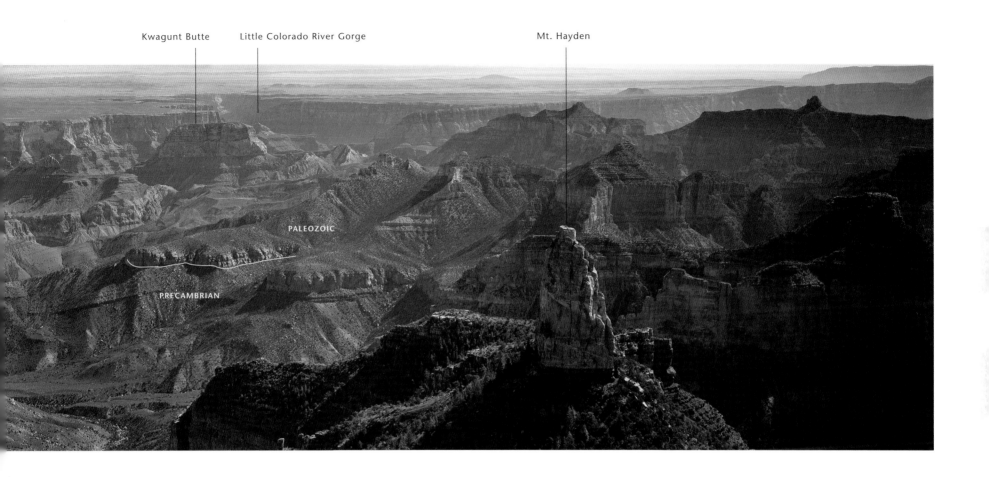

others. Much of the lower canyon in the central part of the scene is carved on the older, tilted red and gray strata of the Precambrian Grand Canyon Supergroup. We can see no prominent Tonto Platform, no Esplanade, and no Inner Gorge. Here the older rocks have been tilted, twisted, and faulted as a result of deformation in the East Kaibab monocline. This type of deformation is best seen in the vicinity of Kwagunt Butte, which is located just north of the Palisades of the Desert, where the rocks are nearly vertical and have been displaced by faulting.

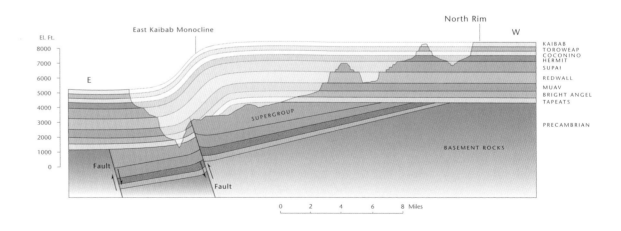

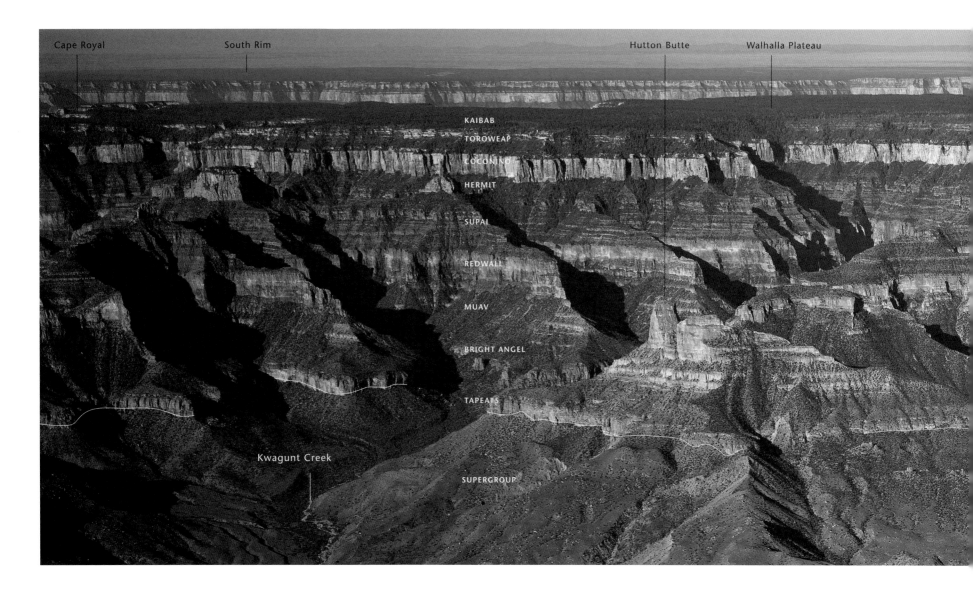

Walhalla Plateau *View west*

The view from a small aircraft flying above the crest of the East Kaibab monocline shows how the fold has been breached by erosion to form a large topographic basin. This is the highest part of the Grand Canyon; conifers and vegetation cover the plateau and much of the upper reaches of the inner canyon. Thus, the color of the rock strata, so striking elsewhere in the canyon, is muted by a cover of vegetation. The east-facing wall of the plateau is incised by Nankoweap and Kwagunt creeks so that long spurs between them jut out from the main plateau and develop buttes at their ends. The most striking formations in this part of the canyon are the light tan cliffs of the Coconino Sandstone high on the canyon wall, and the cliff of the Tapeats Sandstone in the lower part of the canyon. Below the Tapeats cliff, the lower valley is eroded in the sedimentary rocks of the Grand Canyon Supergroup, which lacks well-defined stratification.

This is the narrowest part of Walhalla Plateau. Headward erosion of Bright Angel Creek, which

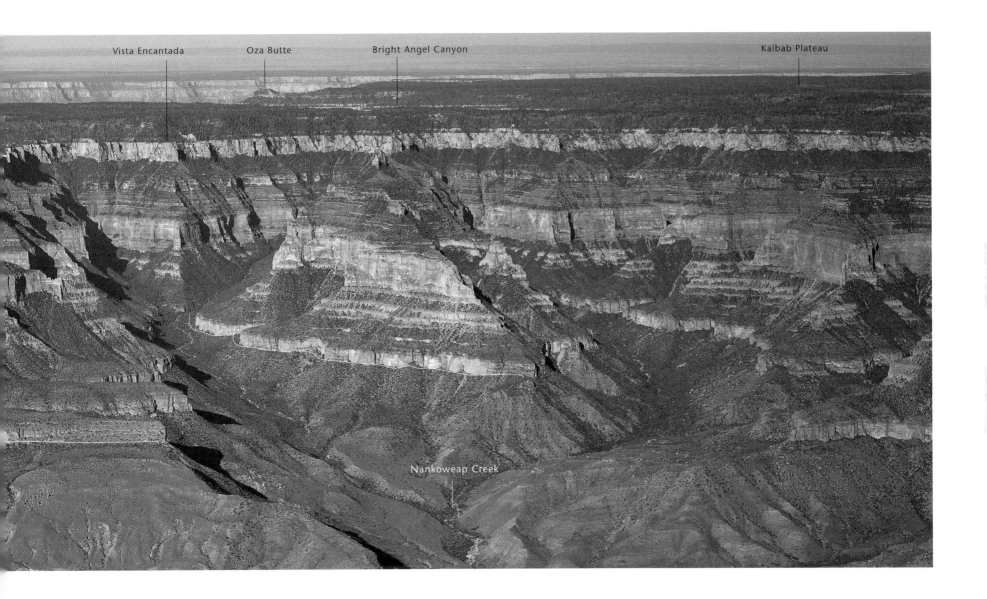

barely can be seen beyond the crest of the plateau, has nearly separated the Walhalla peninsula from the main Kaibab Plateau.

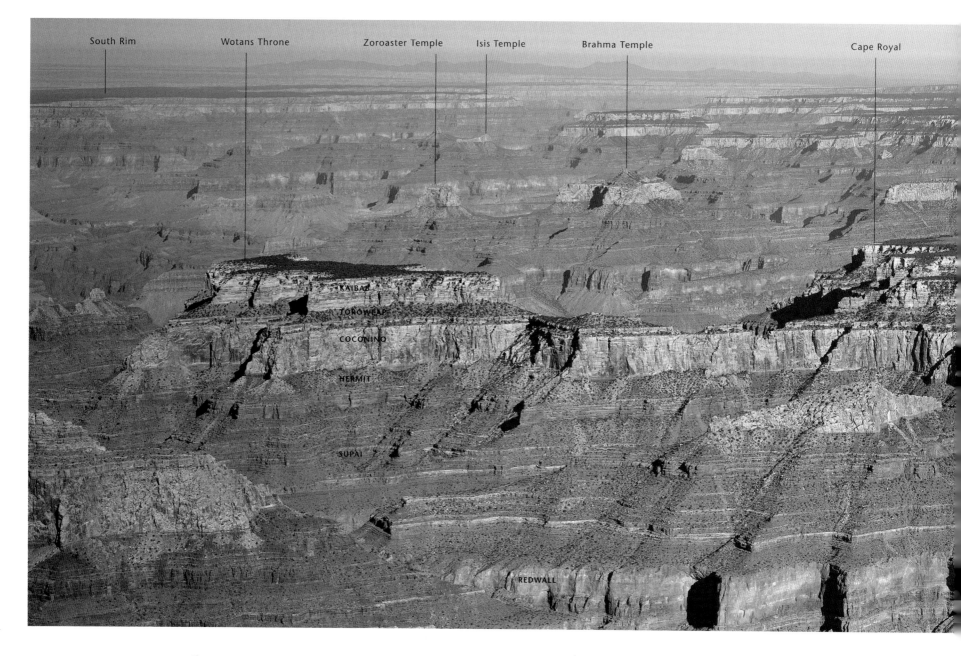

Cape Royal *View west*

The north wall of Grand Canyon's Kaibab Plateau section is dissected by a number of long tributary valleys that leave between them a series of long, narrow spurs or ridges extending from the canyon rim toward the Colorado River. Erosion of these ridges has developed the many isolated plateaus, buttes, and pinnacles that give variety and interest to the canyon landscape. Many of the ridges are more than five miles (8 km) long and two miles (3 km) wide. The northern canyon wall is thus strikingly different from the southern wall.

In this aerial view to the west, the light Coconino Sandstone cliff is especially striking as it can be traced across the entire region. In the foreground the red Hermit Formation and Supai Sandstone form stair-step topography characteristic of this part of the canyon. Here, as elsewhere, the prominent Redwall cliff erodes into a series of alcoves or amphitheaters.

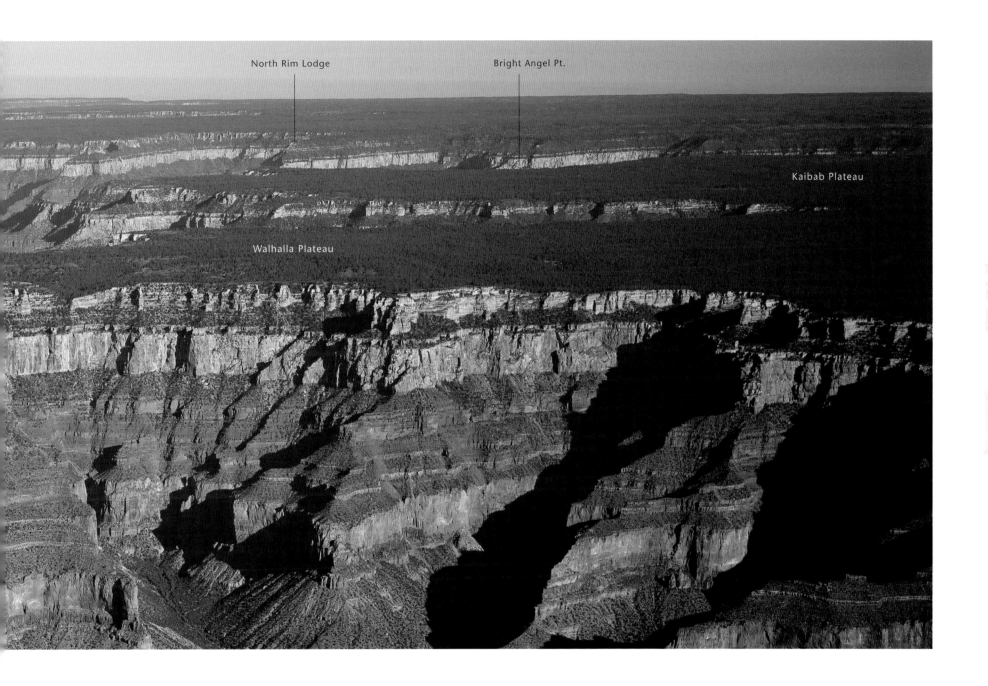
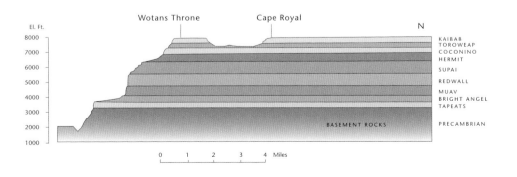

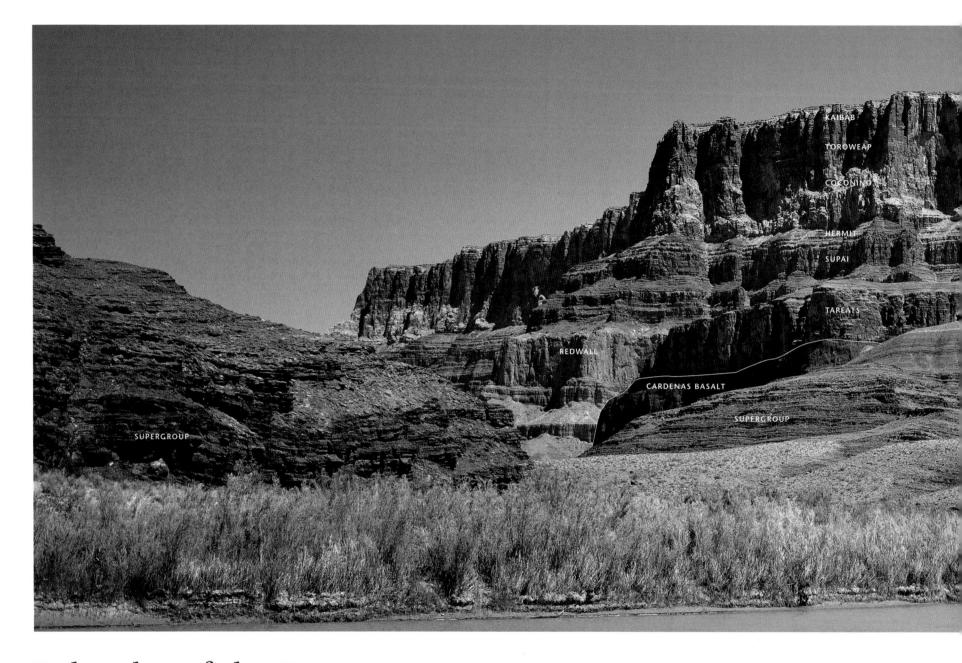

Palisades of the Desert *View upstream near river mile 68*

At this point the Colorado River has cut through the Grand Canyon's upper formations of horizontal Paleozoic rocks. Here the upper formations (Kaibab to Redwall) form the Palisades of the Desert, a long, imposing escarpment along the wall of the canyon just downstream from the confluence with the Little Colorado River. The high escarpment is produced where the Redwall, Supai, Coconino, Toroweap, and Kaibab formations, which are separated only by relatively thin shale units, form a single high, imposing wall.

In addition to the Palisades escarpment, this area is noteworthy because it is the beginning of a very important change in the landscape of the inner canyon near the river. The red siltstones and sandstone (the Dox Formation) of the Grand Canyon Supergroup are exposed on both sides of the river. A short distance downstream (not shown in this view) a

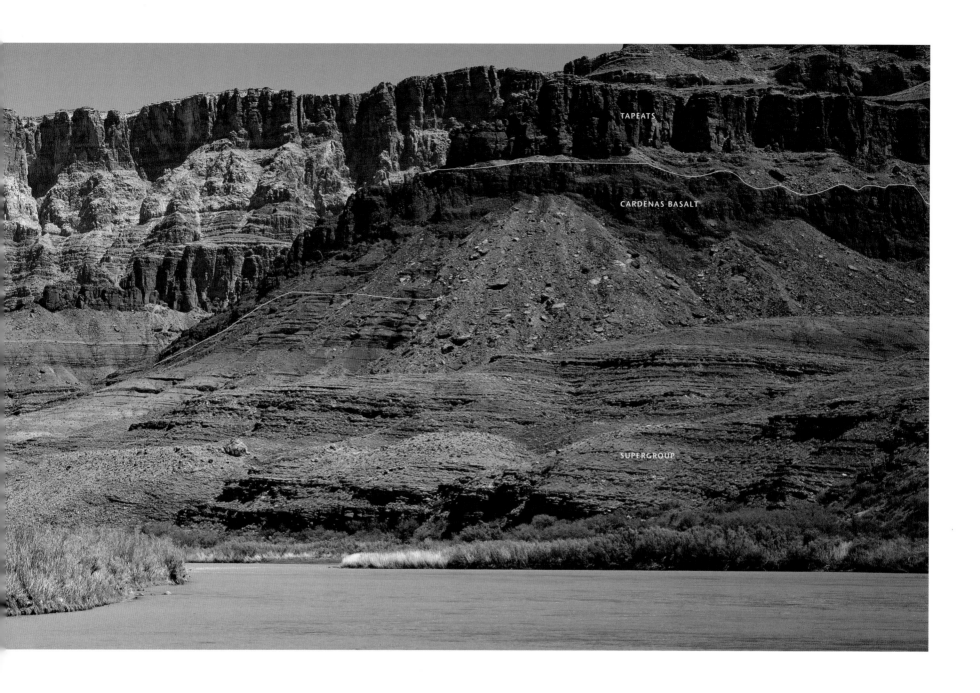

much greater section of these rocks is exposed at river level, and because they are soft and nonresistant they are easily eroded to form a broad, open lowland.

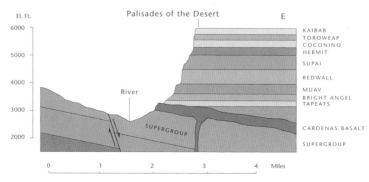

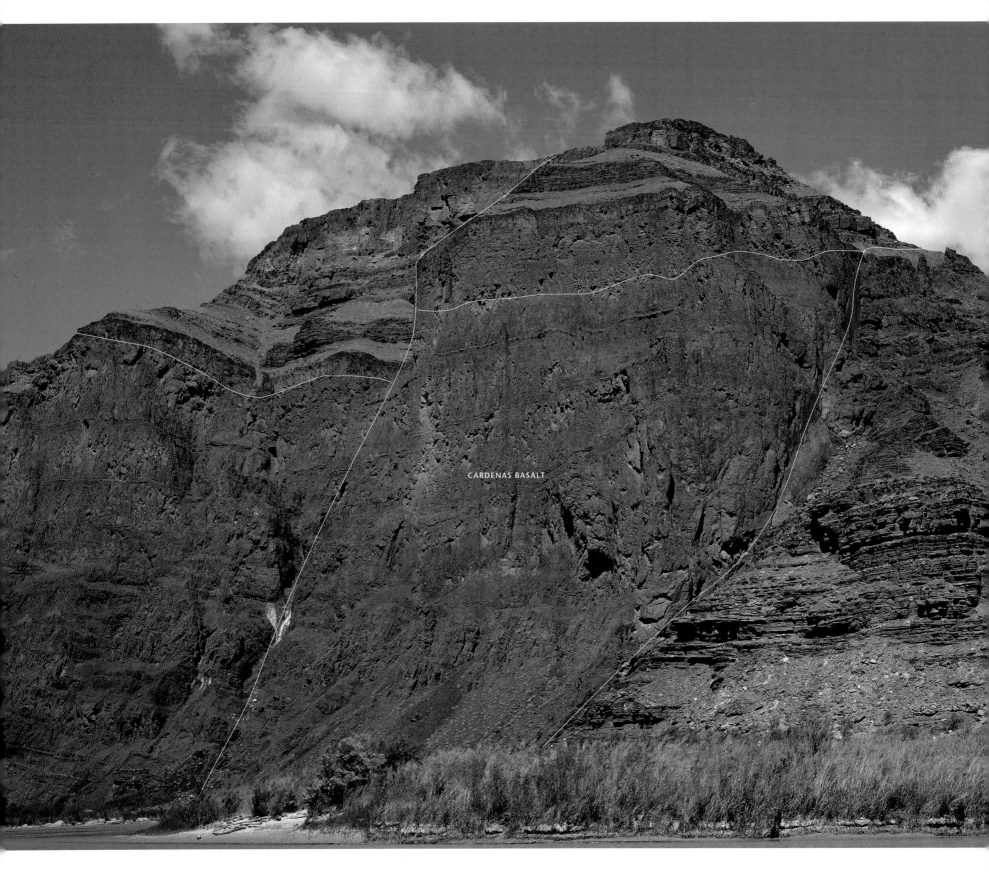
CARDENAS BASALT

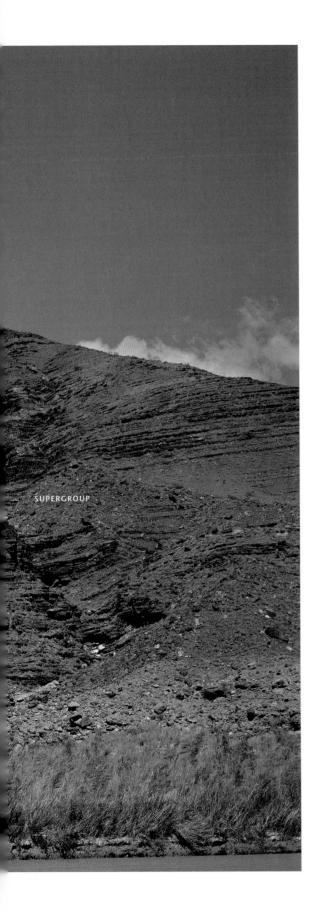

Butte Fault *River right, mile 68*

A large exposure of the Butte fault is seen near Tanner Canyon Rapid. The curved fault surface cuts across the black Precambrian basalt (1.1 billion years old) and separates it from the lower red beds of the Grand Canyon Supergroup. After a long period of successive displacements, the fault dips to the west at sixty to seventy degrees. In Precambrian time the west block moved down; at a much later period, during which the East Kaibab monocline was formed, the west side moved upward again, continuing a complex dance of uplift and down-dropping.

The Butte fault zone presents a remarkable view of Precambrian basalts, faults, and associated red sedimentary rocks, but from a regional geologic standpoint it is more significant for the structural history it represents. The thick red sedimentary rocks, basalt, and faulting are a beautiful example of a rift valley assemblage of rocks. They record a period of time in the late Precambrian when this part of the Grand Canyon area was being split and pulled apart to form a new ocean basin. This type of geologic activity is a major regional event in Earth's history and although rifting was terminated before a new ocean basin was formed, we have a wonderful record of this unique event in Grand Canyon history.

Rift valleys are also discussed on pages 64 and 67.

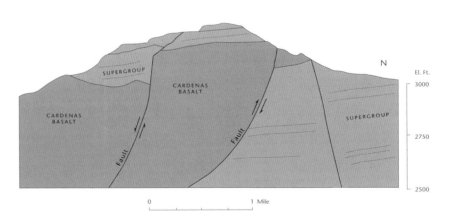

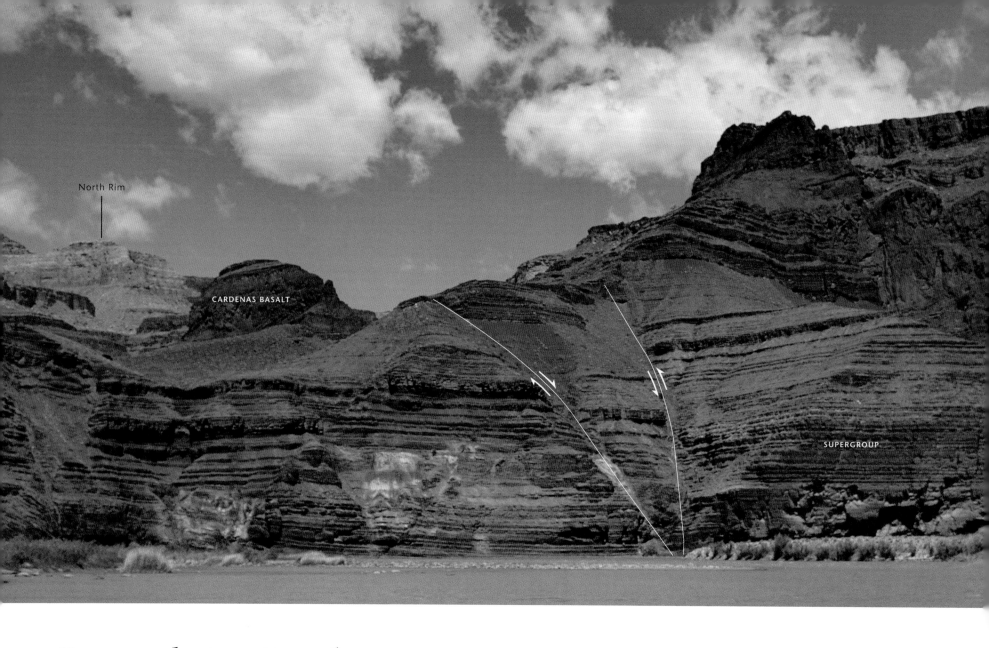

Precambrian Basalts *Volcanic intrusions*

A large volume of basaltic lava formed in the Grand Canyon in late Precambrian time. This 1,000-foot-thick (300 m) sequence of intrusions is exposed only in the eastern Grand Canyon. The most widespread outcrops are found in a stretch about four to ten miles (6 to16 km) downstream from the junction of the Little Colorado River in Lava and Basalt canyons. In some areas the basalt was extruded onto the surface of redbeds of the Grand Canyon Supergroup as they were forming, but it also occurs as dikes and sills cutting across strata.

The exposure seen here is downstream a short distance from Tanner Canyon. The basalt cuts across the red sandstone and shale and then thickens near the river channel. These rocks occur near the boundary between the lower and upper Grand Canyon Supergroup.

This complex assemblage of rocks most likely formed in a rift valley. Rift valleys are major structural features in the earth's crust produced where shifting tectonic plates cause the continents to split apart. Erosion of the valley's margins produces large volumes of sediment that accumulate in these basins. The fracturing of the continents as they pull apart provides channels for underlying lava to rise to the surface where it is injected into or flows over the accumulated sediments. If rifting action is aborted before a new

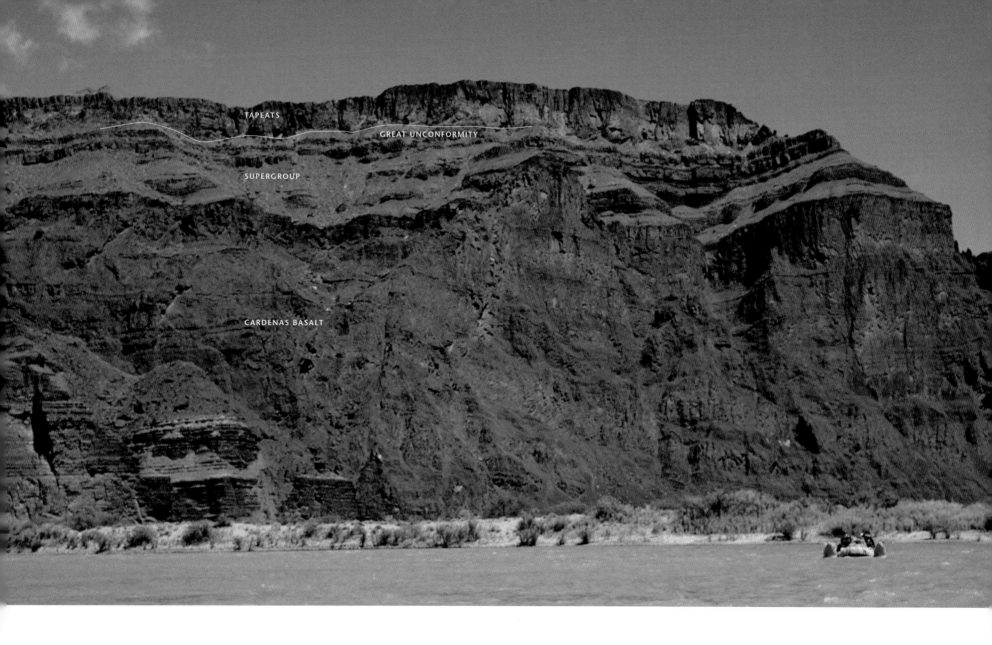

ocean is created, the wedge of sediment and lava is preserved, and constitutes a distinctive rock sequence. A number of ancient rift valley deposits are preserved in North America including the Lake Superior region, Montana, the Basin and Range Province, and the Grand Canyon.

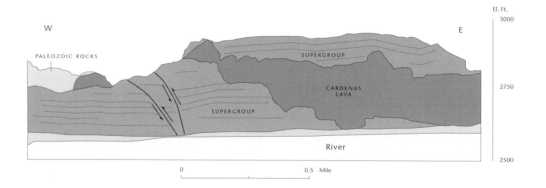

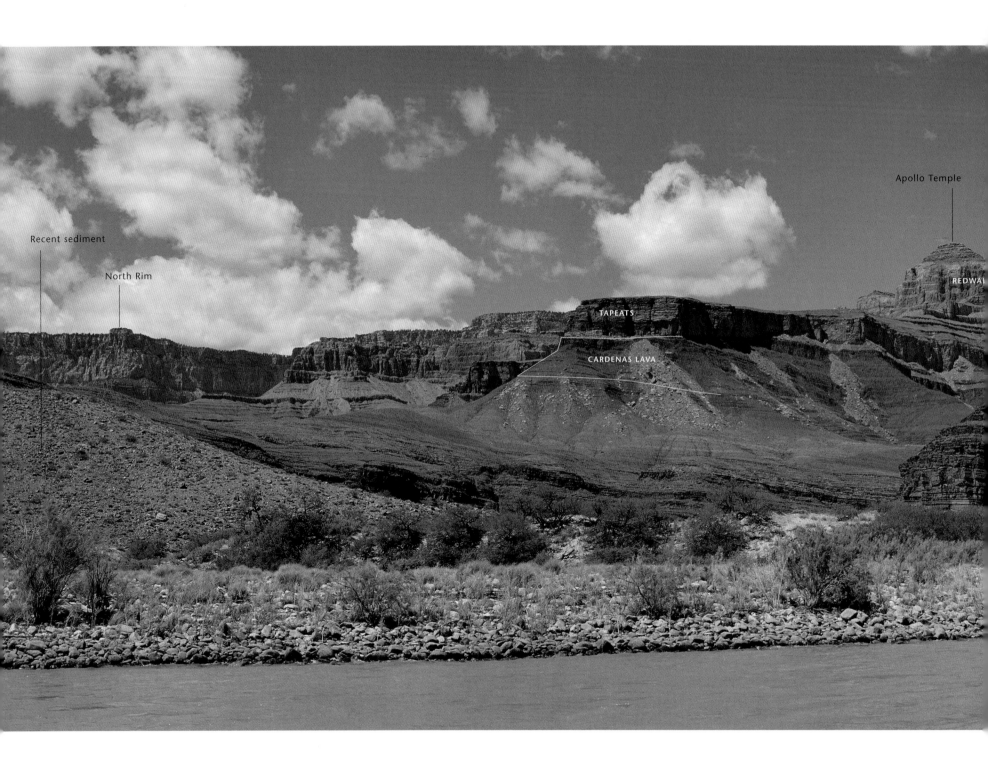

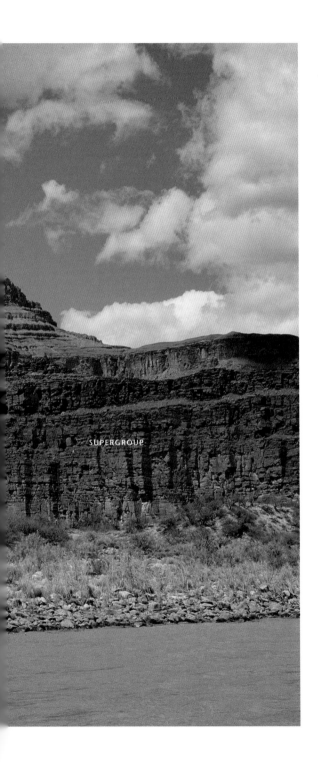

Ochoa Point *View toward the North Rim*

The canyon as seen from the river below Lipan Point is nothing like that seen from the rim. Here the river flows through a broad lowland of rolling hills eroded from the soft, red beds of the Grand Canyon Supergroup. It is unlike anything else seen on the canyon floor because the bottom of the canyon is more than four miles (6 km) wide. Indeed when you are on a float trip through this area you hardly feel like you are in a canyon at all. From the river you rarely get a glimpse of the canyon rim. It is here that the lower Grand Canyon Supergroup is exposed in all its splendor. The rocks dip about fifteen degrees to the northeast. Here you can begin to grasp an idea of the great thickness of the older sequence of rocks (12,000 feet/3,650 m)—more than twice the thickness of the entire sequence of horizontal Paleozoic rocks above it, which forms the walls of most of the canyon.

The bright red sediments (shale and siltstone) of the Grand Canyon Supergroup are 1.2 billion years old and dominate the scene near river level. The prominent cliff of Tapeats Sandstone (525 million years old) forms the low plateau in the background. The black rock just below the cliff is a sequence of basalt (the Cardenas Basalt) nearly 1,000 feet (300 m) thick.

The great thickness of the red beds in the Grand Canyon Supergroup, together with the sequence of interbedded lava, suggests that the rocks accumulated in a rift valley, perhaps similar to the Great Rift Valley of east Africa. Lavas flowed up through weak spots in the crust and sediments intermingled with them, as the early North American continent began to split away.

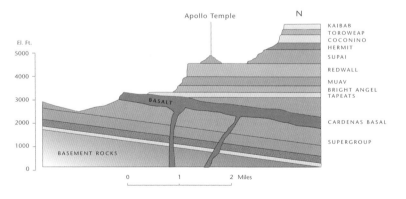

Chapter 3

Central
GRAND CANYON

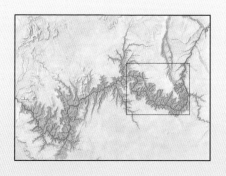

Navajo Point	70
Lipan Point I	72
Lipan Point II	74
Grandview Point	76
Yaki Point	78
Yavapai Point I	80
Yavapai Point II	82
Granite Gorge	84
Faults and Dikes	86
Maricopa Point I	88
Maricopa Point II	90
Hopi Point	92
The Scalloped South Rim	94
Shinumo Amphitheater	96
Middle Granite Gorge	98

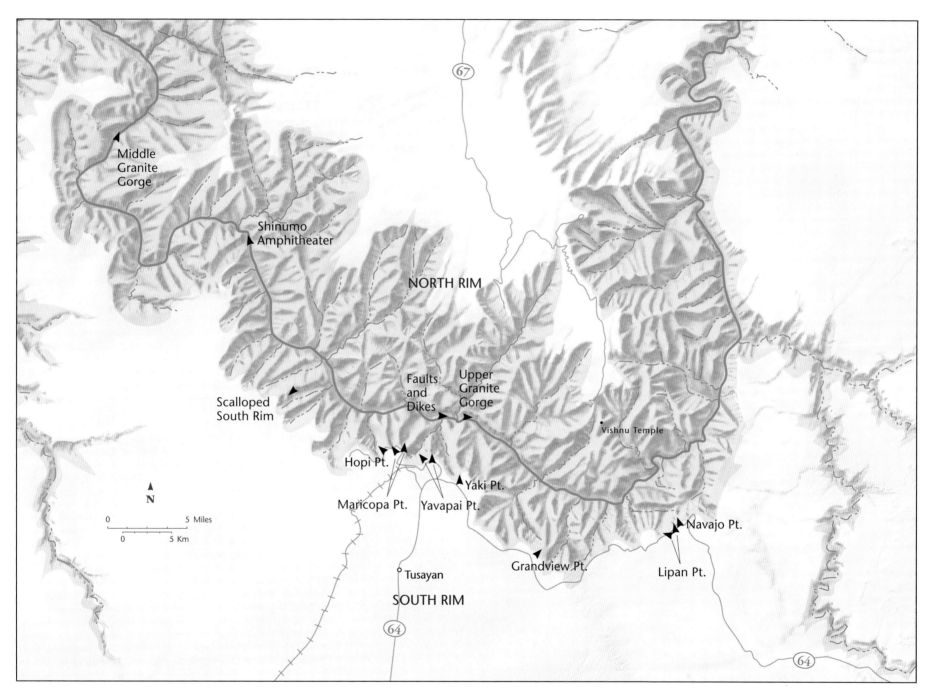

Central Grand Canyon map showing location and direction of photographs

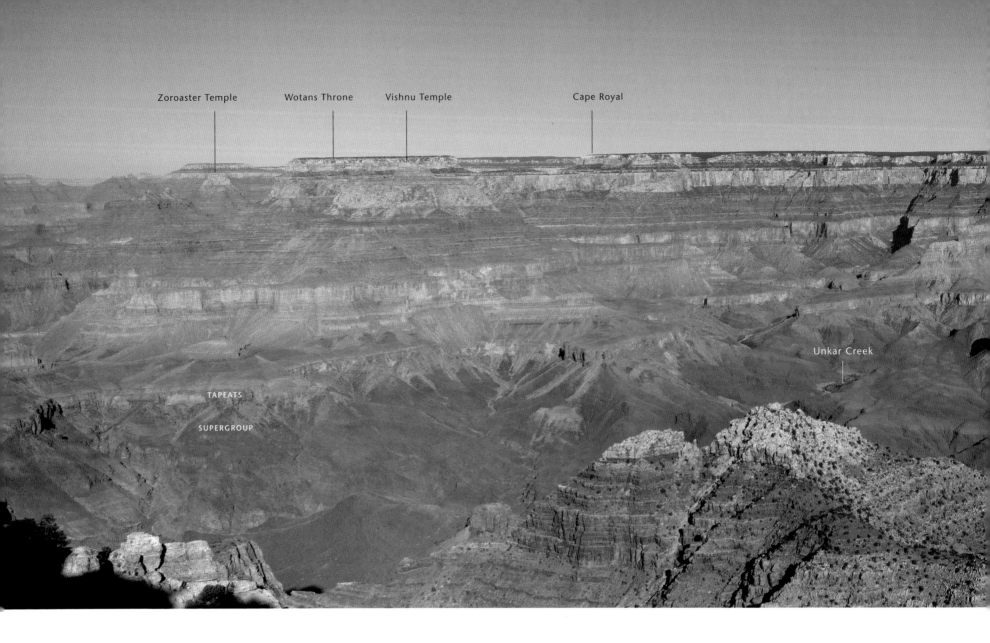

Navajo Point *View northwest*

The view from Navajo Point is certainly one of the most spectacular in the entire canyon. Here the river makes a dramatic sweep to the west and the canyon opens up for a while after leaving the confines of Marble Canyon and before plunging into the Granite Gorge downstream. The easily eroded Grand Canyon Supergroup makes this open canyon profile possible.

On a clear day, wide expanses are visible on both sides of the river for a distance of nearly fifty miles (80 km).

This is also a good place to observe the dip of the East Kaibab monocline. The dotted line in the sky shows the flexure of the monocline as sedimentary layers of the Kaibab Plateau were uplifted to the west (left). The uplift has offset the limestone layer that caps both the North Rim and Chuar Butte (and upon which you are standing), by as much as 3,000 feet (900 m).

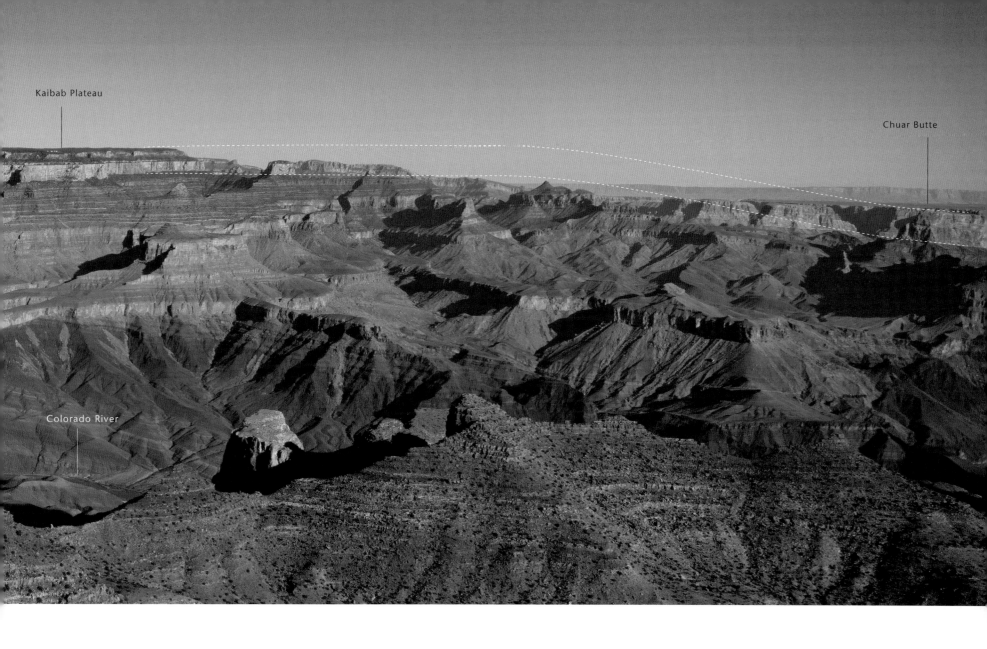
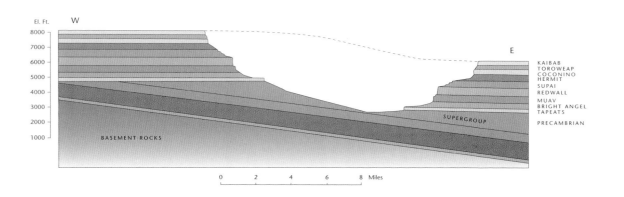

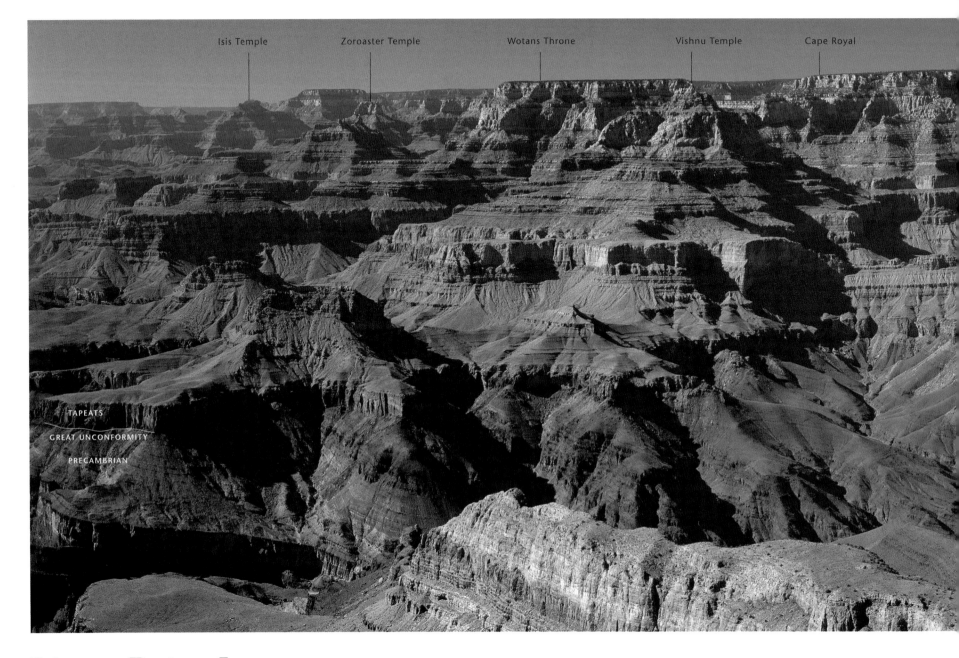

Lipan Point I *View northwest*

As you study the bottom of the canyon immediately below and northeast of Lipan Point, one of the most significant features in the canyon may not be immediately obvious. It is the broad, rolling surface of the canyon floor carved on the strata of the Grand Canyon Supergroup, visible here just above the river. In contrast to the younger, horizontal Paleozoic rocks, the Grand Canyon Supergroup dips twelve to fifteen degrees toward the northeast. Dominantly bright red, these strata are interbedded with white units, producing a distinctive striped appearance in the upper part of the sequence. If you look closely at these exposures it is apparent that the Grand Canyon Supergroup is extremely thick (more than 12,000 feet/3,650 m thick), about twice as thick as the entire overlying horizontal Paleozoic rocks that form the cliffs and slopes in the walls throughout most of the canyon. Lipan Point provides, by far, the most extensive view of Grand Canyon Supergroup rocks.

The Great Unconformity can easily be seen from Lipan Point as it is also well expressed at the base of the Tapeats Sandstone cliff. It can be traced across the tilted and beveled edges of the Grand Canyon Supergroup for a distance of more than twenty miles

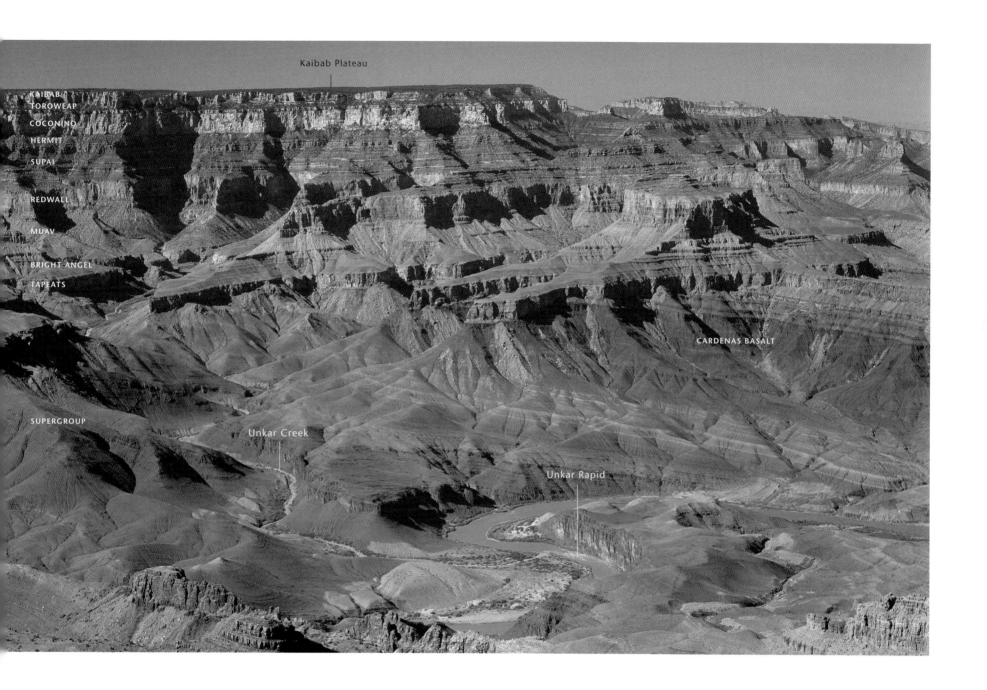

(32 km). Farther downstream, the Grand Canyon Supergroup was completely eroded away prior to the deposition of the younger Paleozoic sediments. The Tapeats Sandstone and the Great Unconformity rest directly upon the metamorphic and granitic basement rocks that form the rugged Granite Gorge.

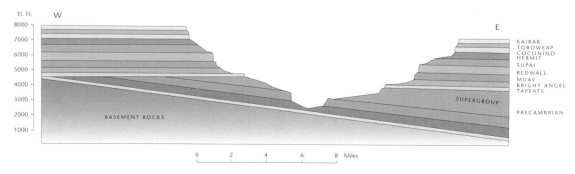

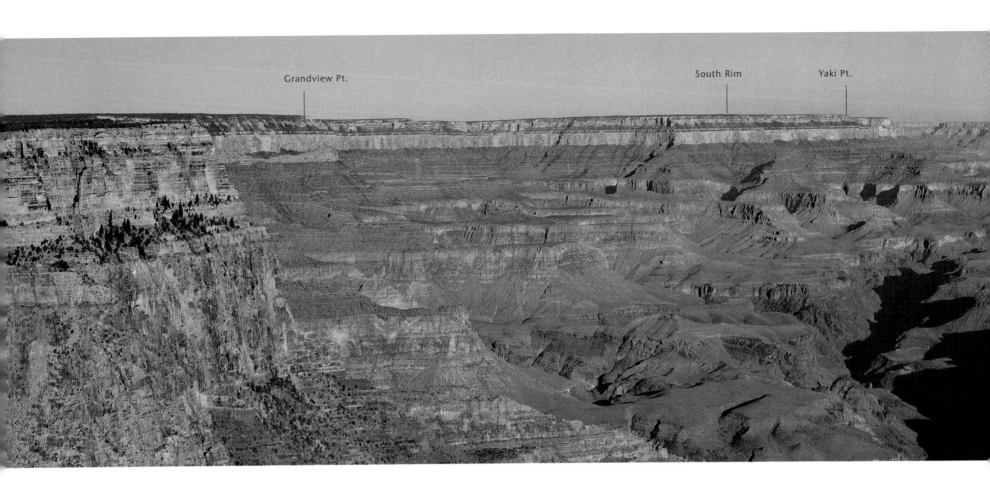

Lipan Point II *View west*

Lipan Point is a critical viewpoint from which the visitor can see many of the major features of the canyon not exposed farther west. Therefore, a visit to this spot is important for those who not only wish to see some exceptional scenery but also would like to gain a more comprehensive knowledge of the canyon. Paramount among these features are exposures of the horizontal Paleozoic rocks, the tilted rocks of the Grand Canyon Supergroup, and the Great Unconformity. The rocks seen from this single point tell the story of the Grand Canyon.

In this view to the west the alternating cliffs and slopes formed on the horizontal Paleozoic rocks dominate the scene. All of the classic landforms for which the Grand Canyon is famous are beautifully expressed. The V-shaped Granite Gorge (partly in shadow in this photograph) begins just downstream. Above it are the Tonto Platform, and the imposing Redwall cliffs. The red Supai and Hermit rocks form the series of low steps 1,000 feet (300 m) high just above the Redwall. The white Coconino Sandstone cliff is especially prominent near the canyon rim.

Note the asymmetry of the canyon. The river is less than two miles (3 km) from the South Rim but as much as eight miles (13 km) from the North Rim. Erosion has formed more prominent ridges, mesas, buttes, and temples on the north side of the river than on the south, which contributes to the scenic beauty seen from viewpoints on the South Rim. (See pages 16 and 32 for an explanation of the dynamics of headward erosion.)

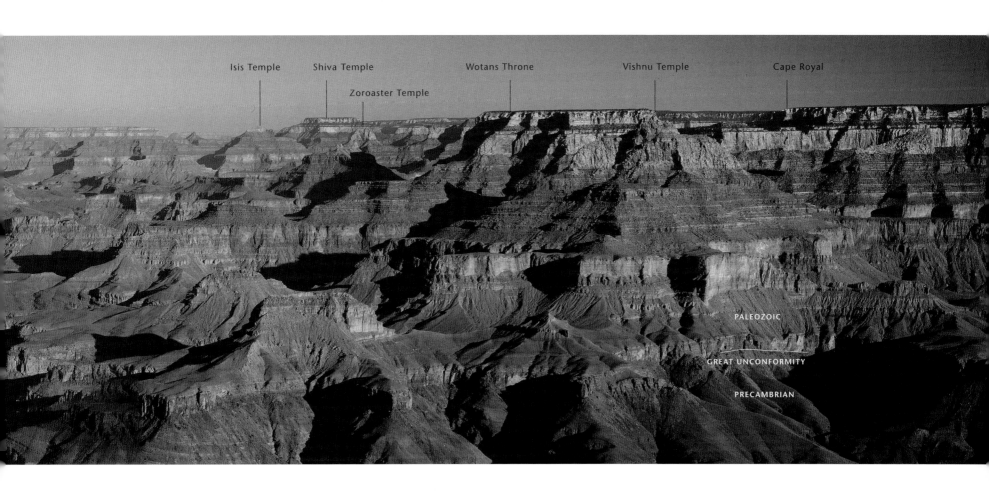

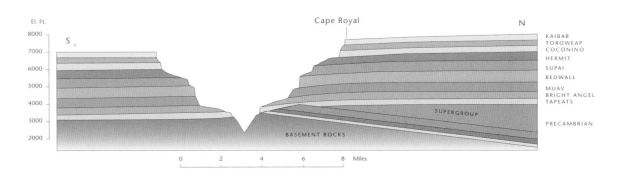

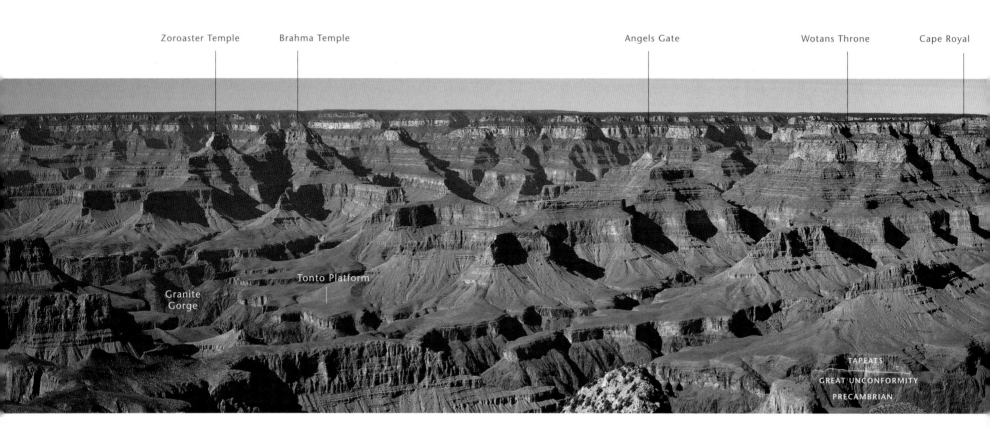

Grandview Point *View north*

The panorama from Grandview Point, regarded by many to be one of the finest in the canyon, is strategically located so that many of the relationships between the eastern and western parts of the canyon are clearly seen. This part of the canyon was one of the earliest tourist attractions. In 1895, a two-story log hotel was built here and for some time this was the leading tourist facility in the area. Horseshoe Mesa, below the rim, was the site of some of the canyon's earliest and most productive mining activity.

All of the major elements of classic Grand Canyon geology can be seen from Grandview Point including: the Granite Gorge, the Grand Canyon Supergroup, the Great Unconformity, the Tonto Platform, the Redwall cliff, and the Palisades of the Desert.

Although the Colorado River is visible only to the east, the upper part of the Granite Gorge is well exposed for some distance to the northwest. Tapeats Sandstone forms the lowest cliff of the horizontal Paleozoic rocks and the Great Unconformity, at its base, is exceptionally clear. The Tonto Platform above the Tapeats cliff is best developed in the (left) portion of this image where, in many places, it is more than a mile (1.6 km) wide on both sides of the river.

The profile of the lower part of the canyon to the east of Grandview Point is defined by exposures of the Grand Canyon Supergroup's inclined strata, which contrast markedly with the igneous and metamorphic rocks in the Granite Gorge to the west. The Bass Limestone and the brick-red Hakatai Shale (the lowest

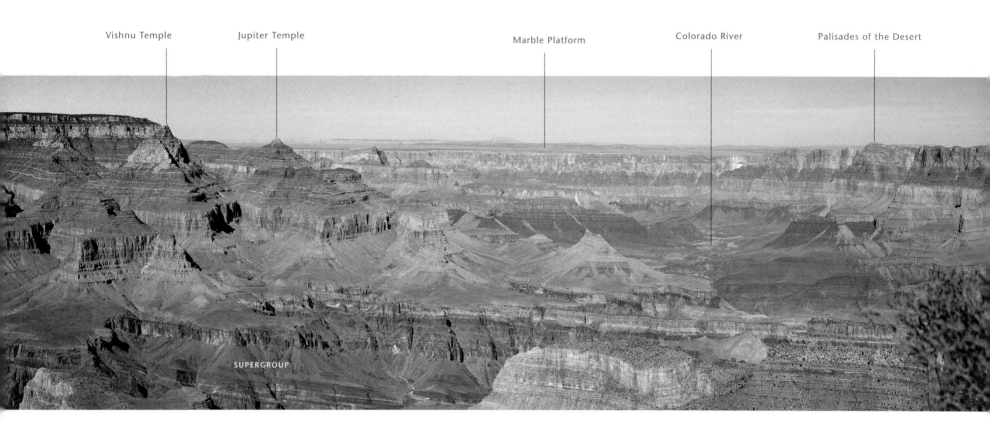

units of the Grand Canyon Supergroup) dip to the east at an angle of approximately ten degrees. They were deposited 1.25 billion years ago.

Far in the distance the east wall of the canyon is distinctly visible in clear weather and the flat surface of the Marble Platform can be seen. This platform is 1,400 feet (430 m) lower than Grandview Point. The difference in elevation is caused by the East Kaibab monocline.

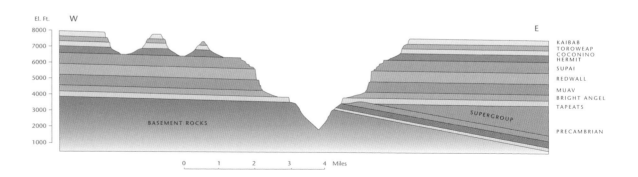

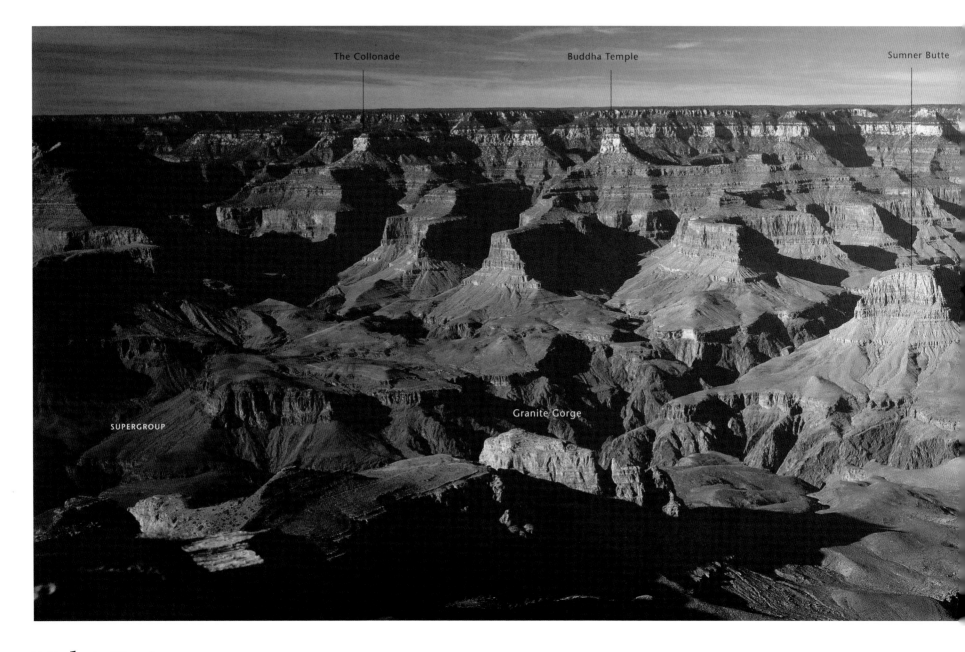

Yaki Point *View north*

The temples and buttes for which the Grand Canyon is famous are beautifully displayed north of Yaki Point. Near the river, many of the buttes that rise above the Tonto Platform are capped by the massive Redwall Limestone; their upper layers have long since eroded away and they appear to be short and stubby. Farther north, most of the buttes are still capped with Coconino Sandstone and erode into a more typical pyramid form. The Tonto Platform is well developed in this area and forms a wide terrace above the rugged V-shaped Granite Gorge.

Note how the Redwall Limestone forms large crescent-shaped amphitheaters, especially in the right portion of the panorama. The vivid contrasts of the white Coconino, red Supai, and greenish-gray Bright Angel Shale present the classic Grand Canyon scene.

Differential erosion of the hard Coconino Sandstone, which formed in an environment of windblown sand dunes, and the softer shales of the Hermit and Supai formations, laid down in estuarine and tidal zones, has resulted in the alternating cliff-and-slope profile characteristic of the Grand Canyon landscape.

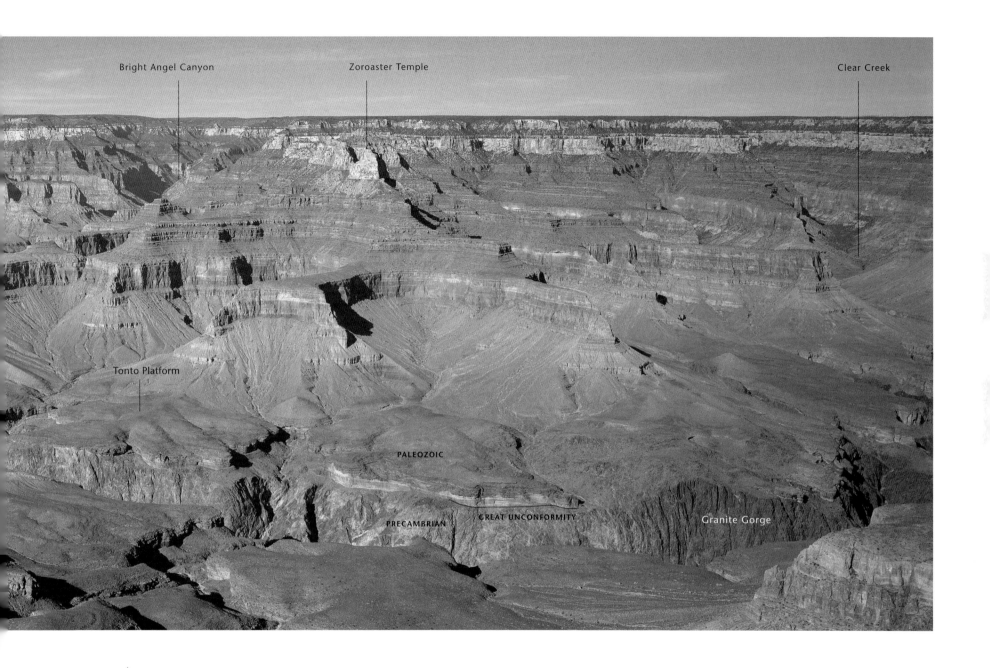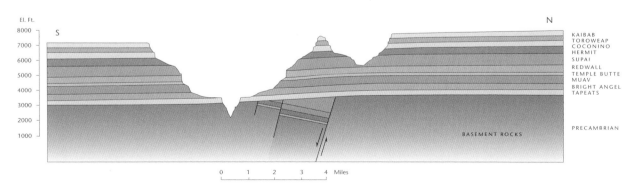

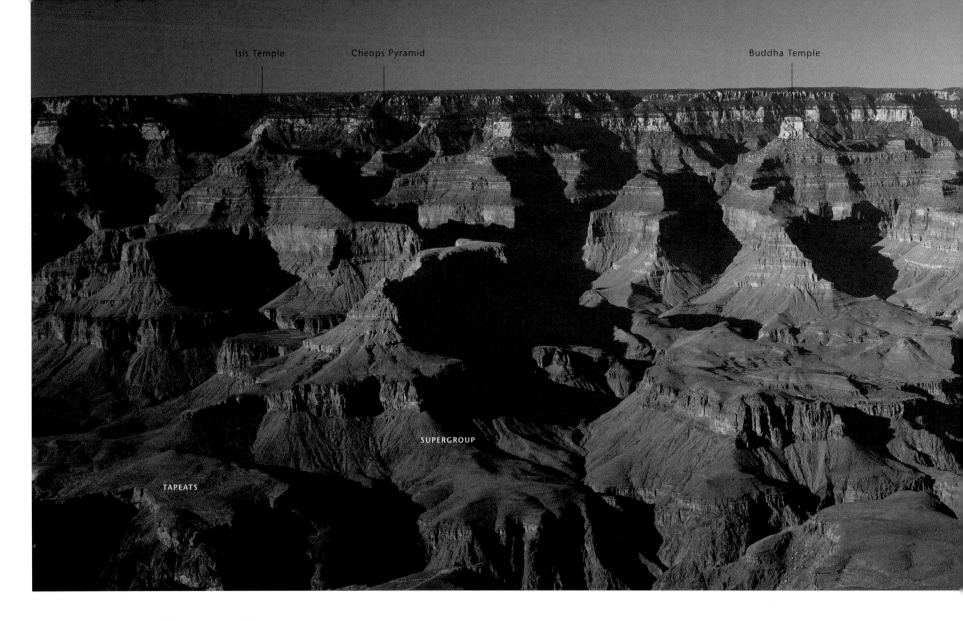

Yavapai Point I *View north*

The central location of Yavapai Point, together with the broad panoramic view of the North Rim, makes this an ideal place from which to see the typical features of the canyon and contemplate their meaning. From this view you can see the entire sequence of horizontal strata. The canyon rim is formed by the gray Kaibab and Toroweap limestones, below which is the prominent light-colored Coconino cliff. The central part of the canyon wall is dominated by the red rocks of the Hermit and Supai formations. These two rock bodies combined are more than 1,000 feet (300 m).

Perhaps the most imposing rock unit of all is the massive vertical cliff of the Redwall Limestone, which is more than 500 feet (150 m) high. Laid down by a Mississippian sea 340 million years ago, the Redwall extends across the middle of the entire panorama and caps many of the buttes near the Granite Gorge. Locally the cliff is eroded into large alcoves separated by long, narrow spurs projecting south from the canyon's northern wall.

The Muav Limestone, underlying the Redwall, is relatively inconspicuous. It is typically greenish-gray in color and is commonly covered with slope debris. It is important to note that in the eastern Grand Canyon the Muav is relatively thin and is composed of nonresistant shale with only a few beds of limestone. It is therefore difficult to distinguish from

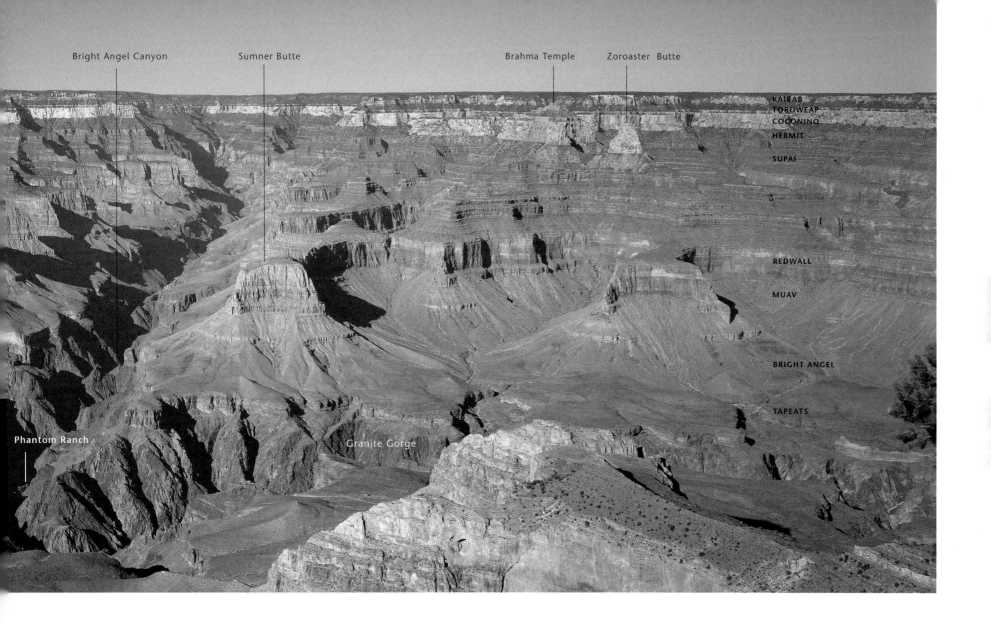

the underlying Bright Angel Shale. This observation is important because westward the Muav changes to a thick, resistant limestone and forms a high vertical cliff, in some places higher than that of the Redwall Limestone itself. Thus it is a major feature in the landscape of the lower canyon walls of the western canyon.

The Tapeats Sandstone forms the lowest cliff in this scene, and caps the dark, V-shaped Granite Gorge.

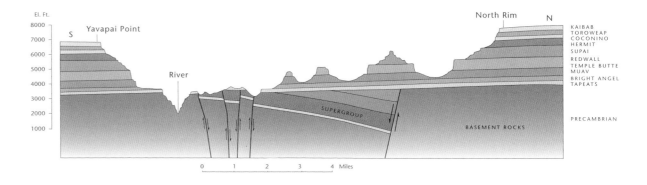

81

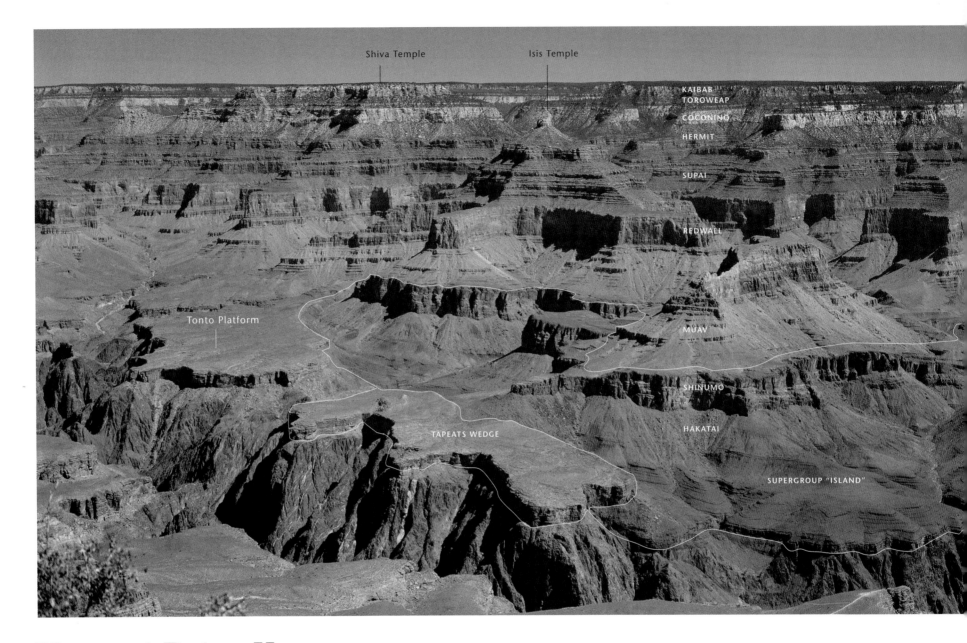

Yavapai Point II *View northwest*

From Yavapai Point a large segment of the Granite Gorge is visible across much of the panorama. It is distinguished by its dark, somber color and rugged, steep walls. In the vicinity of Bright Angel Creek, the schist of the Granite Gorge is laced with numerous pink granitic dikes.

One of the most striking features seen from Yavapai Point is the Bright Angel fault, a linear structure trending northward from the South Rim, across the Colorado River, and into the Kaibab Plateau. The fault is an inherent zone of weakness where erosion has carved the long canyon through which Bright Angel Creek flows. Complex movement had occurred along the fault before the horizontal Paleozoic rocks were deposited, and subsequent movement has displaced the Paleozoic strata by 185 feet (56 m). Given the Grand Canyon's enormous scale, this is hard to see, but it is equivalent to an eighteen story building.

An extremely significant geologic feature is exposed just west of Bright Angel Canyon. With the bewildering array of colorful cliffs, slopes, and temples, it is easy to overlook yet it records an incredible period in geologic history. The resistant rocks of the Grand Canyon Supergroup stood up as an island during the expansion of the first Paleozoic seas across the area. The Tapeats and Bright Angel seas lapped up against this island but did not cover it;

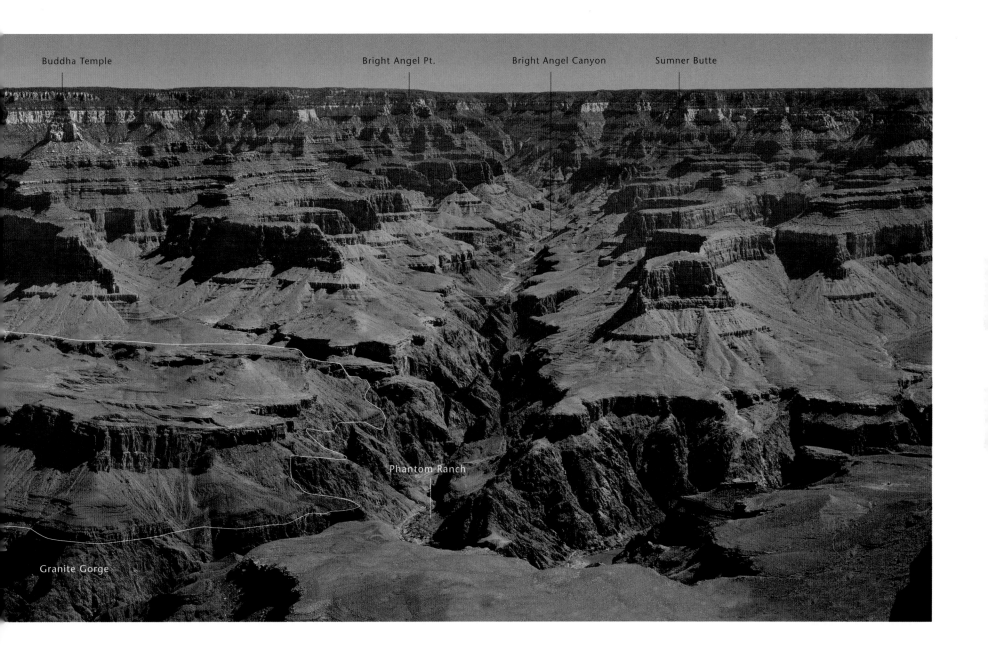

it was not covered by the sea until Muav time. It is preserved here as a buried island that was covered with mud deposited 505 million years ago. If you take time to study this area you will see many things not obvious at first glance. Maricopa Point provides additional perspectives of this most unusual geologic feature.

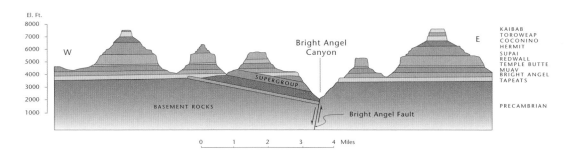

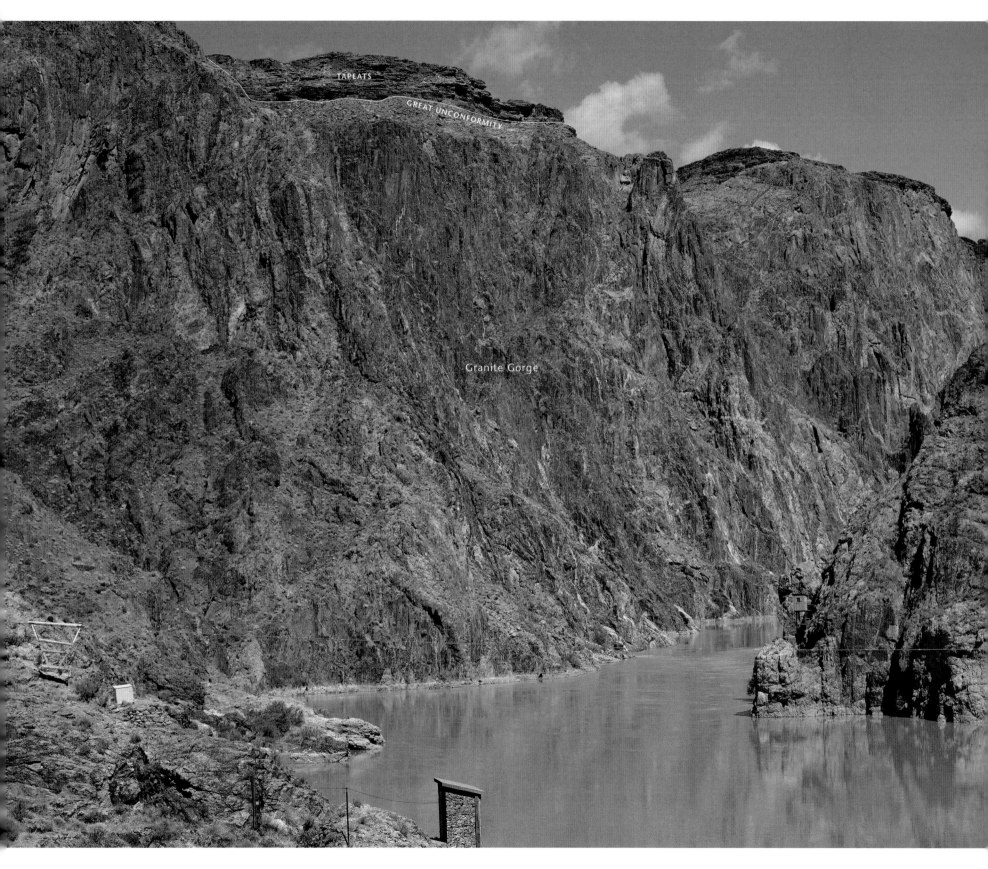

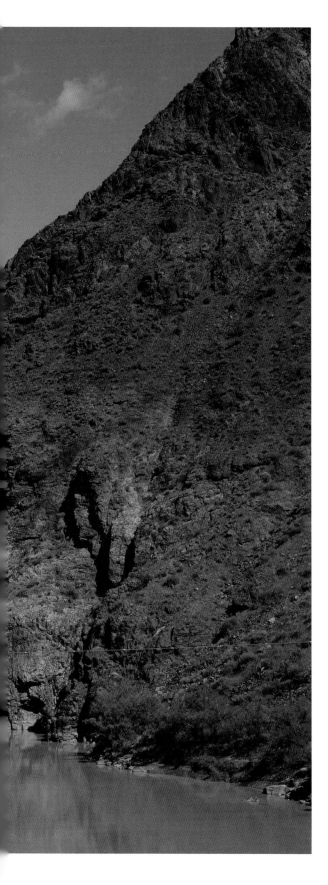

Upper Granite Gorge
View upstream from Kaibab Bridge

The Grand Canyon's Upper Granite Gorge (river mile 77–116) is a dark, ragged, V-shaped chasm that slices through some of the oldest and hardest rocks in the world. It is a dark and foreboding section of the canyon, as explorer John Wesley Powell remarked more than one hundred years ago.

> *We are three quarters of a mile in the depths of the earth, and the great river shrinks into insignificance, as it dashes its angry waves against the walls and cliffs, that rise above; they are but puny ripples, and we but pygmies, running up and down the sands, or lost among the boulders.*

Here the Granite Gorge is slightly more than 1,000 feet (300 m) deep, while the total depth of the canyon is more than 5,000 feet (1,500 m). It is here that the complex metamorphic and igneous rocks (1.7 billion years old) provide a rare window into the deep continental crust and the roots of ancient mountain belts. They record early tectonic activity involving the growth of continents.

This spectacular exposure near the mouth of Bright Angel Creek shows large, pink granite dikes that were intruded in a liquid state into the cracks of the older, dark metamorphic rocks commonly referred to as schist. The top of the Granite Gorge is capped with a horizontal layer of sedimentary Tapeats Sandstone.

The surface between the underlying crystalline rocks and their cap of sedimentary Tapeats Sandstone is referred to as the Great Unconformity. This surface represents an enormous period of time not preserved in the rock sequence at the Grand Canyon—a 1.2-billion-year period of erosion during which mountain systems were stripped away to expose the igneous and metamorphic rocks that formed at high temperatures and extreme pressure deep within their roots. This is twice the length of time that has passed since the first horizontal Paleozoic rocks were deposited, and is vastly longer than the time it has taken to cut the Grand Canyon.

The rocks of the Granite Gorge are believed to have originated in volcanic islands similar to those in Indonesia today where the Australian tectonic plate is moving north and colliding with the volcanic arcs. The tectonic blocks that ultimately formed the Granite Gorge would have originally included volcanic islands, oceanic crust, and some small continental fragments. The collision of plates, spanning a period of 20 million years, welded these diverse materials together into a new segment of the North American continent and culminated in intense compression. Under extreme heat and pressure, rocks were formed in the root of a mountain belt at a depth of more than five miles (8 km). Geologists can read the basic elements of this story recorded in the rocks with considerable confidence.

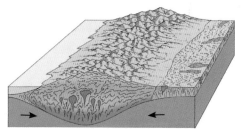

Mountain building by collision of tectonic plates

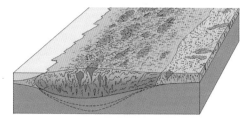

Erosion of mountains and crustal rebound

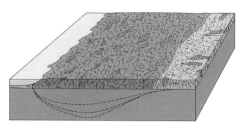

Erosion exposes mountain roots at the surface

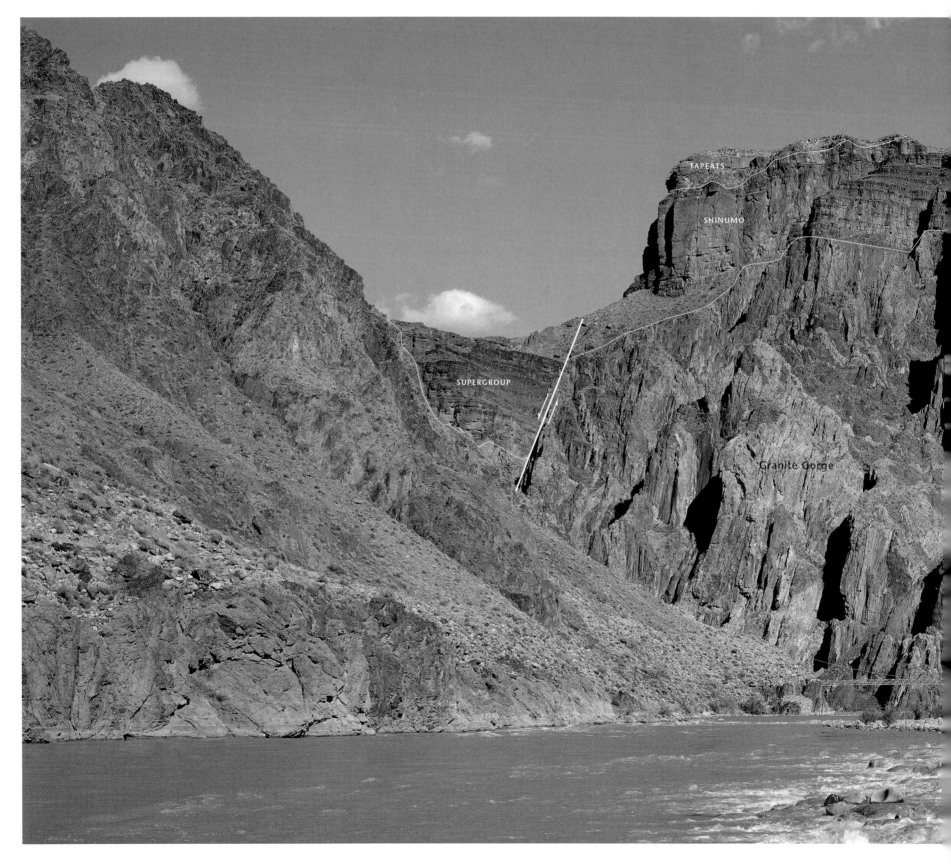

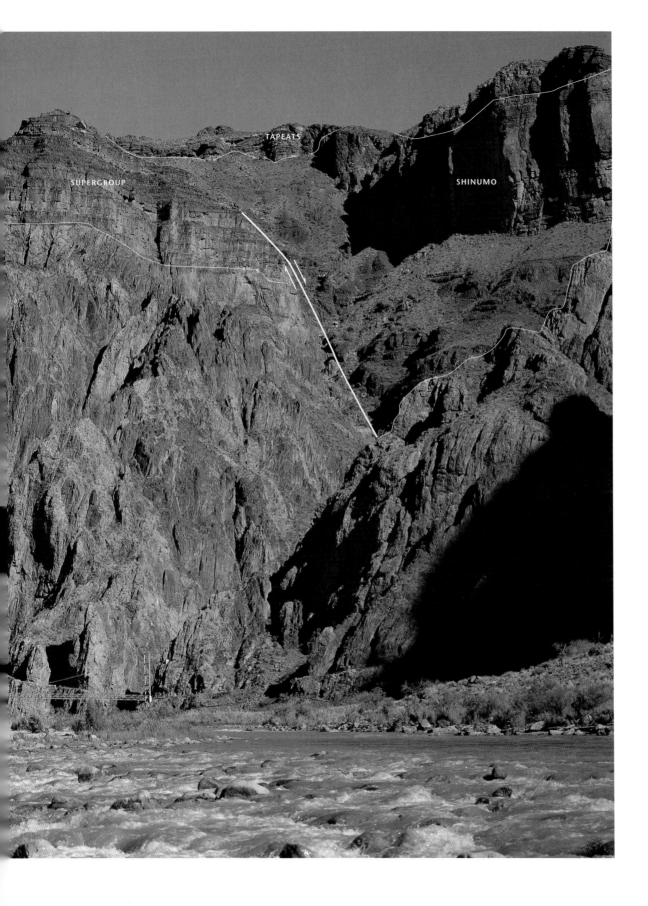

Faults and Dikes
View upstream from river mile 90

This area near Bright Angel Creek is the best place along the Colorado River to see the complex faulting and granite dikes of the canyon's Precambrian rocks. Also visible here are several small blocks of the younger Grand Canyon Supergroup, which are caught in the Bright Angel fault zone. The presence of these younger rocks records a period of complex deformation during recurrent periods of movement along faults prior to the development of the Great Unconformity. In some places movement was upward during one period and downward during another.

Near the skyline, at the lowest point on the horizon, sedimentary rocks of the Grand Canyon Supergroup are down-faulted against the Precambrian metamorphic rocks. In the mid-ground, just beyond the suspension bridge, the Grand Canyon Supergroup rests uncomfortably upon the older Precambrian rocks. The bold cliff on the right is a resistant formation, the Shinumo Quartzite, within the Grand Canyon Supergroup. At far right, exposures of the Grand Canyon Supergroup can be seen up a steep tributary gorge.

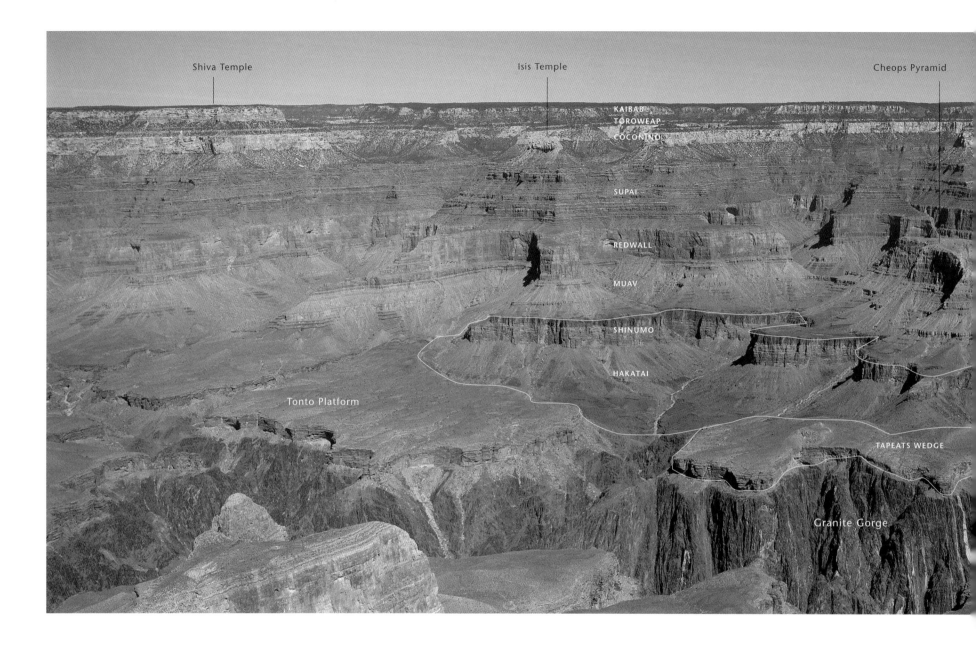

Maricopa Point I *View north*

At Maricopa Point the Colorado River is hidden from view as it flows at the bottom of the Upper Granite Gorge, 1,500-feet (450-m) below the Tapeats Sandstone cliff. The gorge's dark Precambrian metamorphic rocks are laced with the pink dikes of granite that intruded cracks and crevices while in a molten state and under extreme pressure.

West of Bright Angel Canyon a large wedge of the Grand Canyon Supergroup is exposed for a distance of more than four miles (6 km). See page 20 to learn more about the significance of this rare exposure.

Compare this view from Maricopa Point with the one on the following pages. Though they are taken from the same overlook in morning light (but not on the same day), their colors are markedly different. Anyone who takes time to really see the canyon realizes that the view is constantly changing—from season to season, day to day, and even from hour to hour.

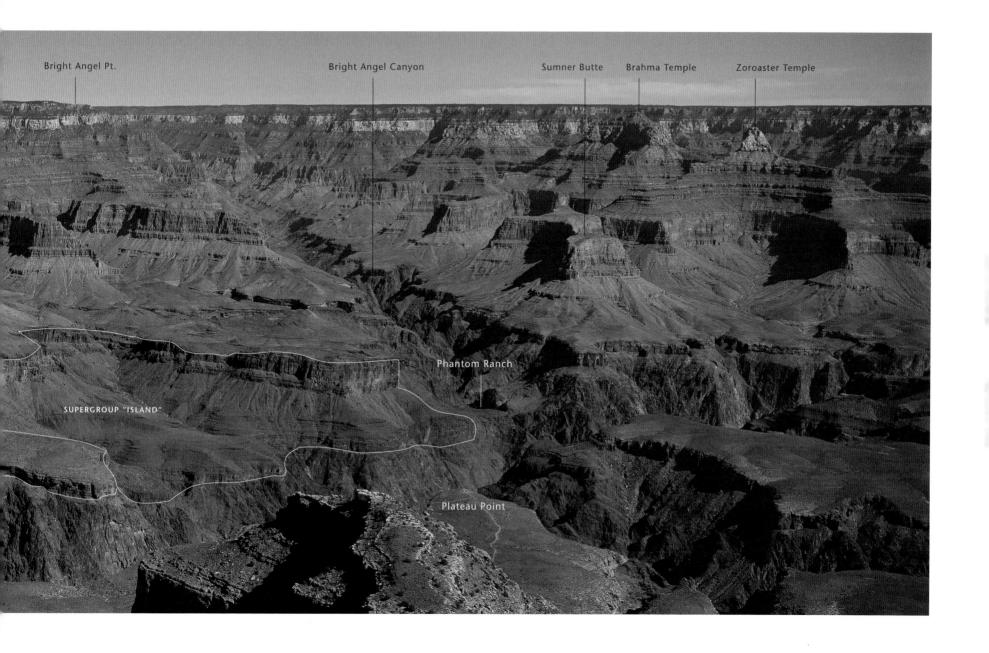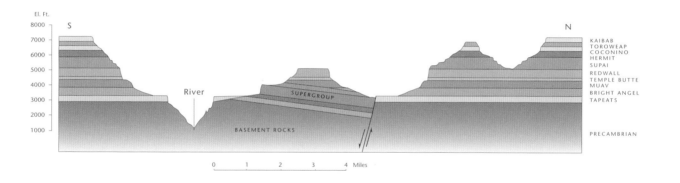

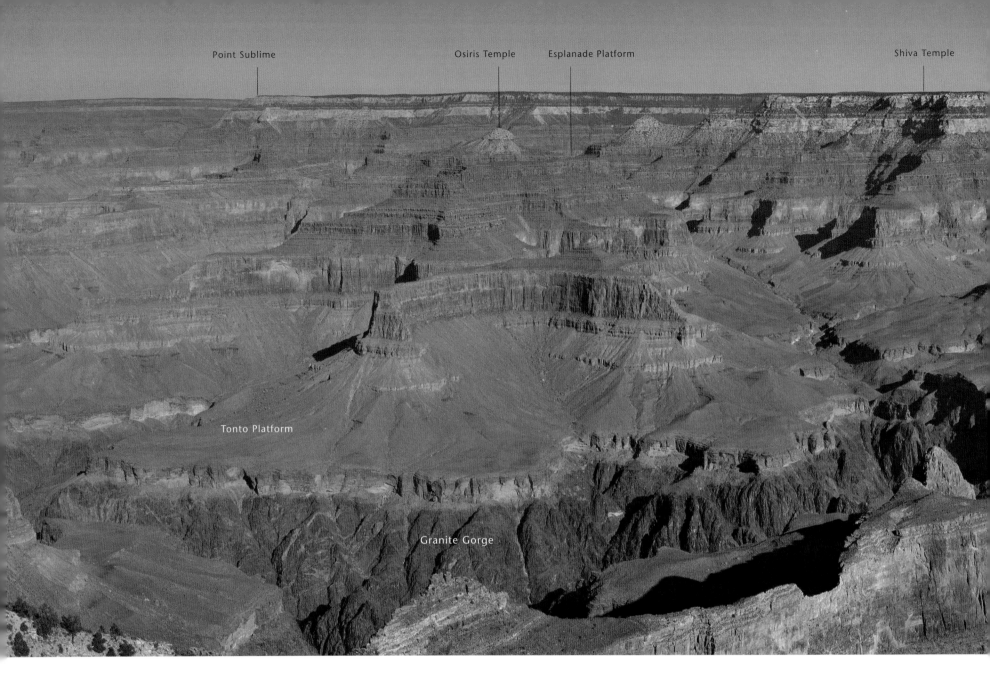

Maricopa Point II *View northwest*

Maricopa Point affords an extended east-west view of the Grand Canyon and the landforms that make it famous. Three important things can be seen from Maricopa Point: the dark schist of the Granite Gorge infused with a series of thin pink granitic dikes; the well-developed Tonto Platform, which forms a wide bench atop the Tapeats Sandstone; and our first glimpse of the Esplanade Platform, which is expressed by the flat surface capping the ridges or spurs of the Supai sandstones. This is the classic profile of the Grand Canyon in all its glory.

As you observe the canyon from this viewpoint, you will note in the far background, the Coconino Sandstone cliff extending across the entire north wall as a thin, light-colored band, above which are the

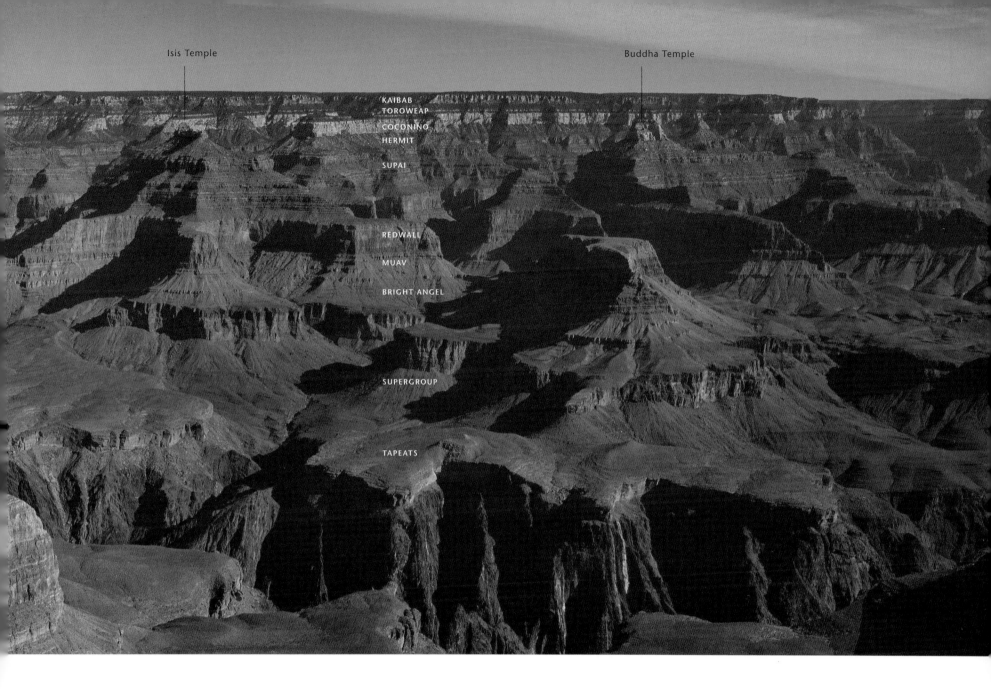

grayish cliffs of the Kaibab and Toroweap formations that comprise the canyon rim.

Note the many temples and buttes carved from the north wall of the canyon. Most of the temples, including Osiris, Shiva, Isis, and Buddha, are capped by resistant limestones or sandstones. These features evolved as erosion and mass wasting whittled away at larger mesas that had been cut off from the main north wall by the erosive force of tributary streams.

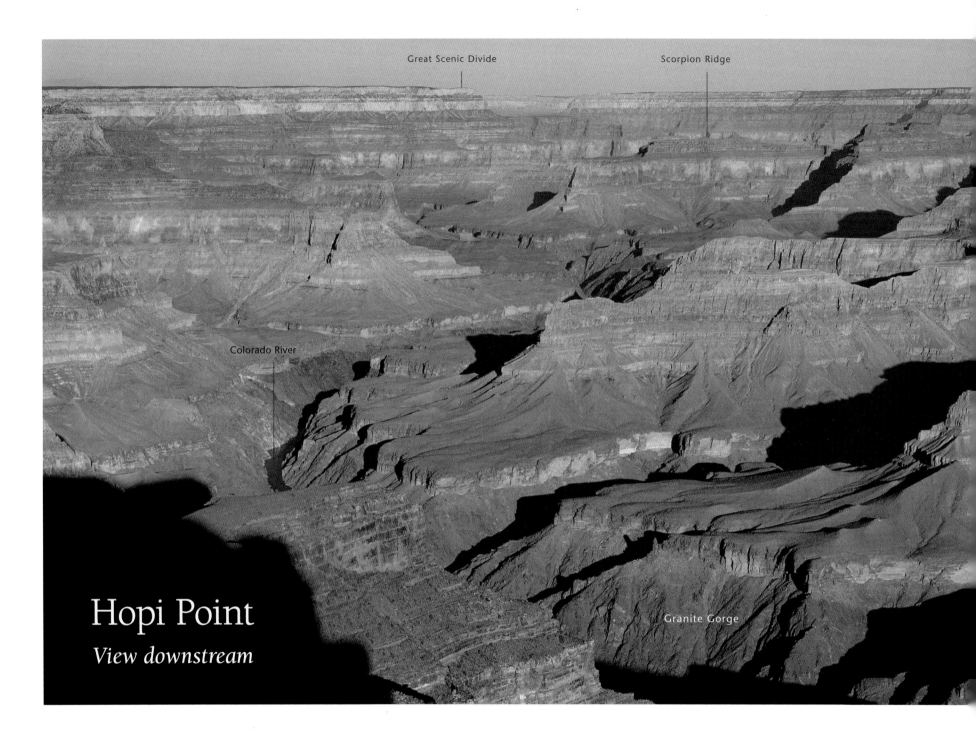

Hopi Point
View downstream

Looking across the river from Hopi Point, notice how the north side of the canyon is dissected into a series of prominent ridges, spurs, and amphitheaters by the relatively long streambeds that drain the Kaibab Plateau.

Here, as in all other sections of the canyon, the massive Redwall cliff extends across the central part of the canyon and is eroded into a series of crescent-shaped amphitheaters for which the Redwall is famous. Above the Redwall cliff, the thick, red Supai sandstones and shales have eroded into a series of alternating low cliffs and slopes, typical of the Supai sediments in this part of the canyon. In the background, near the skyline, the Coconino Sandstone forms the prominent light-colored cliff that extends across the scene like a bathtub ring. Osiris is capped by a small pyramid-shaped remnant of the Coconino Sandstone. Above the Coconino, the

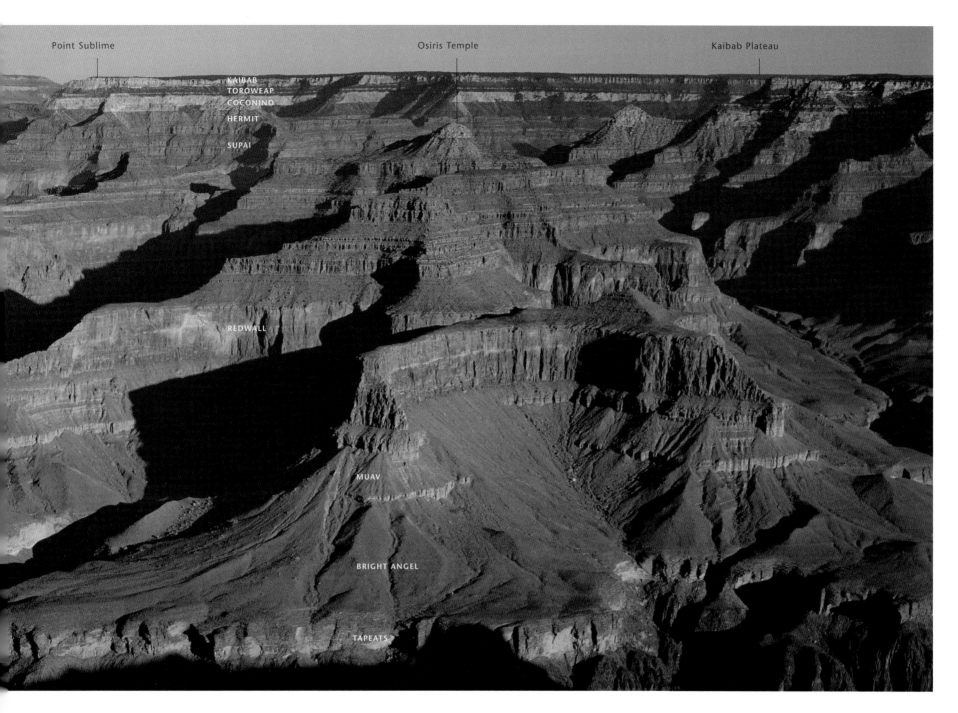

grayish cliffs of the Kaibab and Toroweap units form the canyon rim.

The myriad temples, buttes, alcoves, and colorful cliffs separated by narrow slopes make this one of the most scenic parts of the canyon.

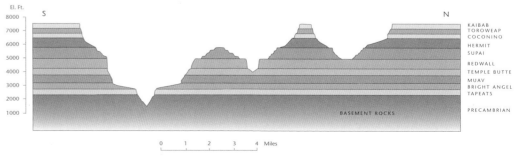

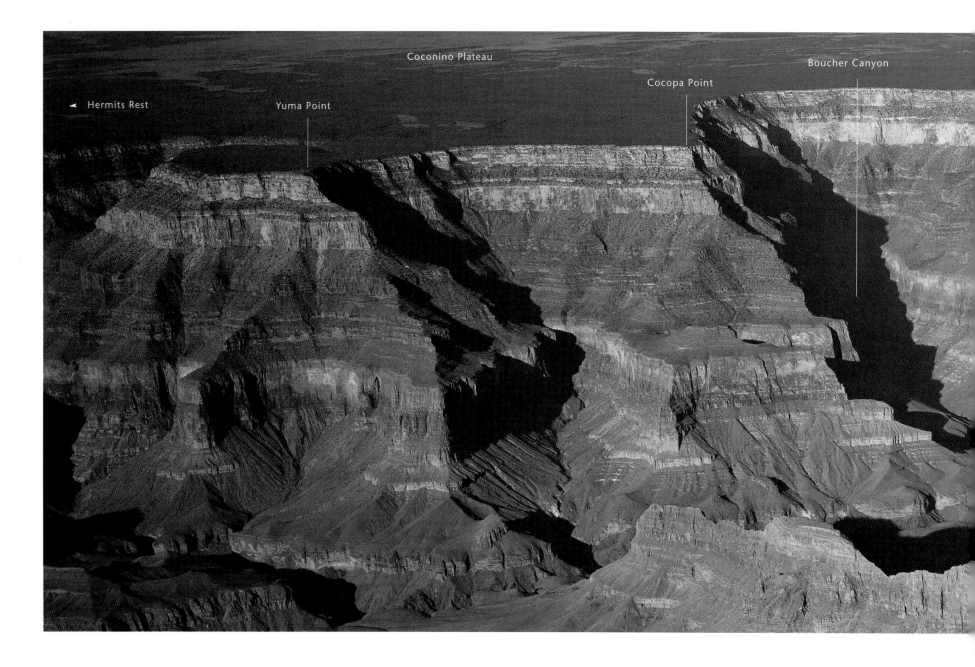

The Scalloped South Rim *View south*

Along most of the South Rim, the surface of the plateau slopes southward away from the Colorado River. Consequently, most of the surface runoff and groundwater does not flow into the canyon; instead, it flows southward away from the river, inhibiting headward erosion. As a result, the tributary canyons on the southern canyon wall are short and poorly developed. The South Rim is therefore relatively steep and undissected, but is serrated into a series of semi-circular alcoves. This is in striking contrast to the North Rim where runoff and groundwater flow into the canyon, aiding the process of headward erosion. Consequently, the North Rim is highly dissected into long tributary canyons separated by narrow spurs or ridges.

In the central foreground of this view, two long ridges stretch southward toward the river from the Tower of Ra. A complete cross section of classic

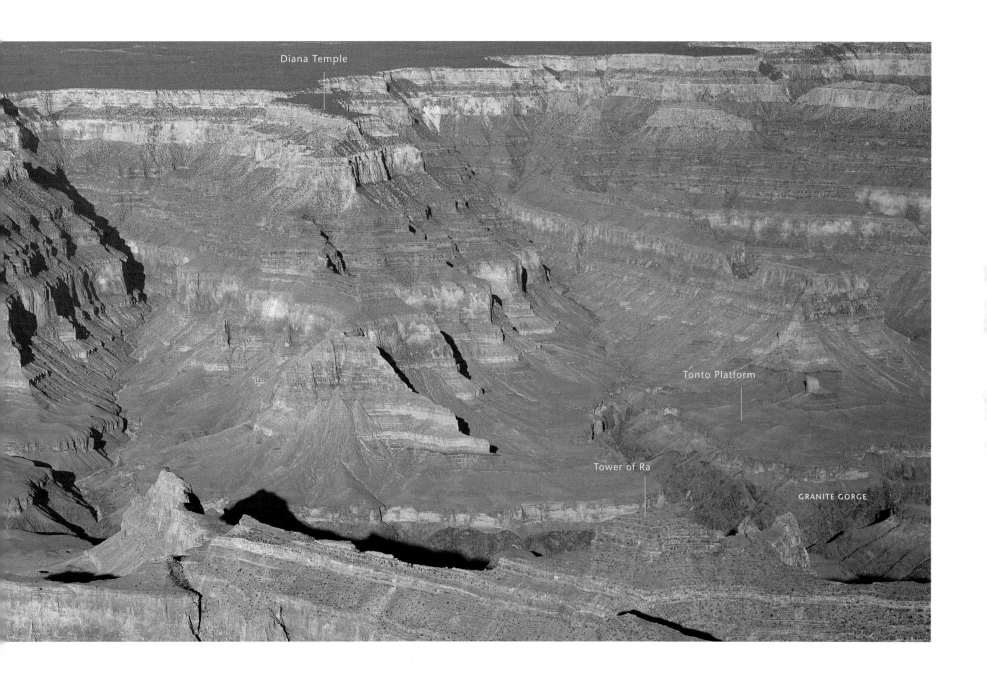

canyon geology can be seen extending up from the Granite Gorge to the Kaibab Formation, which caps the Coconino Plateau to the south. Below the South Rim, the Tonto Platform is well developed.

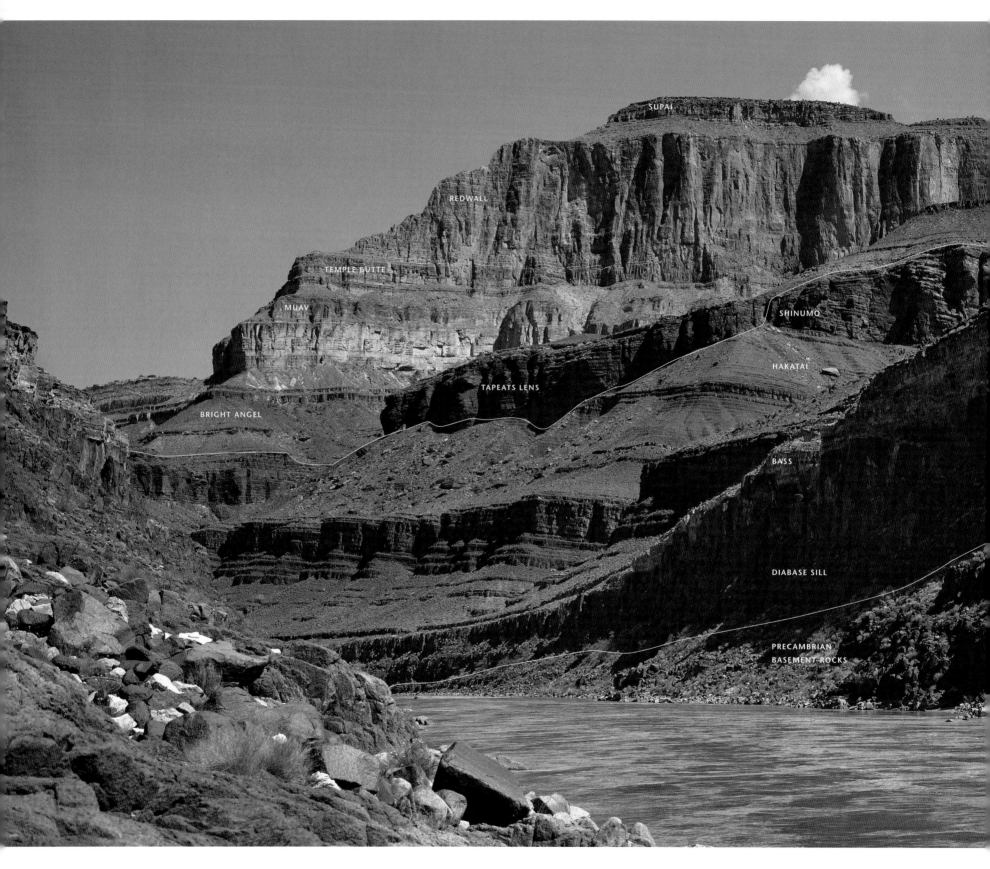

Shinumo Amphitheater
View downstream, river mile 108

An impressive exposure of the Grand Canyon Supergroup sweeps across the central part of this photograph (between the white lines). The bold cliff on the right, angling up from the river, is a diabase sill that was injected into the lower part of the Grand Canyon Supergroup. A sill is a tabular body of igneous rock that has been injected between layers of the enclosing rock.

The same high temperatures and extreme pressure that caused the sill to form also altered the surrounding rock into asbestos at the point of contact. Asbestos was one of the few minerals mined profitably at the Grand Canyon. For years it was used in making fire-retardant curtains for the great theaters of Europe.

The rock layers in this area are inclined to the north, although from this perspective many appear to be almost horizontal. Paleozoic rocks (Muav, Temple Butte, Redwall, and lower Supai) form the profile of the upper walls. The Esplanade Platform is beginning to develop in this part of the canyon and forms the flat skyline. This is not the rim of the canyon; it is only the edge of the Esplanade Platform. The actual rim of the canyon stands nearly 2,000 feet (600 m) higher and has eroded back more than five miles (8 km) from the rim of the Esplanade.

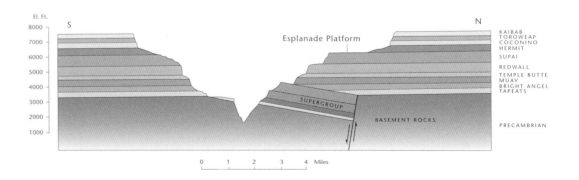

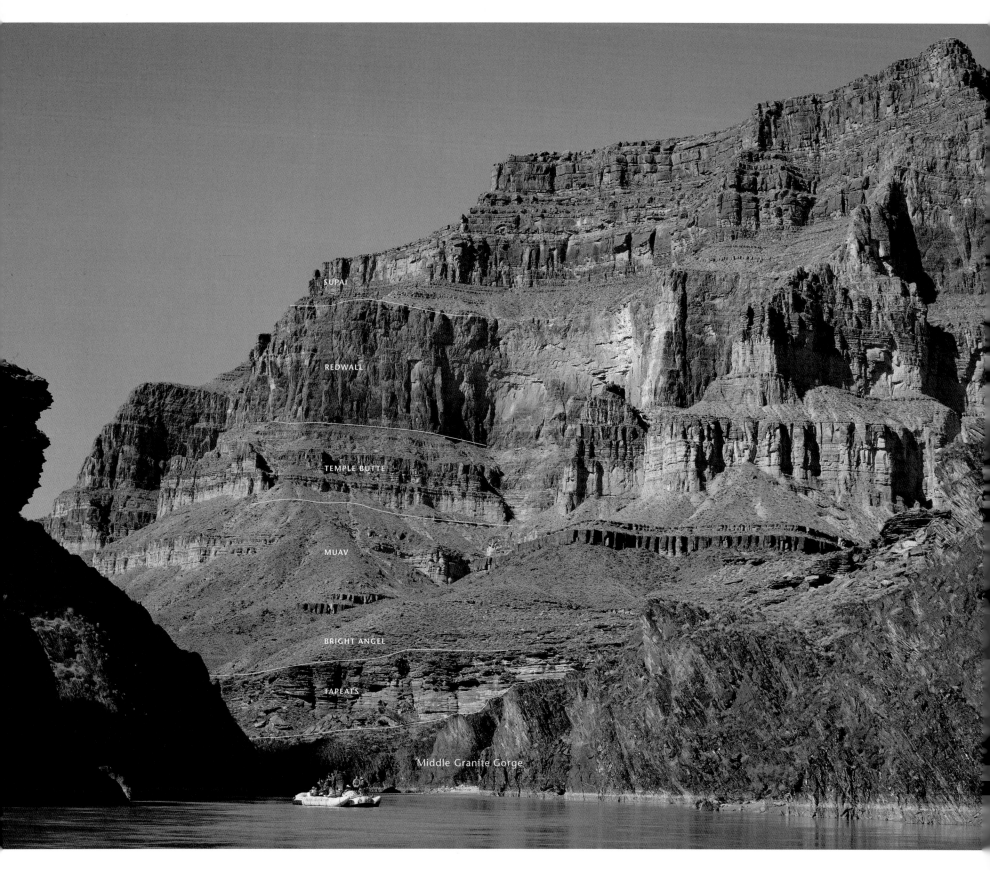

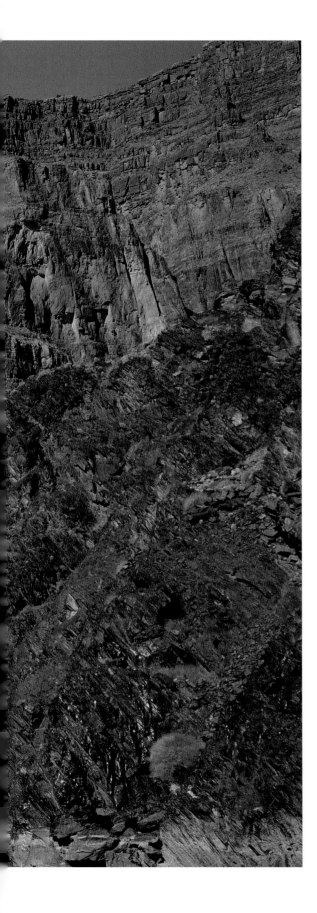

Middle Granite Gorge *View downstream*

Whereas the Upper Granite Gorge cuts through a continuous exposure of metamorphic basement rocks between river miles 77 and 116, the basement rocks of the Middle Granite Gorge are interrupted by changes in uplift, and appear only between river miles 127 and 130 and again between 134 and 136. It is smaller and less impressive than the Upper Granite Gorge, but it is important to geologists because it provides insight into different aspects of Precambrian history in the canyon area.

In this view only thirty to forty feet (9 to 12 m) of the Precambrian rocks are exposed above the river, forming a narrow, steep channel. The rock is dark black and appears to be polished in many places. The well-bedded Tapeats Sandstone lies above the Precambrian rocks and forms a low vertical wall visible beyond the boat in this scene. Above the Tapeats is the greenish Bright Angel Shale, which forms a narrow slope (the Tonto Platform) up to the base of the Muav Limestone cliff. It is important to note that the Muav Limestone consists of three units: a lower cliff of limestone, a middle shale, and a much higher cliff of limestone (dolomite). This is the typical Muav sequence in the eastern Grand Canyon, but as it progresses westward the thickness and nature of the rock rapidly changes and the formation becomes a prominent cliff-forming limestone.

Above the Muav is the Temple Butte, absent farther east, but visible here below the great imposing cliff of Redwall Limestone. In the higher wall of the canyon, Paleozoic rocks form an almost uninterrupted cliff. Supai Sandstone on the skyline marks the edge of the Esplanade Platform. Upper Paleozoic rocks (Hermit, Coconino, Toroweap, and Kaibab formations) cannot be seen from the bottom of the canyon because they have eroded back three miles (5 km) from the river as the Esplanade Platform developed.

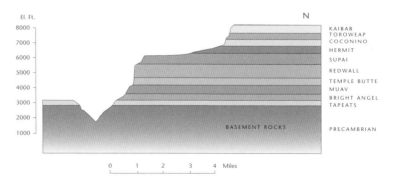

Chapter 4

Western
Grand Canyon

The Esplanade	102
Kanab Point	104
Inner Gorge	106
Mount Sinyella	108
Volcanoes of the North Rim	110
Lava Dams	112
Beneath Vulcans Throne	114
Remnants of Lava Dams	116
High-Level Remnants of Lava Dams	118
Ancient Lakes in Grand Canyon	120
Lake Deposits in Havasu Canyon	122
Below Whitmore Wash	124
Hurricane Fault Zone	126
Peach Springs Canyon	128
Shivwits Plateau	130
Sanup Plateau	132
Grand Canyon West	134
Grand Wash Cliffs	136
The End of the Grand Canyon	138

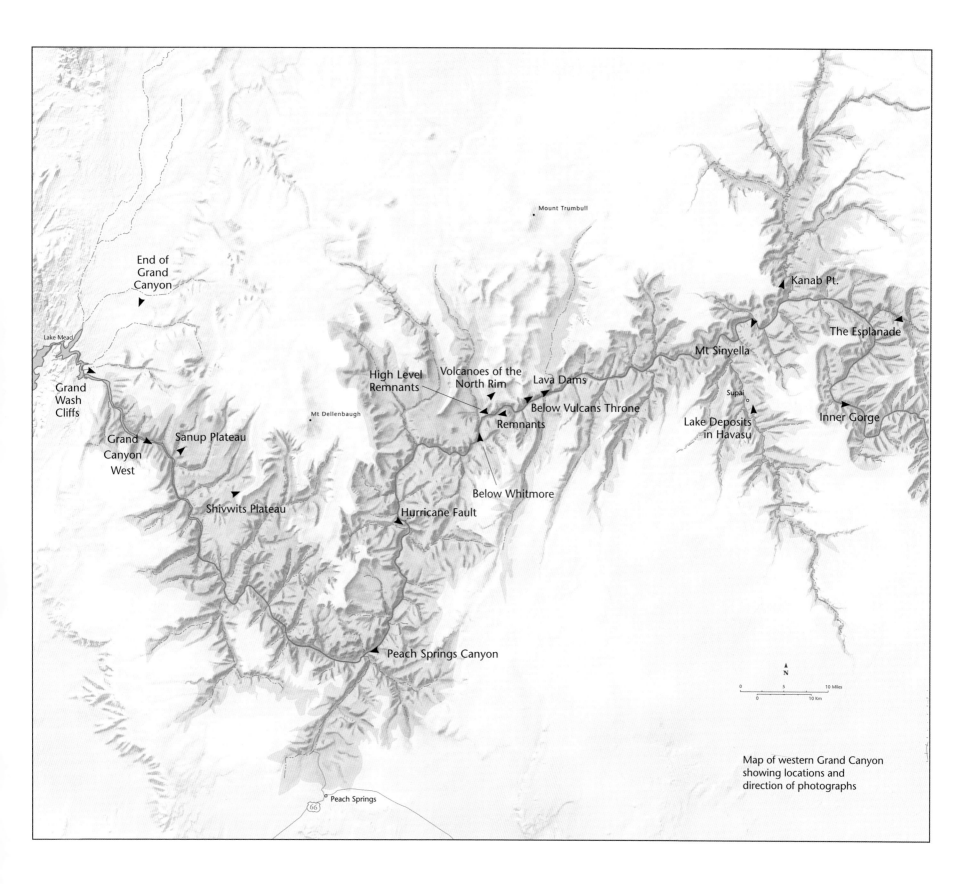

101

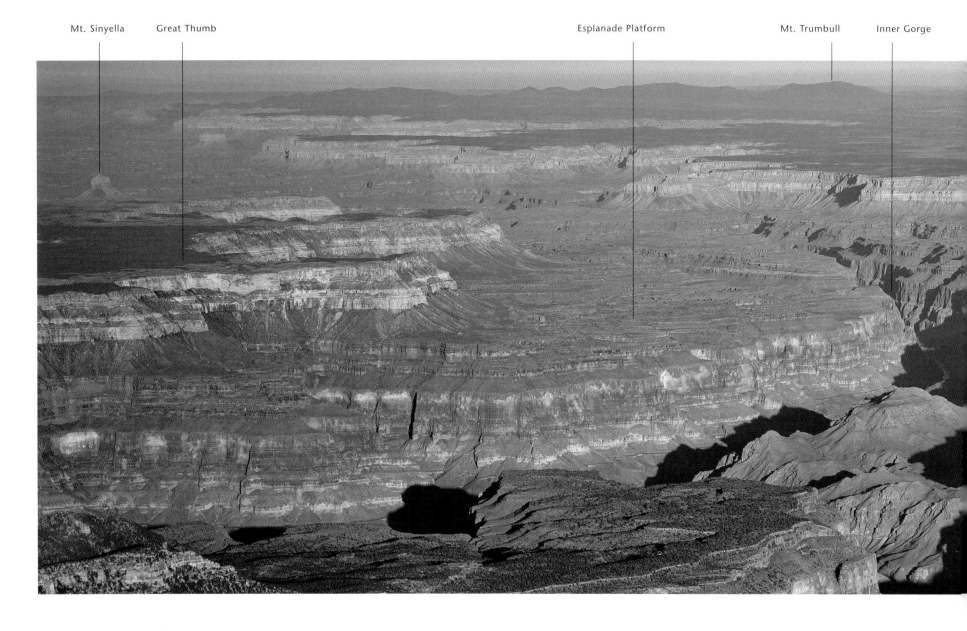

The Esplanade *View downstream*

The Esplanade Platform is one of the most prominent and spectacular landforms in the Grand Canyon, but few people see it. It begins to take form about twenty miles (32 km) west of Grand Canyon Village. At this point the canyon takes on a completely different character. The light-colored Kaibab, Toroweap, and Coconino formations form the outer canyon wall just as they do in the village area, but the Esplanade Platform and the Inner Gorge below it dominate the landscape. The point at which the scenery takes on this new character is known as the Great Scenic Divide.

The Esplanade forms atop the thick sandstone beds of the Supai Group, which are thicker and more resistant in the western canyon than they are farther east. Throughout most of the eastern canyon, the Supai is composed of relatively thin alternating shale and sandstone beds, which erode into a series of step-like ledges and slopes instead of forming a flat platform.

Where the Esplanade begins at the Great Scenic Divide, it is one-half mile (1 km) wide but increases in width farther west. In the Toroweap area it is between two and six miles (3 to 10 km) wide on each

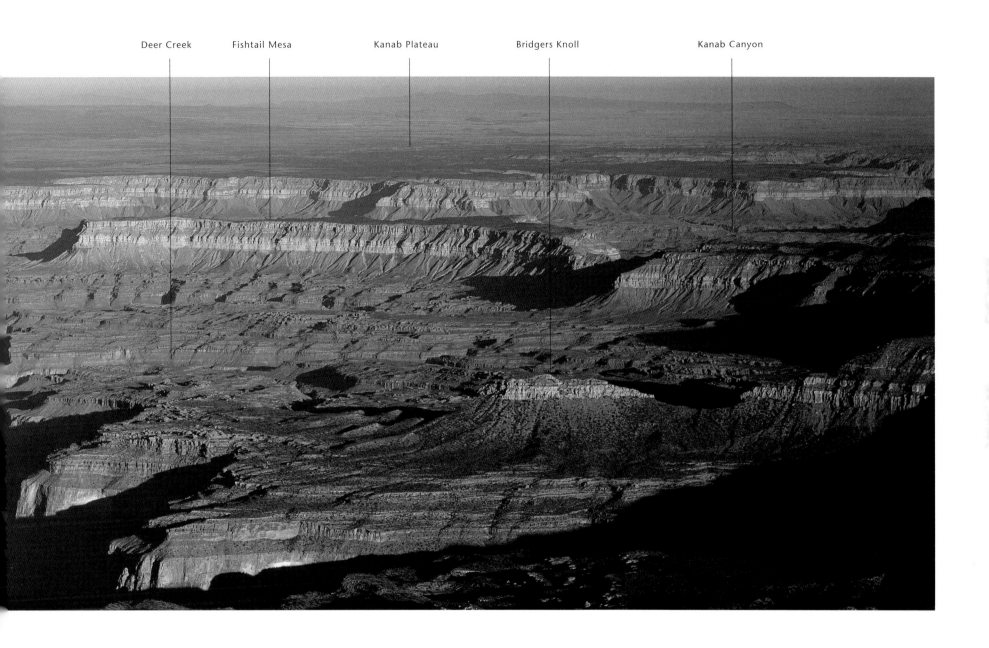

Deer Creek | Fishtail Mesa | Kanab Plateau | Bridgers Knoll | Kanab Canyon

side of the canyon. Below Snap Point, near the Grand Wash Cliffs, the platform is seven miles (11 km) wide and is known as the Sanup Plateau. The Esplanade extends approximately 175 miles (280 km) through the canyon to Lake Mead, becoming the largest terrace in the canyon, in both width and extent.

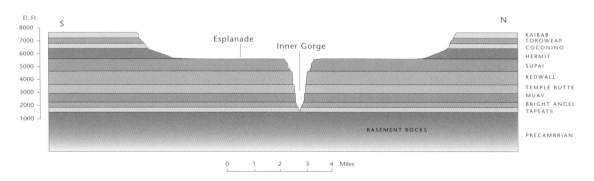

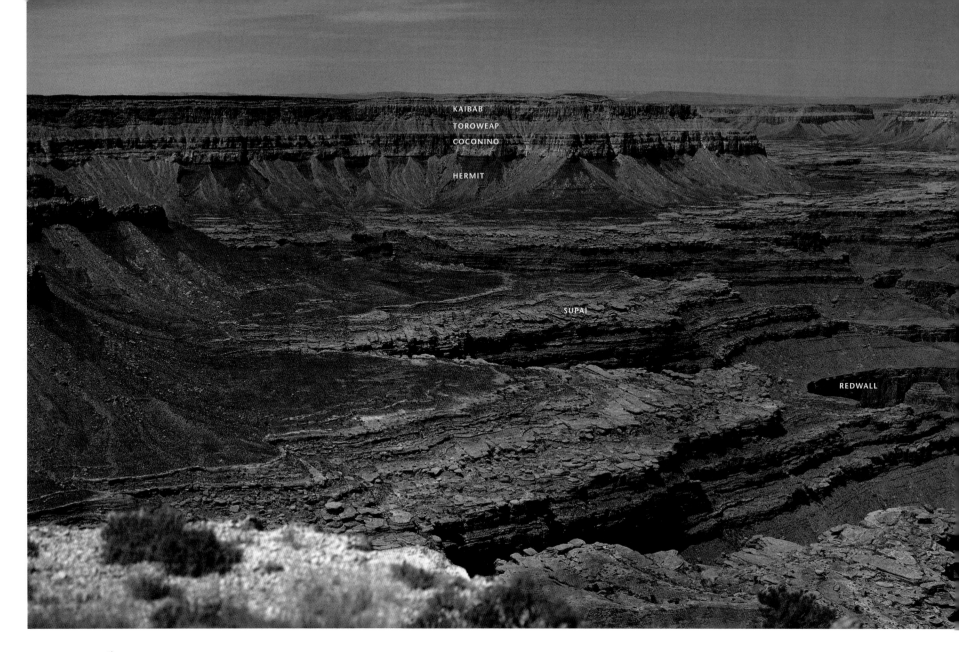

Kanab Point *View north up Kanab Creek*

The spectacular panoramic view of the Grand Canyon from Kanab Point is dominated by the Esplanade Platform and the deep, steep-walled Inner Gorge. This photograph is a mosaic of six panoramas stitched together to capture a ninety-degree view looking northward up Kanab Creek, a major tributary to the Colorado River. The headwaters of Kanab Creek begin in the high plateaus of Utah, fifty miles (80 km) to the north. Soon after exiting the Grand Staircase near the Utah-Arizona border, Kanab Creek begins to cut deeply into the Kaibab Formation to create this magnificent side canyon.

This area is as instructive as it is magnificent. Most of the major changes in the Grand Canyon begin in this area where we can see how the rock formations and structure control the anatomy of the landscape. The profile of the canyon in this area is typical of the western part of the Grand Canyon where lateral changes in the Supai Group have developed a thick reddish sandstone unit upon which the Esplanade terrace is formed. The Hermit Formation above it is much thicker in this region than it is to the east and is easily eroded, facilitating slope retreat and development of the terrace. Note the purplish slope between the vertical cliffs on the Esplanade Sandstone and the Redwall Limestone exposed in the Inner Gorge. These marine beds in the lower Supai Group become thicker westward.

Beneath the Supai Group only the top of the vertical walls of Redwall Limestone is visible in the

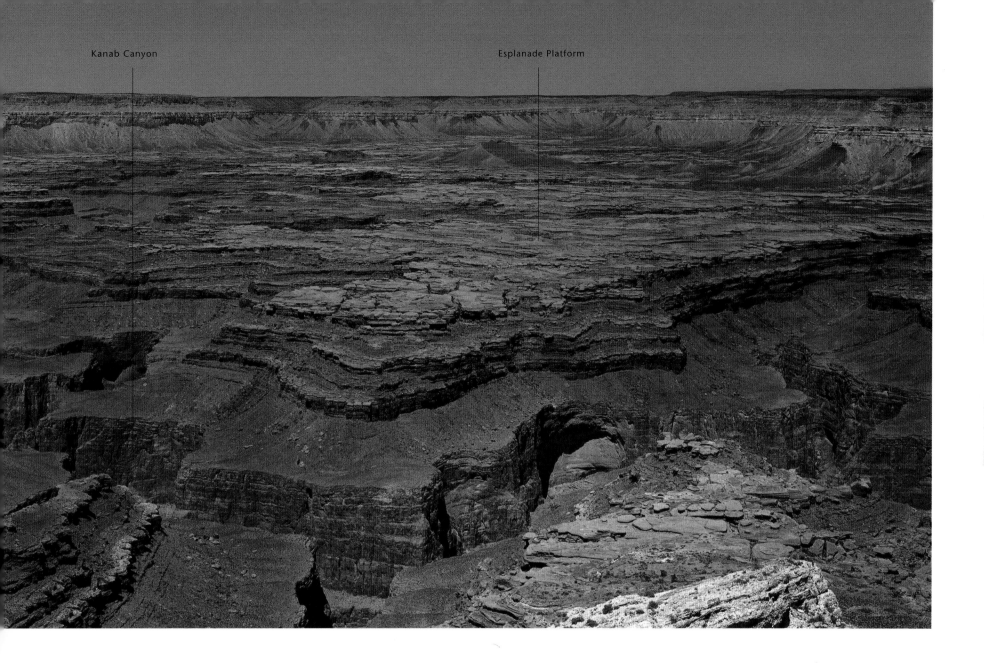

steep, narrow gorge. Entrenched meanders have developed in the Redwall, some of which are seen in the central foreground of the photograph.

Note that the gray talus slopes on the red Hermit Formation are not active surfaces of deposition (i.e., they are not accumulating surface material). Rather, they have been dissected by recent erosion that exposes "islands" of the red shale beneath. This suggests that the talus slopes were probably active during the last ice age, but with a change in climate the talus slopes began eroding.

Regardless of how spectacular Kanab Canyon is when seen from the canyon rim, rafters on the Colorado River hardly notice Kanab Creek; even at its junction with the Colorado River there is no hint of its tremendous size and splendor. At river level Kanab Creek reveals itself as a narrow slot canyon. We see no suggestion of the broad Esplanade from the river and when the Esplanade comes into view downstream, it appears to be the canyon rim.

Kanab Creek is where Major Powell terminated his river trip in 1871 by hiking up the canyon to Kanab, Utah, a distance of approximately sixty-five miles (105 km). It is also the area where Charles D. Walcott, a famous paleontologist, measured the thickness of all the Paleozoic formations in the Grand Canyon from the Colorado River up to Kanab, Utah, in 1879.

Inner Gorge *Canyon within a canyon*

The Inner Gorge of the western Grand Canyon cuts down through the Esplanade Platform into the underlying limestone formations. We see a different canyon here—a deep, narrow canyon within a canyon. The Muav and Temple Butte formations are much thicker here than they are in the Grand Canyon Village area to the east, and, together with the overlying Redwall and Supai formations, they form the impressive scenery of this image.

The details of cliff topography on each formation are distinctive. The Muav cliff is a set of brown ledges that superficially resemble columnar jointing in basalt seen in lava flows farther downstream. Above the Muav, the Temple Butte Formation exhibits numerous relatively thin beds etched out in relief. The high Redwall Limestone cliff is exposed on both walls and in the background where the river disappears around the bend.

In the far background, the red sandstone of the Supai Group forms the skyline. This is the rim of the Inner Gorge, more than 2,000 feet (610 m) above the river. It is not the rim of the Grand Canyon, it is only the edge of the Esplanade Platform. The actual rim of the canyon is on the top of the Kaibab Formation located three miles (5 km) back from the edge of the Inner Gorge and 2,000 feet (610 m) higher than the Esplanade. It cannot be seen from this perspective on the river.

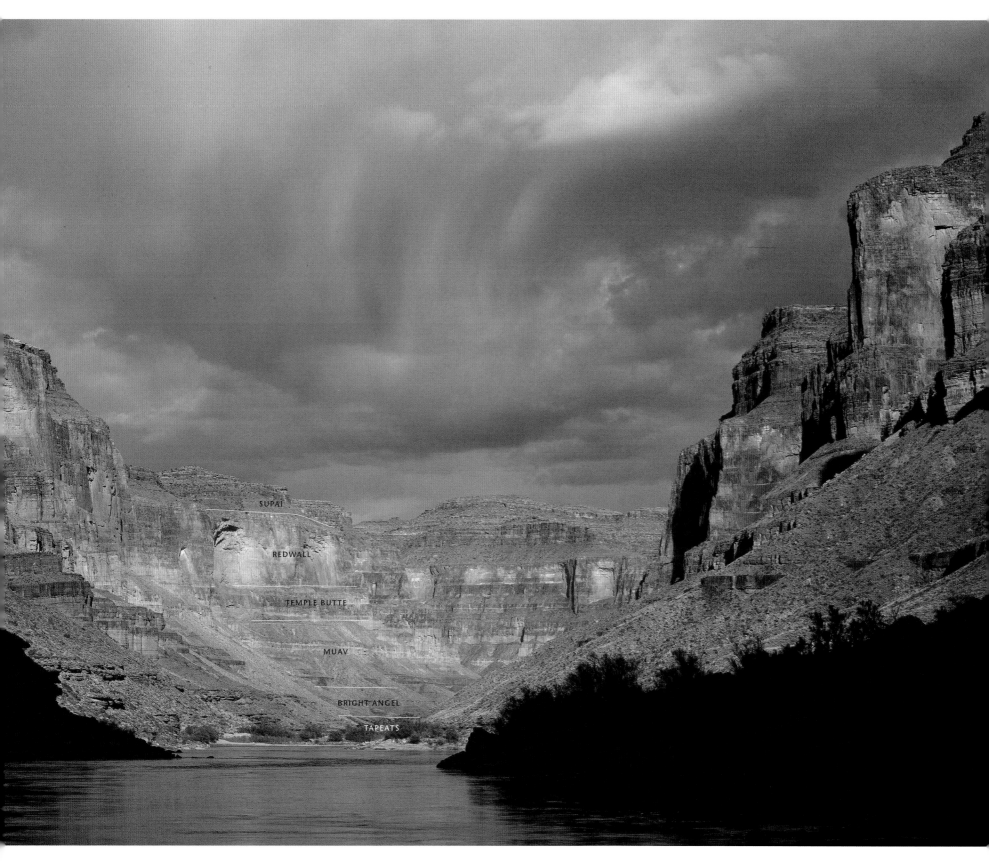

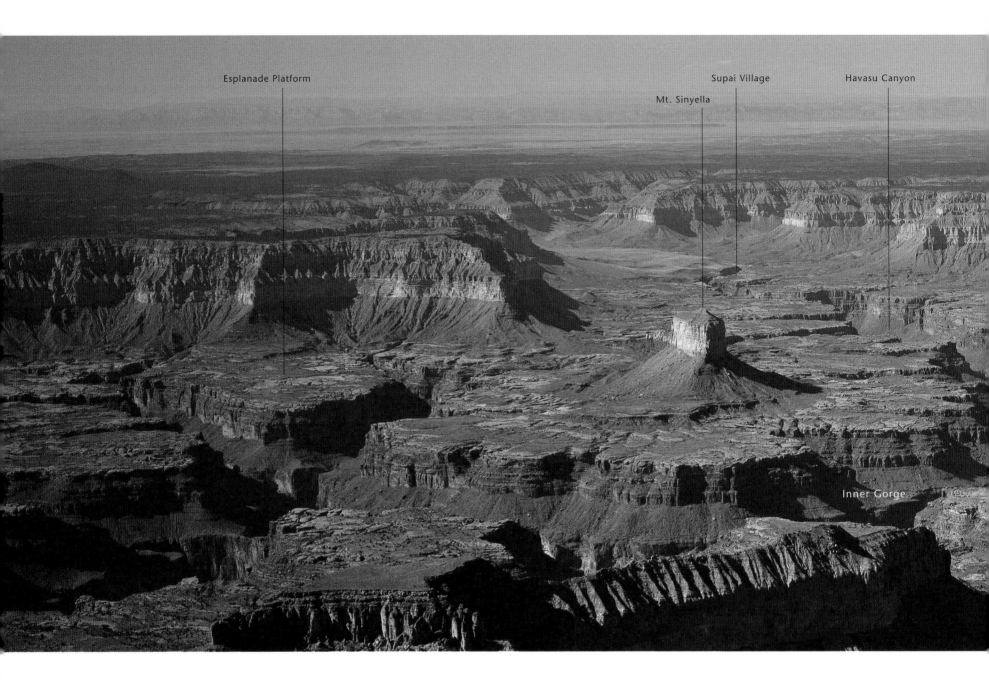

Mount Sinyella *View south*

A spectacular erosional remnant of upper Paleozoic rocks forms a small isolated butte called Mount Sinyella. It appears to be standing out in the middle of the Esplanade Platform but it is actually located near the mouth of Havasu Canyon on the south side of the Inner Gorge. The broad expanse of the Esplanade is more than five miles (8 km) wide here and presents a remarkable panorama. The Inner Gorge, however, is only one-half mile (0.8 km) wide so that only the upper part can be seen from the rim of the platform. This view to the south looks into Havasu Canyon.

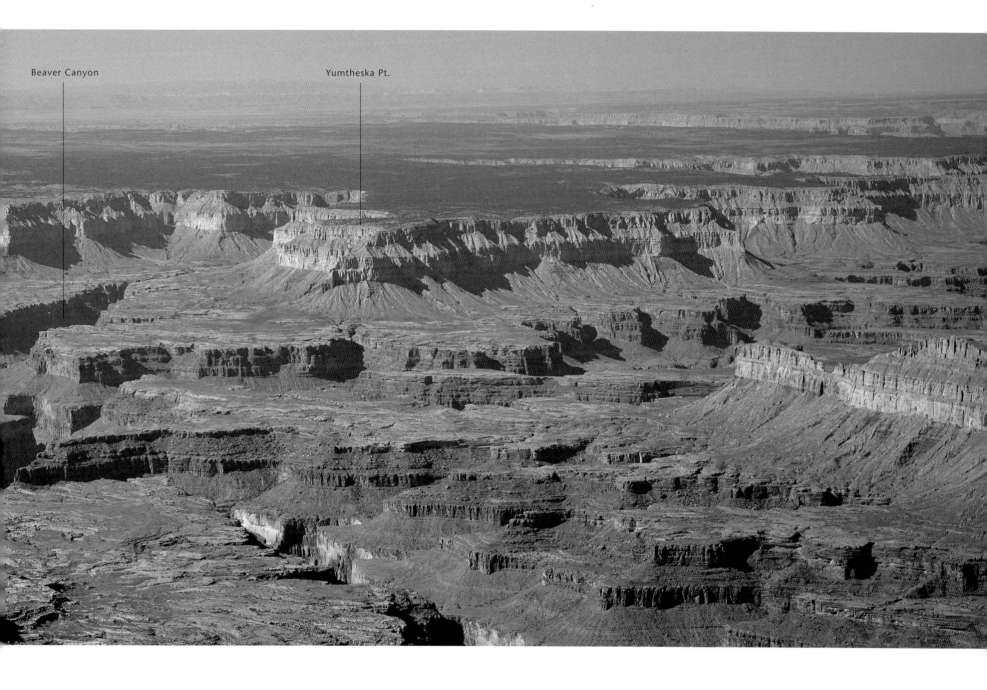
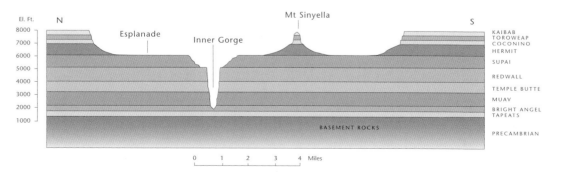

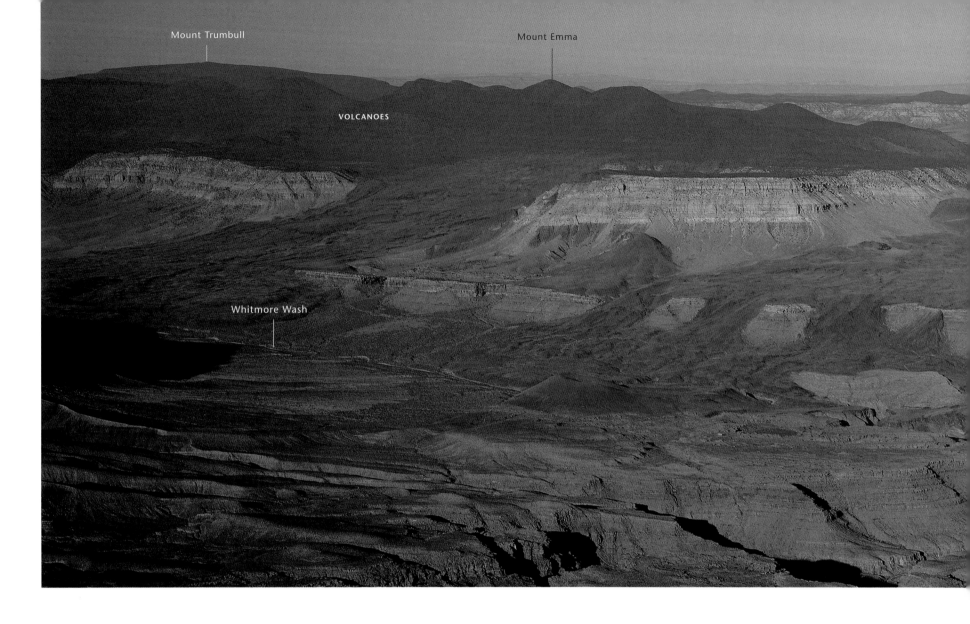

Volcanoes of the North Rim *View northeast*

The "frozen lava falls" that spill over the rim of the Inner Gorge and cascade into the Colorado River 3,000 feet (900 m) below are among the most impressive sights in the entire Grand Canyon. Those who see the area from viewpoints at the mouth of Toroweap Canyon or from a float trip on the Colorado River are justifiably impressed. But they see only a small fraction of this spectacular scene because there is much more to the volcanic features of the Grand Canyon than can be seen from one viewpoint. Lava not only spilled over the rim of the Inner Gorge like a frozen waterfall, but also numerous eruptions occurred high on the Uinkaret Plateau and cascaded over the outer canyon rim.

This view to the northeast is taken from an aircraft flying at an altitude of 9,000 feet (2,750m). Here the black basalt stands out in stark contrast to the red, white, and gray sandstone and limestone cliffs over which they flowed. From this perspective you can begin to grasp the remarkable sequence of events that the Uinkaret volcanic eruptions record.

The most spectacular lava cascades are those that spill over the edge of the Esplanade Platform between Toroweap Valley and Whitmore Wash. Every tributary canyon that dissects the Esplanade Platform was filled with lava. Other flows simply moved across the Esplanade and cascaded over the rim of the inner canyon. At first glance, the cascades may appear to record a single event, but the extrusion of lava actually occurred repeatedly over a period of 630,000

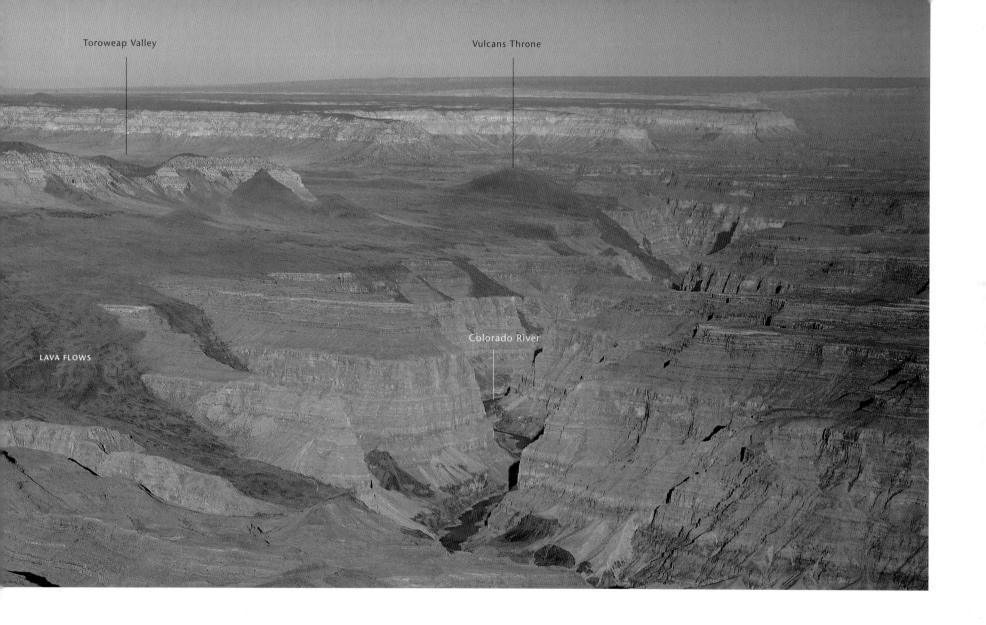

years. In all, more than 150 lava flows poured into the western Grand Canyon and formed a sequence of thirteen major lava dams ranging from 200 to more than 2,000 feet (60 to 600 m) high. The larger lakes impounded behind these dams extended upstream beyond the present location of Lake Powell. Near the river, lower right, are remnants of huge lava dams that impounded the water of the Colorado River to form a series of lakes upstream.

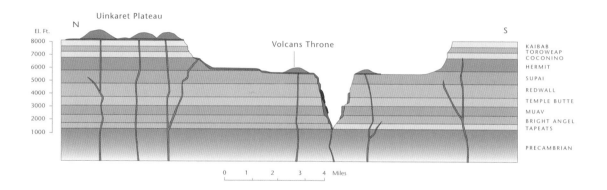

Lava Dams *View upstream at Vulcans Throne*

The lava cascades immediately west of Vulcans Throne, near Toroweap Overlook, are certainly the best known and most frequently visited volcanic phenomena in the Grand Canyon. At first glance, Vulcans Throne appears to rest upon the cascades, marking the vent from which the lava flowed. This is not the case. The lava erupted from fissures high on the Uinkaret Plateau, more than five miles (8 km) to the north, near Mount Emma. The lava spilled over the outer rim of the canyon, flowed down Toroweap Valley for two miles (3 km), and then across the Esplanade Platform, ultimately plunging over the rim of the Inner Gorge just west of Vulcans Throne.

The cascades are about one-quarter mile (0.4 km) wide and fall 2,160 feet (660 m) down the steep walls of the Inner Gorge. They do not reach the Colorado River but terminate abruptly at the top of a vertical cliff formed on older horizontal basalt flows 540 feet (165 m) above river level. They once may have flowed into the river; if so, their original extent has been destroyed by erosion. Did these cascades once form a lava dam? We are not sure. All remnants of lava dams near the river are much older than the cascades, and it is likely that if the cascades formed a barrier across the river it was relatively small and short-lived.

On the Esplanade Platform, the flows that form the cascades are "fresh" and retain most of their original surface features, such as pressure blisters and flow structures. The original margins of the flow are essentially unmodified by weathering and erosion. Therefore, these basalts would be classified as among the youngest in the Uinkaret volcanic field. On the steep slopes of the Inner Gorge, however, these same flow units lost their definition as the lava spilled over the rim and became a "lava fall." What continues to adhere to the cliffs is commonly a chaotic jumble of steeply inclined fragments of the lava flow, lava gutters, and basalt rubble, frozen against the canyon wall. It is apparent from remote viewpoints on the South Rim that the sequence of flows forming the cascades is relatively thick, consisting of at least twelve to fifteen flow units.

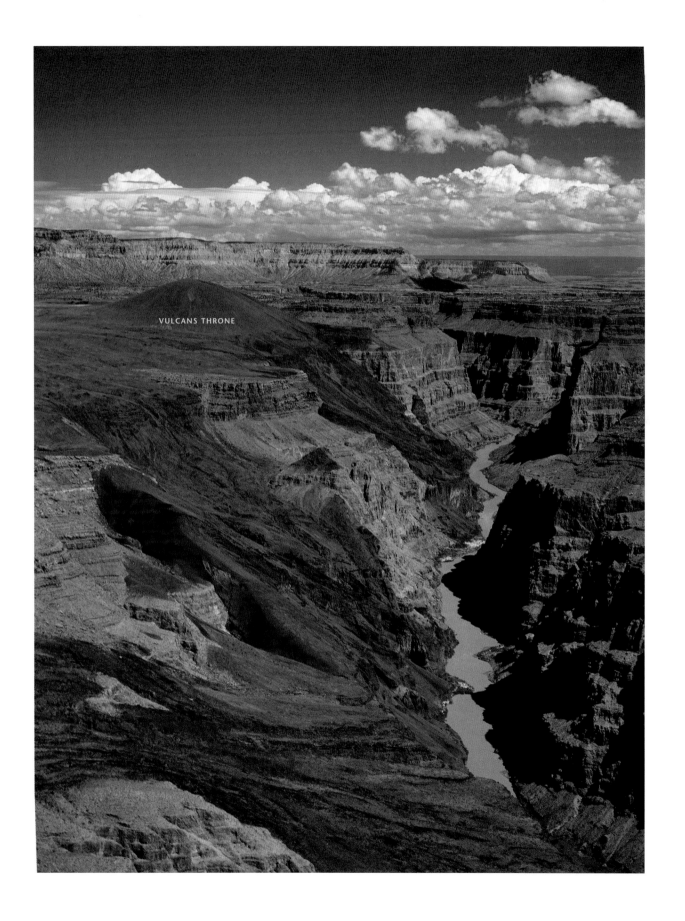

Beneath Vulcans Throne

View upstream

This photograph was taken from a remote point on the south side of the canyon at the mouth of Prospect Canyon, west of Toroweap Valley. This is what you don't see from the river or from Toroweap Overlook. From Prospect Canyon we can clearly see the relationships between several major volcanic features in the Grand Canyon that are not visible from the North Rim. The youngest feature is the lava cascade on the left, just west of Vulcans Throne.

Beneath Vulcans Throne is a series of older lava flows that fill Toroweap Valley to the level of the Esplanade. Erosional debris from these flows partly covers much of the slope beneath Vulcans Throne and could be mistaken for part of the younger cascades. High-level remnants of an older lava dam are preserved against the wall of the Inner Gorge just upstream (right) from beneath Vulcans Throne. Look closely and you will see that this dam consisted of several lava flows, each ranging from 150 to 200 feet (45 to 60 m) in thickness. They are partially preserved as narrow slabs adhering to the canyon wall.

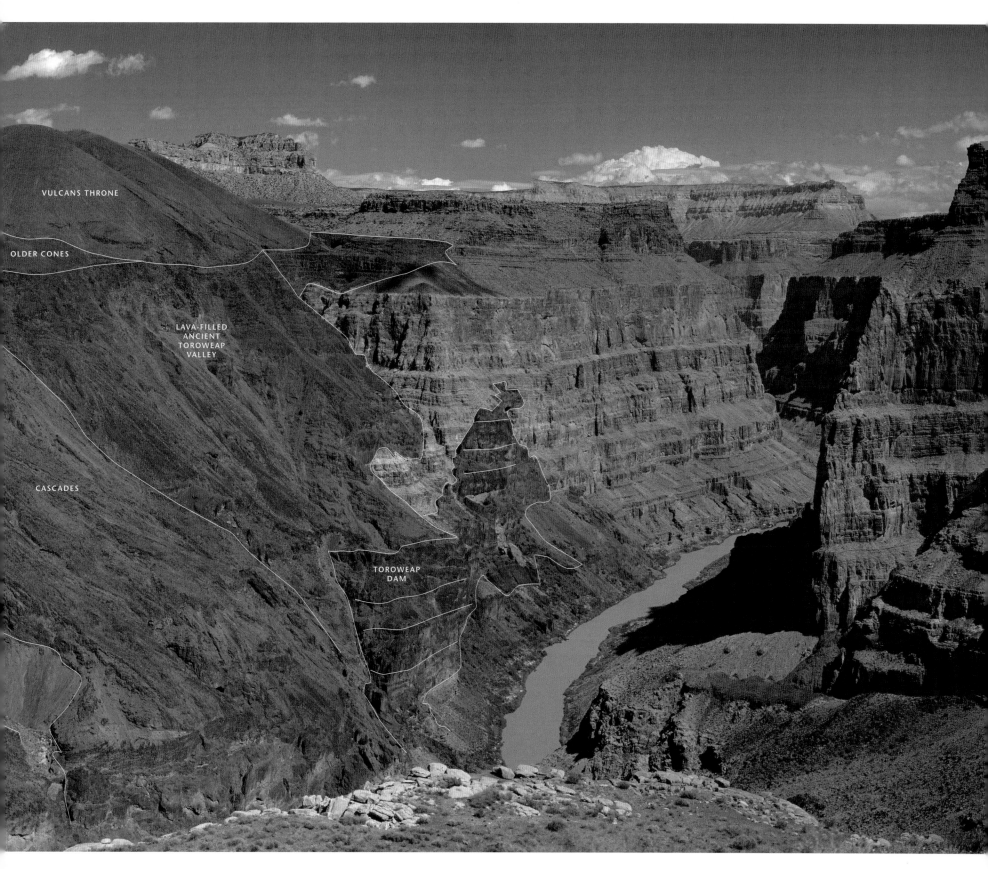

Remnants of Lava Dams

View downstream, river mile 181

From the river we have a completely different perspective of the volcanic activity in the Grand Canyon. The lava flows preserved on the walls of the Inner Gorge may not look as spectacular as the lava cascades seen on the previous pages, but the nearly vertical walls of black basalt flows more than 1,400 feet (430 m) high preserve an astounding record of lava dams that once existed in the Inner Gorge.

Numerous remnants of the dams are preserved on both sides of the canyon between Vulcans Throne and Whitmore Wash. Some are large and form vertical walls; others are smaller, preserved only in alcoves and other protected areas such as the mouths of small tributary streams. The entire wall on the right is covered with basalt—the remnants of at least three large lava dams. Elsewhere, small patches of frozen lava rest on narrow ledges or fill recesses and alcoves giving the canyon wall a spotted appearance.

In this view, remnants of three major dams and several small cascades can be seen. In the background, the massive basalt flow extending from near river level (near the white sandy beach up to the skyline) formed a dam more than 800 feet (250 m) high. Juxtaposed against this flow at the bend in the river is a remnant of a much lower and younger dam consisting of approximately twenty thin flows, all of which have weathered to a tan color. In the foreground to the right is the vestige of still another dam consisting of five massive flows, each is about 150 to 200 feet (50 to 60 m) thick. Resting on top of the entire sequence are the edges of young cascades, which, although they appear to be horizontal from this perspective, incline toward the river.

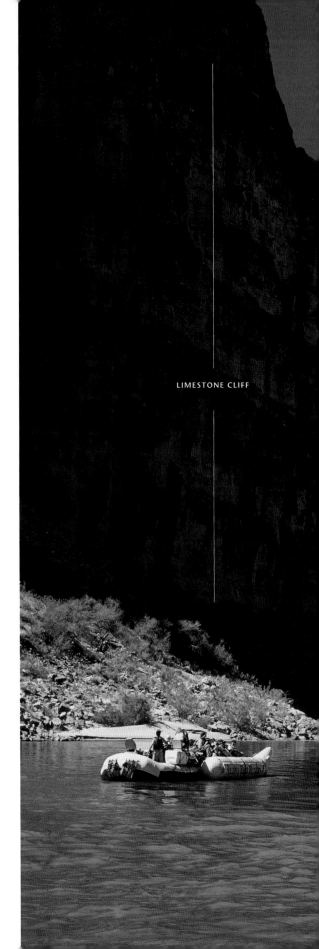

LIMESTONE CLIFF

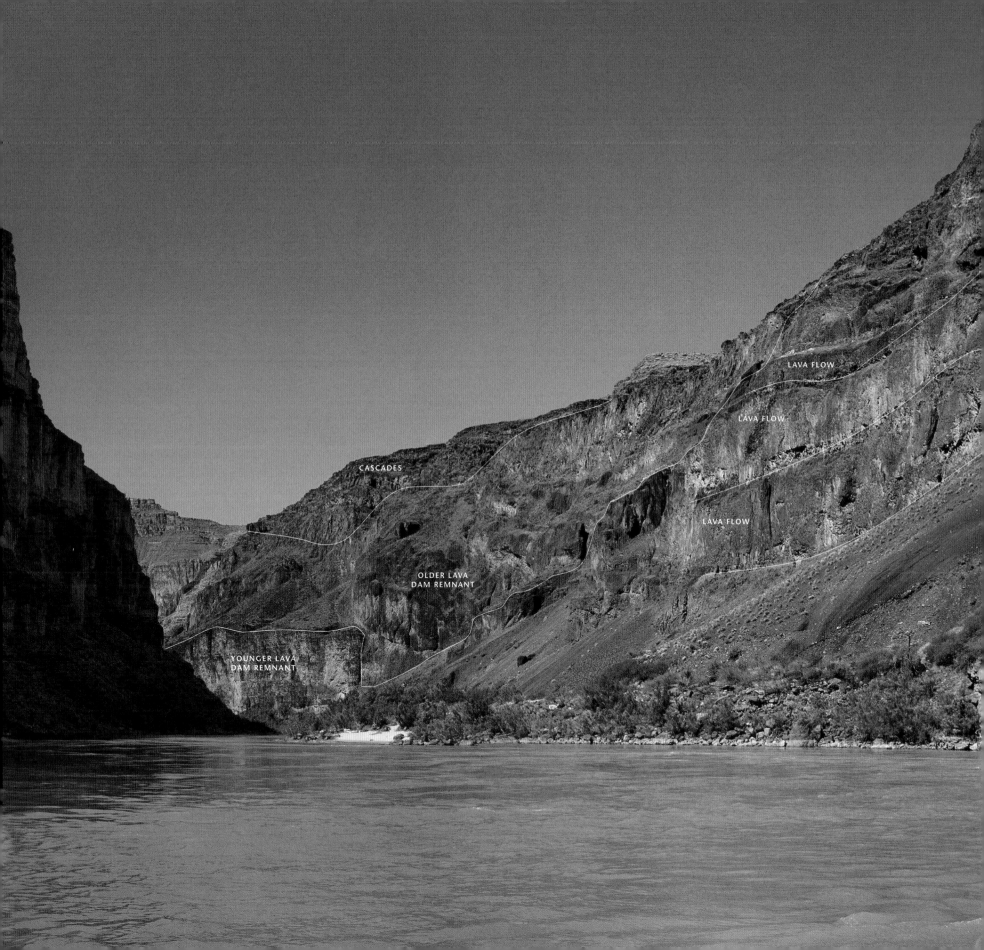

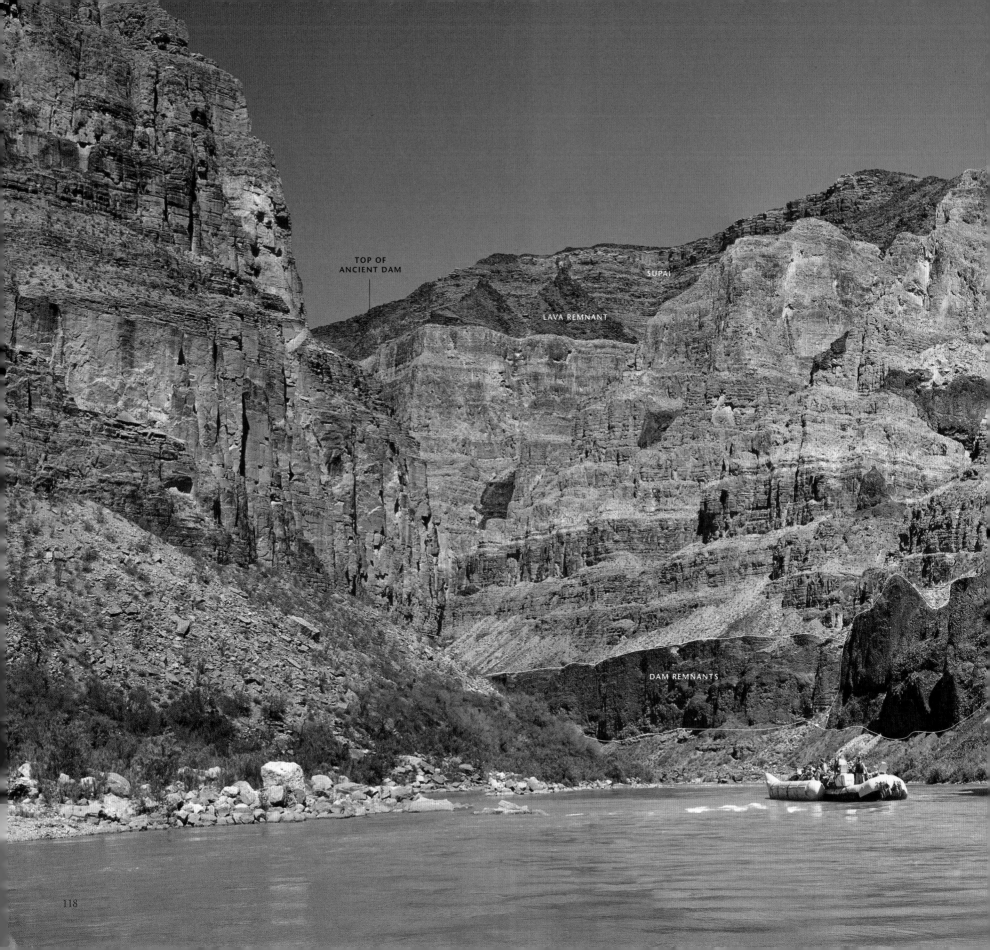

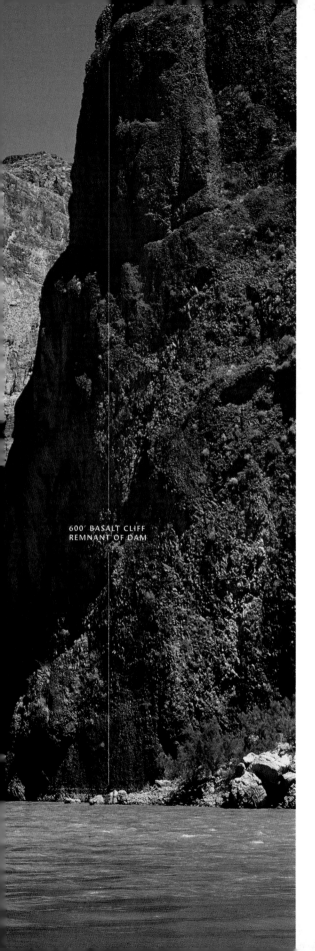

600' BASALT CLIFF REMNANT OF DAM

High-Level Remnants of Lava Dams

Downstream view, mile 184

From this vantage at river mile 184, we can see remnants of at least five lava dams and several small cascades. The basalt forming the vertical black cliff at the right is a remnant of a massive lava dam approximately 600 feet (180 m) high, the base of which extends below river level. Downstream, where the river disappears around the bend, is a long remnant of a younger dam consisting of more than twenty individual flows.

High on the canyon wall are vestiges of still other dams. These are preserved in almost every nook and cranny and appear to have been squeezed into small recesses and galleys in the canyon wall. The tops of these flows are all at approximately the same elevation (930 feet/280 m above river level) indicating a dam nearly 1,000 feet (300 m) high. By comparison, Glen Canyon and Boulder dams are slightly more than 700 feet (200 m) high.

The wall shown at right is covered with basalt. Elsewhere, small patches of frozen lava rest on narrow ledges or fill recesses and alcoves giving the canyon wall a spotted appearance. Remnants of lava are found on both sides of the river, but are more prevalent on the inside bends of the river where slower water velocity has less erosive power.

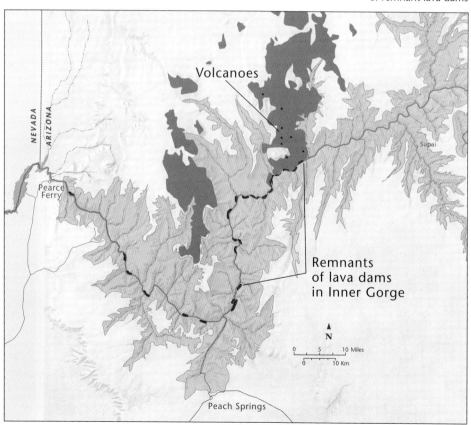

Map showing the extent of remnant lava dams

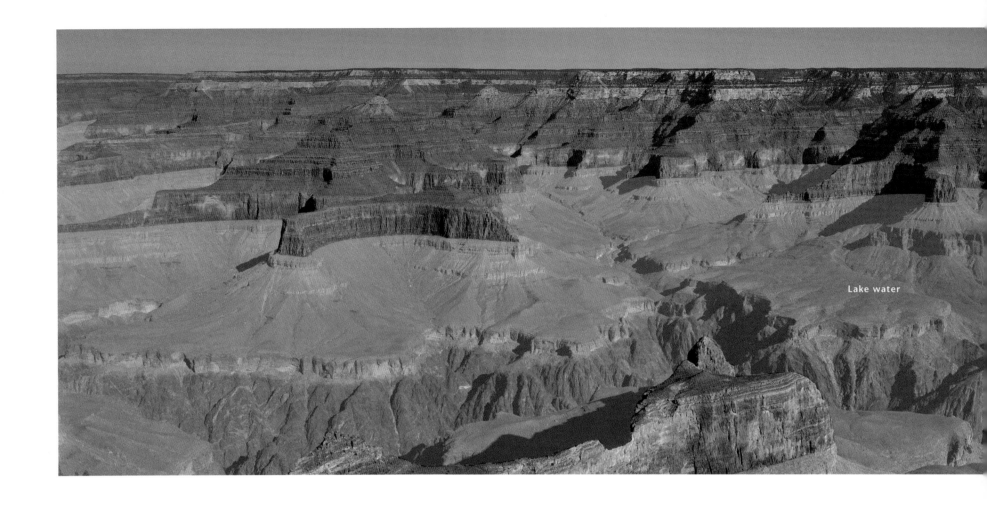

Ancient Lakes in Grand Canyon

Lava dams, and the lakes that formed behind them, had a profound effect upon the entire Grand Canyon. Some of the dams were more than 2,000 feet (610 m) long. The highest dams formed lakes that extended all the way through the canyon and beyond today's Lake Powell. Imagine a lake in the Grand Canyon with the shoreline near the base of the Redwall cliff. It might have been similar to the reconstruction shown here. Then try to visualize the lake filled with sediment and the Colorado River meandering across the top of mudflats more than five miles (8 km) wide. (For a view of what the canyon might have looked like when partially filled with silt, see Havasu Canyon on the next page.)

The lava dams in the Grand Canyon were unlike the man-made dams constructed today. They were not a local barrier like Boulder Dam or Glen Canyon Dam. Most were higher and much, much longer. They were asymmetrical structures that extended downstream for an average of twenty miles (32 km). One extended from the Toroweap Valley area to Lake Mead, a distance of more than eighty miles (129 km).

The lakes that formed behind the dams were long, narrow, and deep but they existed for only a moment in geologic time. They interrupted the flow of the Colorado River, filled to capacity with water within a few years, and overflowed the dam. They could have been completely filled with silt if the dams held for a few hundred years. The overflow soon eroded the lava dam leaving only vestiges of basalt clinging to the canyon walls, and small remnants of lake sediments preserved in a few scattered recesses of the canyon upstream. Although the dams and lakes lasted only a brief moment in geologic time they were the most significant event in the recent geologic history of the canyon.

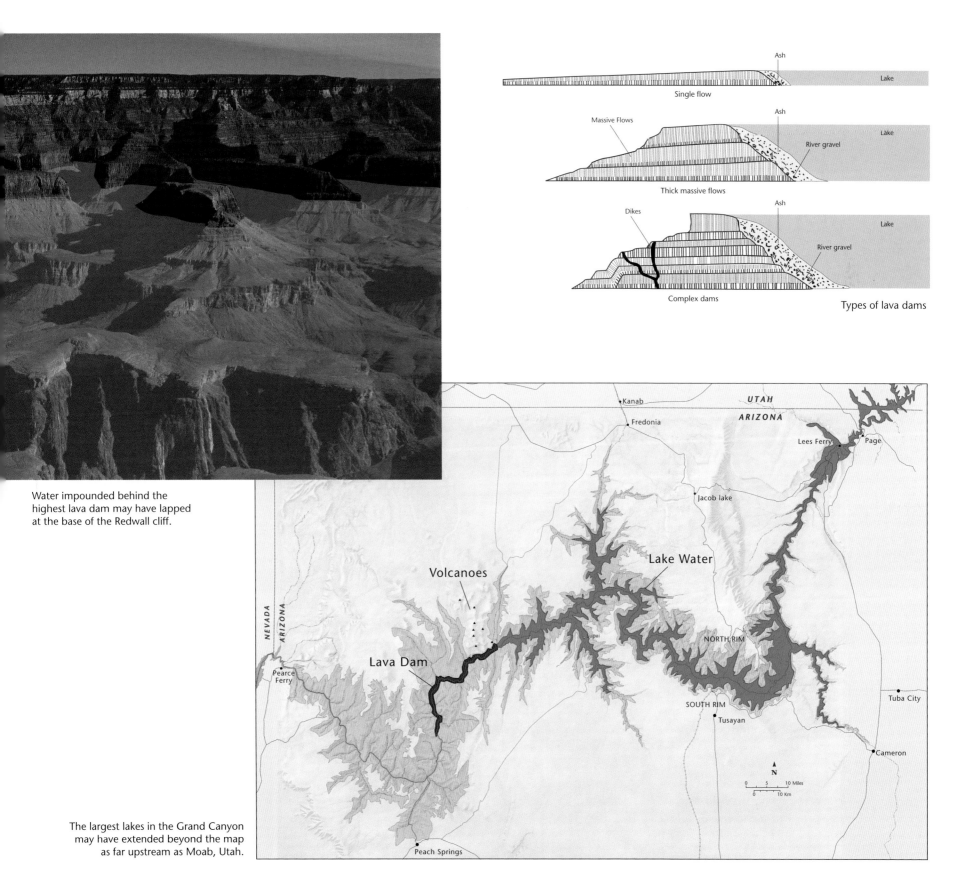

Types of lava dams

Water impounded behind the highest lava dam may have lapped at the base of the Redwall cliff.

The largest lakes in the Grand Canyon may have extended beyond the map as far upstream as Moab, Utah.

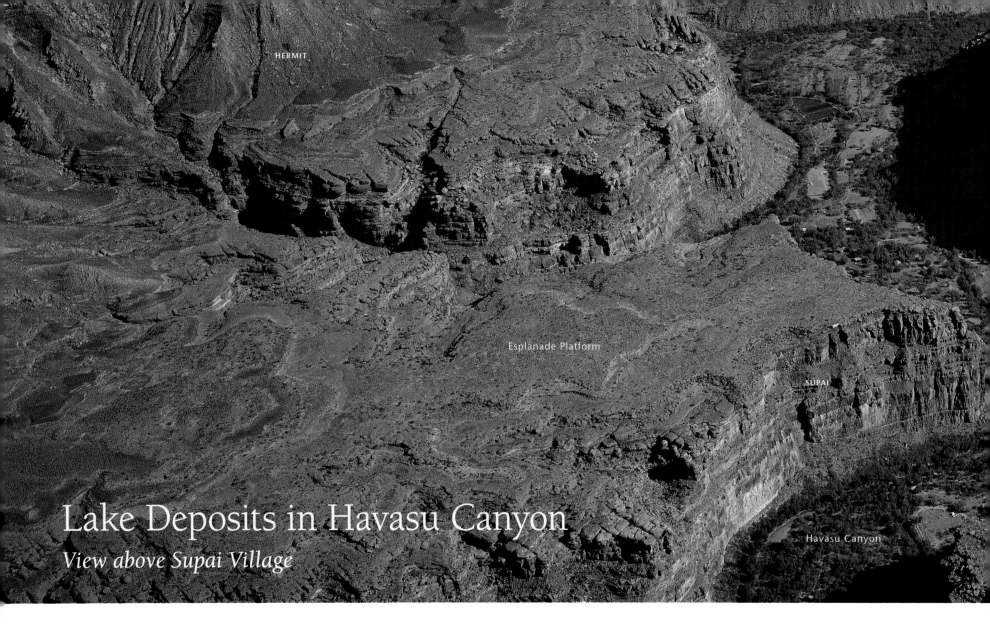

Lake Deposits in Havasu Canyon
View above Supai Village

The lakes that formed behind lava dams in the Grand Canyon were temporary lakes in a deep canyon, similar in every respect to present-day reservoirs impounded behind man-made dams. Indeed, Lake Mead and Lake Powell could be considered modern models of the ancient lakes that formed in the canyon behind lava dams.

Soft and saturated with water, sediments that accumulated in these lakes were easily flushed out of the canyon in the event of catastrophic dam collapse. Only a few remnants of lake deposits remain. Most are small and may be mistaken for river deposits that temporarily filled the canyon but were largely removed by subsequent erosion.

The silt deposits in Havasu Canyon, however, are different. Resulting from not one, but several dams, they are up to 1,500 feet (450 m) deep and are preserved throughout the lower ten-mile (16-km) stretch of the canyon from Havasu Springs to the Colorado River. They form a nearly flat surface at an elevation of 3,145 feet (950 m), which correlates with the height of dam remnants preserved at the mouth of Toroweap Canyon. The series of downstream terraces also correlate with lower lava dams in the Toroweap-Whitmore areas.

Where the sediment is undisturbed, it is well stratified and is identical to the silts of lakes Mead and Powell, forming a unique surface within the Grand Canyon: a flat surface formed on rich soil, which permits the agricultural practices of the Havasupai people.

Why are such deposits preserved only in Havasu Canyon and not in other major tributary valleys such as Bright Angel and Kanab creeks? The answer may be found in the fact that the waters of Havasu Creek are charged with calcium bicarbonate in concentrations sufficient to deposit large quantities of travertine. Since the lake sediment accumulated, Havasu Creek has been depositing almost as much

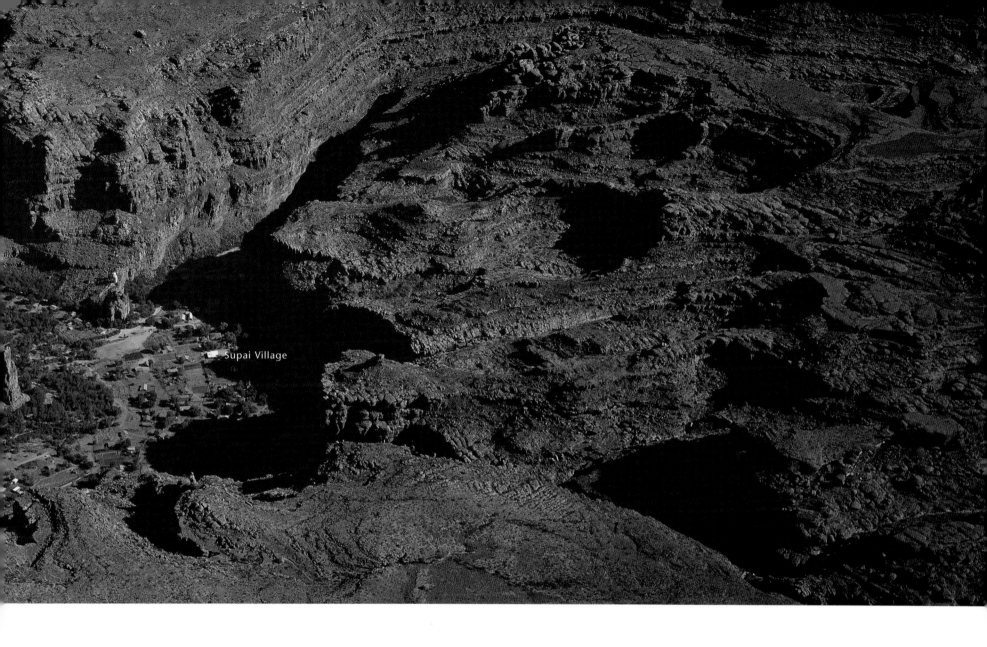

travertine as it has been carrying away. Sheets of travertine form "curtains" protecting the face of the escarpments that formed on old lake terraces. In many cases, the lip of the waterfalls has actually grown outward ten to fifteen feet (3 to 5 m) beyond adjacent cliff faces. These extensive travertine deposits have armored the soft lake deposits and fostered their preservation.

Although evidence seems overwhelming that the sediments in Havasu Canyon are lake deposits, some geologists believe that they are normal stream deposits.

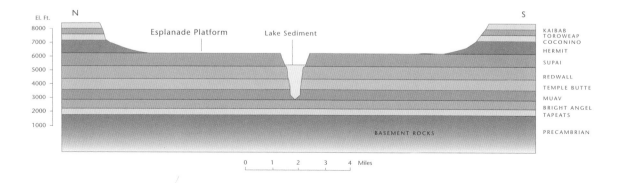

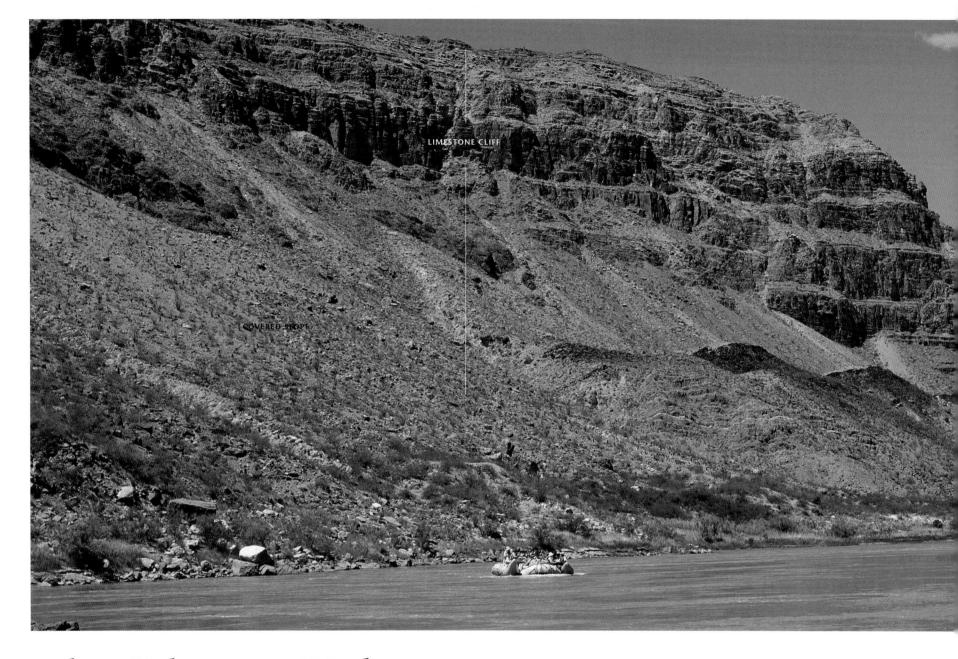

Below Whitmore Wash *View upstream, river mile 188*

Many of the lava dams that formed from volcanic eruptions in the area between Toroweap Valley and Whitmore Wash extended many miles downstream. Numerous remnants of these dams are preserved in protected areas of the canyon such as the inside of meander bends. In this photograph remnants of two different types of lava dams are preserved. The older and highest remnant consists of numerous thin flows, the top of which form a well-defined terrace high on the canyon wall just above the bend of the river. This dam, built from lava flowing down Whitmore Wash and then into the Colorado River, was 886 feet (270 m) high and more than twenty miles (32 km) long.

Near river level, on the right, is a younger dam remnant formed by a thick lava flow capped by coarse gravel and large, angular blocks of rock, some larger than a pick-up truck. This unusual deposit of huge boulders is believed to be an outburst flood

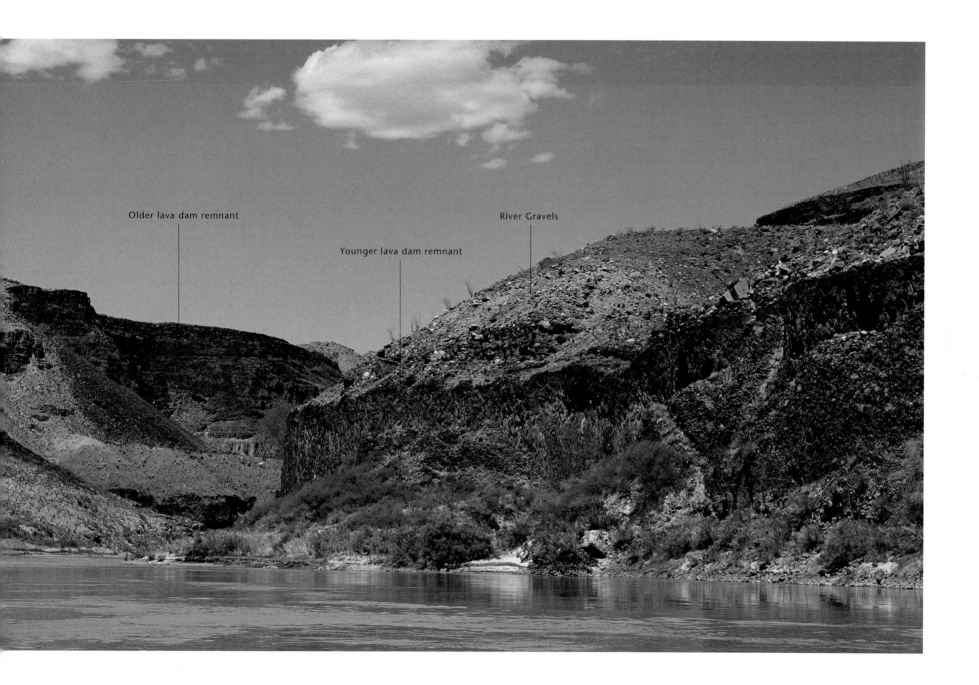

deposit—the result of a lava dam's sudden failure in which great volumes of water rushed down the canyon carrying sediment and debris.

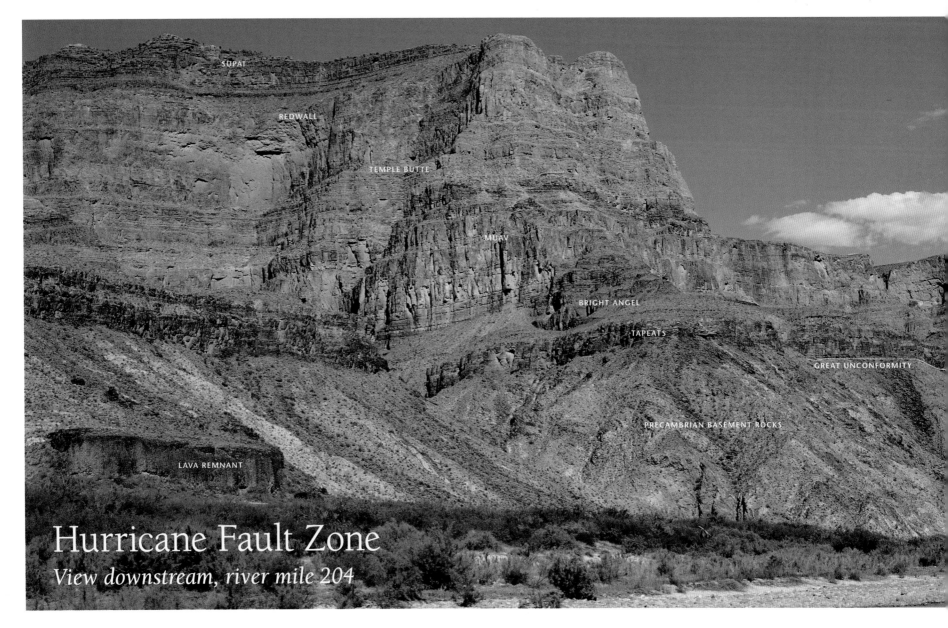

Hurricane Fault Zone
View downstream, river mile 204

At river mile 198.5 the river makes a ninety-degree turn and flows due south for approximately twenty-five miles (40 km). In essence it follows the Hurricane fault zone that is located a short distance east of the river. The Hurricane fault has a displacement of as much as 1,500 feet (450 m) so that on the up-thrown block on the east side of the river a large section of Precambrian granite is exposed. Like the Granite Gorge upstream, this stretch, called the Lower Granite Gorge, is a complex of metamorphic rocks and granite that provides us with a glimpse of events early in the history of our planet. It extends for a distance of about forty miles (64 km), from roughly ten miles (16 km) below Whitmore Wash. The original rocks in this sequence included both sedimentary and volcanic material derived from an ancient volcanic island arc.

Metamorphism occurred when the converging tectonic plates collided, formed a mountain belt, and depressed the rock sequence to a depth of nearly twelve miles (19 km). Resulting friction raised the temperature to 1,200° F (650° C). The granites were formed 1.77 billion years ago by partial melting at converging plate margins. The high mountain belt produced by this tectonic event was then eroded down to a surface of low relief. Erosion of the mountain belt removed a total thickness of approximately thirteen miles (21 km) of rock between 1.35 and 1.25 billion years ago.

This view of the Lower Granite Gorge is taken at Granite Park looking downstream. The cliff of Tapeats Sandstone forms a horizontal layer above the weathered granite and a narrow Tonto Platform is developed on the overlying Bright Angel Shale. The thick limestone formations (Muav, Temple Butte, and Redwall) above the Bright Angel appear to merge

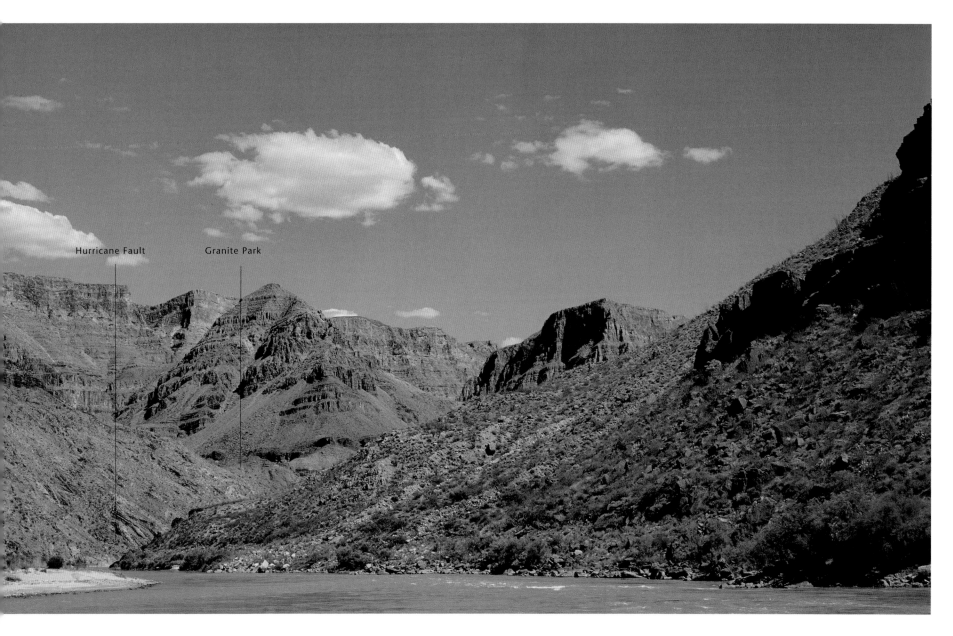

into a single high cliff that rises 4,000 feet (1,220 m) above the river. What appears to be the canyon rim is actually the rim of the Esplanade Platform. Beyond the Esplanade the actual canyon rim is 2,000 feet (610 m) higher. Here, the vertical distance from rim to river is greater than at any other point in the canyon.

The broad Esplanade Platform in this area is about thirteen miles (21 km) wide. The Hurricane fault system trends parallel to the river and has numerous branches resulting in a canyon profile that lacks the symmetry and simplicity seen in other areas.

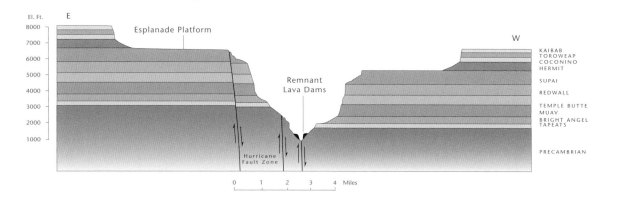

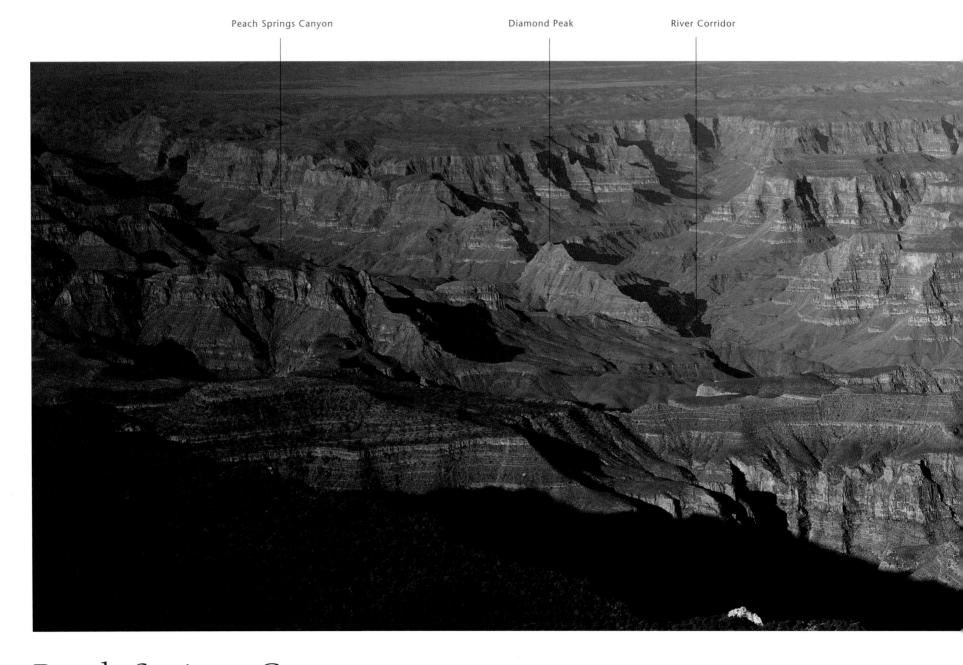

Peach Springs Canyon *View west*

After flowing due south, parallel to the Hurricane fault, for twenty miles (32 km), the Colorado River abruptly turns ninety degrees and flows toward the northwest. This view looks west from near the mouth of Peach Springs Canyon where it meets the Colorado River on the far side of Diamond Peak and extends southward in a straight line.

Although not as scenic as the canyon is to the east, this view shows the western Grand Canyon's distinctive anatomy. What appears to be the rim of the canyon on the Kaibab Formation is actually the edge of the Esplanade Platform. Note that the Esplanade Platform is not a stripped surface on top of a thick sandstone bed, but rather is an erosional surface that cuts across the lower strata of the Supai, Redwall, and even older formations. Above the Granite Gorge an incipient Tonto Platform is developed. In this area the outer rim of Kaibab and Toroweap rocks does

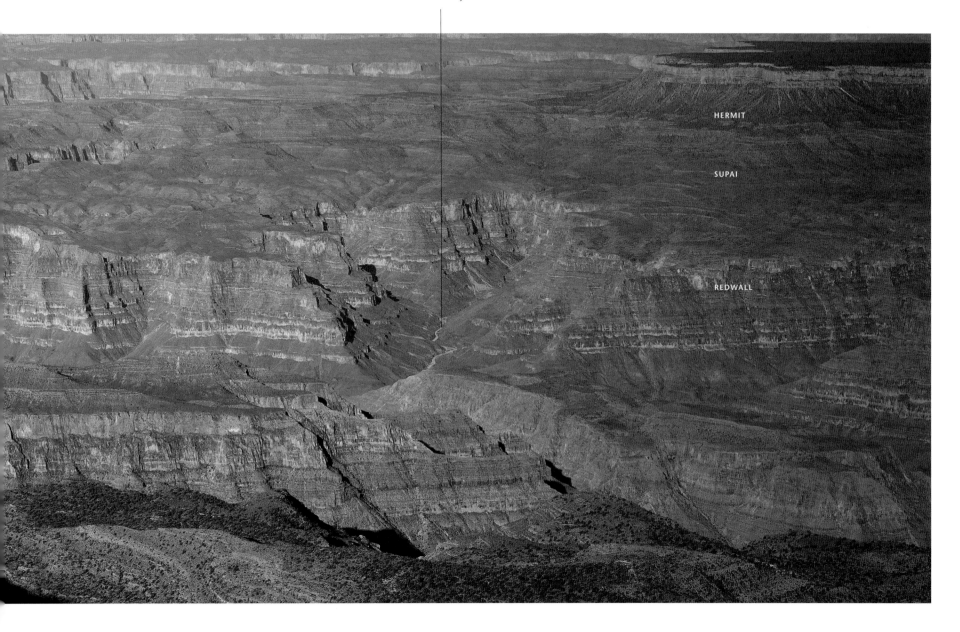

not exist on the south side of the river as it does elsewhere because every formation above the Supai has eroded away.

Much of the red color that contributes so much to the canyon scenery to the east is muted here in the west and is replaced with the tan and greenish-gray color of the Redwall, Temple Butte, and Muav layers. The thick Hermit Shale has eroded back to form a wide platform atop the Supai Group, so that the underlying Redwall Limestone lacks the typical red surface stain so common in the east. Below the Redwall, the Temple Butte and Muav are much thicker than they are to the east, resulting in large rock sequences that are smoky gray in color.

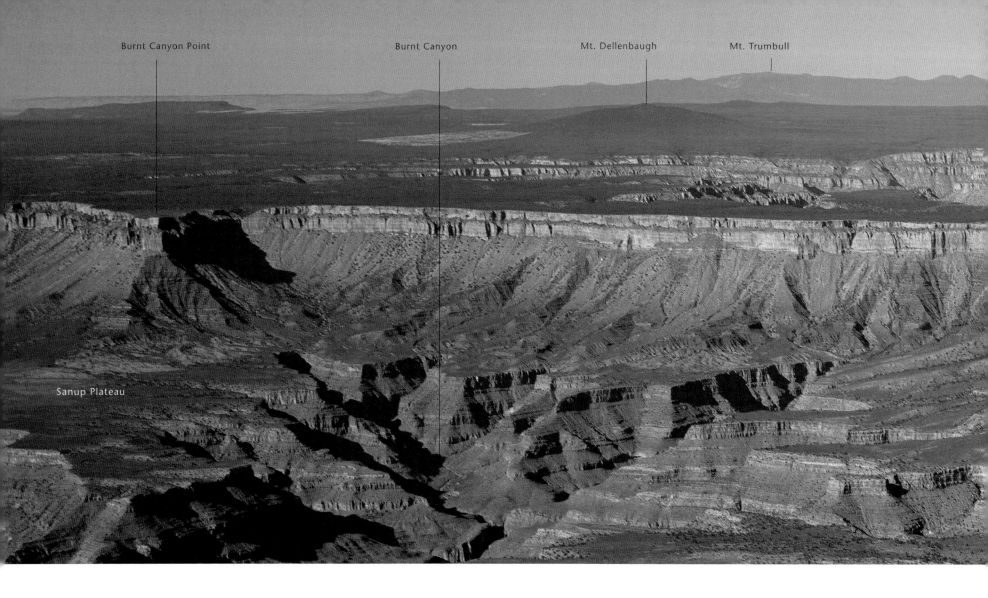

Shivwits Plateau *View northeast*

The Shivwits Plateau is located between the Hurricane and Grand Wash faults on the north side of the canyon. It is distinctive in that older (6 million years old or more) lava flows cap a number of isolated mesas and buttes. This view from a small aircraft looks toward the northeast. Lava caps much of the plateau but does not extend to the canyon rim in the foreground. Mounts Dellenbaugh and Trumbull, and the volcanic field of the Uinkaret Plateau, can be seen on the central skyline. From a geologic standpoint the most significant feature shown in this photograph is the thick red layer of the Hermit Formation. In the Grand Canyon Village area, 100 miles (160 km) to the east, the Hermit is only 200 to 250 feet (60 to 75 m) thick, but here more than 900 feet (275 m) of Hermit Formation is exposed. This great thickness has played an important role in the development of the Esplanade Platform, known as the Sanup Plateau in this portion of the canyon.

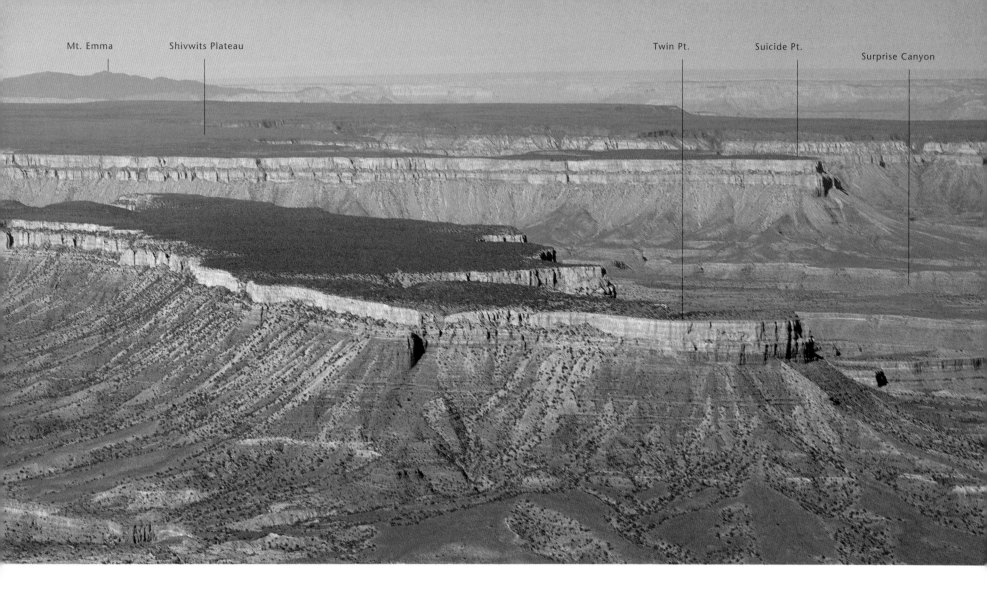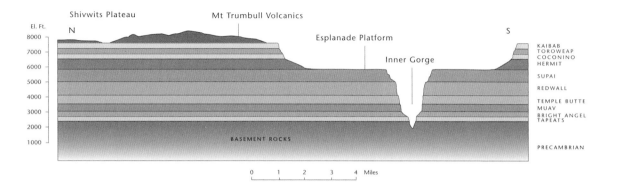

Sanup Plateau
View northeast

The Sanup Plateau, on the north side of the river in western Grand Canyon, is a distinctive part of the Esplanade Platform. It is exceptionally wide and flat, and is covered with vegetation that obscures much of the color of the Supai rocks that make the Esplanade so striking farther east. Perhaps the most remarkable feature in this part of the canyon is the exceptional thickness of the lower Paleozoic rocks that form a steep cliff below the plateau. The canyon profile here is quite different from that in other parts of the canyon. We see no prominent cliff-and-slope landforms, no striking variations in rock type and color, and no isolated buttes and mesas. All of the formations below the Sanup Plateau form a rugged, steep cliff with only subtle slopes separating them from one another. Even the rocks that form the outer rim of the canyon (which can be seen in the background) appear to be subdued and indistinct from one another. It seems that the western Grand Canyon is a different canyon altogether, with a distinctive beauty and character of its own.

This panorama does not show the broad Esplanade Platform south of the Colorado River gorge. But in this area the Supai rocks have been stripped away by erosion, leaving the beveled edges of the Redwall Limestone to form the upper surface of the Esplanade here. In some places this terrace is fifteen miles (24 km) wide.

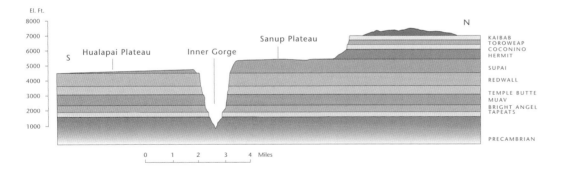

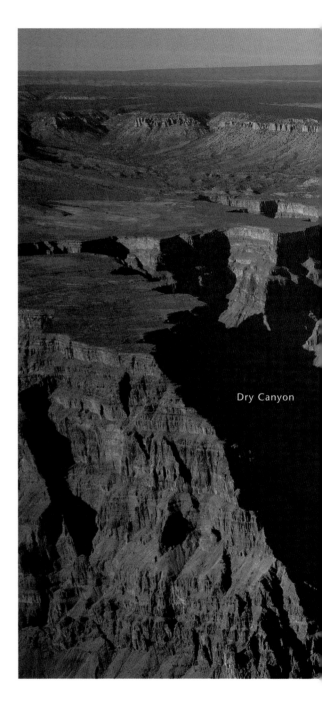

Dry Canyon

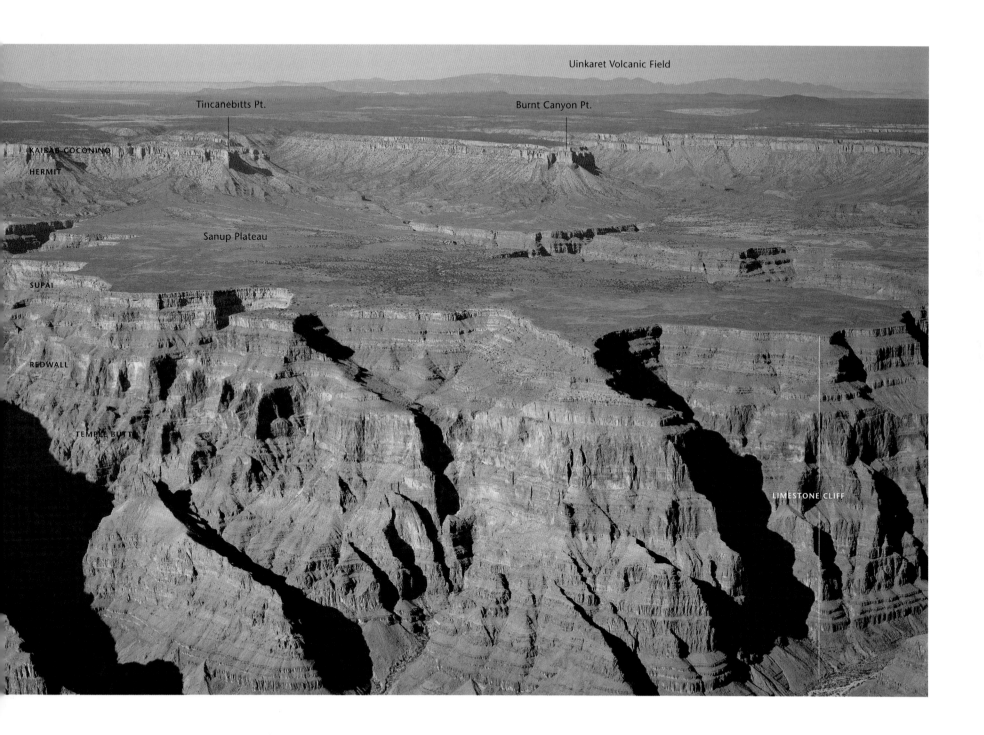

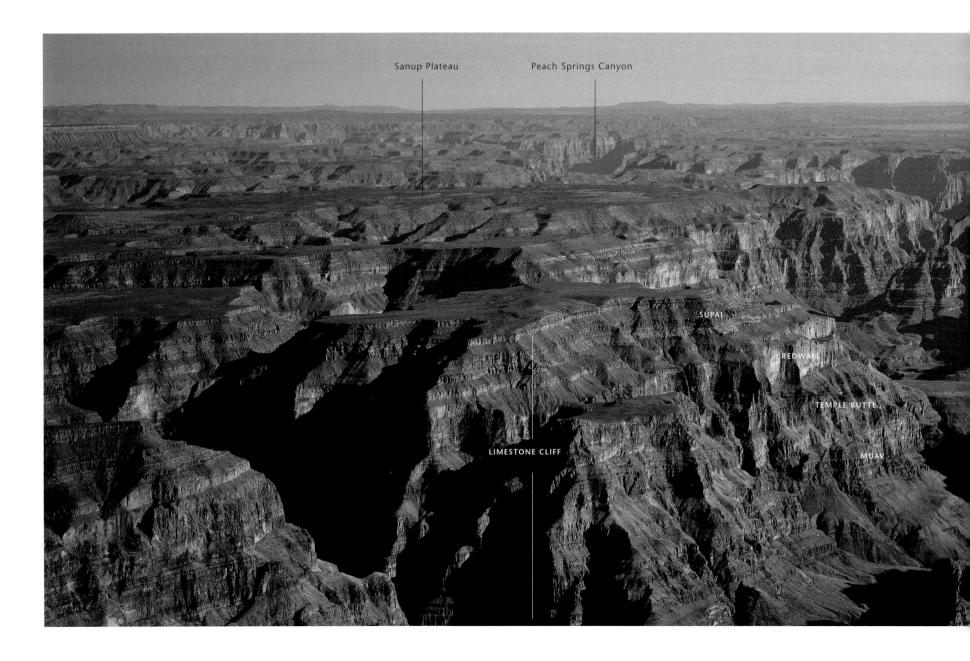

Grand Canyon West *View east*

The western end of the Grand Canyon is extremely rugged and largely inaccessible. Only a select few have had the opportunity to see it. Most of the area south of the river is on the Hualapai Indian Reservation where the tribe has developed an air strip, paved roads, and provided unique observation points that provide access for visitors.

Note that in this image the Colorado River extends across the central part of the panorama but is largely hidden by high spurs. As you can see, the Hualapai Plateau is characterized by numerous long tributary canyons that dissect the landscape into a bewildering complex of deep canyons separated by long narrow ridges. In addition, the walls of the Inner Gorge are bold and imposing, forming a single high, nearly vertical cliff instead of the stair-step topography so typical in central Grand Canyon.

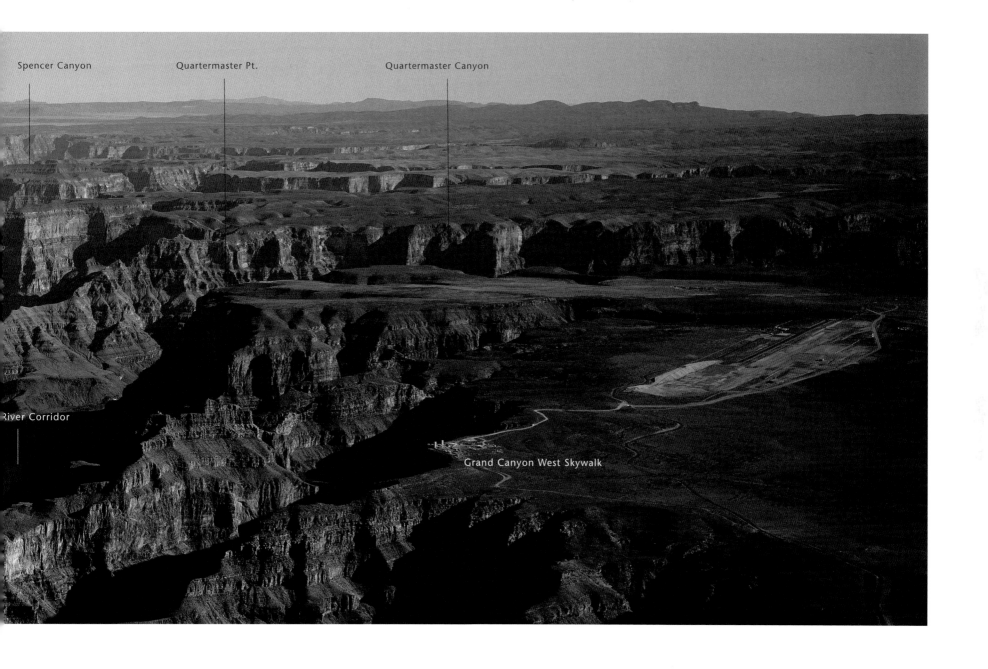
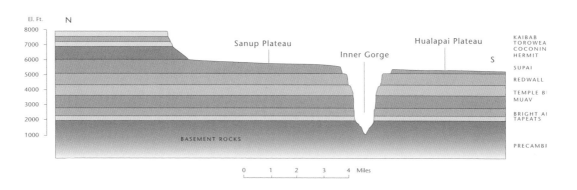

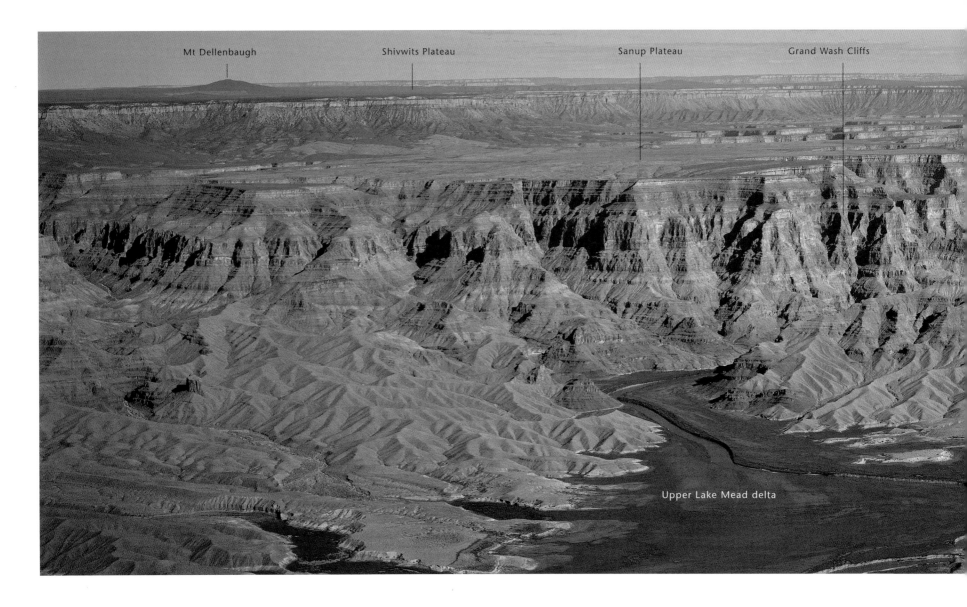

Grand Wash Cliffs *View south*

In this scene, looking upstream, the Grand Wash Cliffs are perpendicular to the river. The delta area of upper Lake Mead can be seen in the lower part of the photograph just left of center, now largely covered with vegetation. The Sanup Plateau comprises the broad, flat surfaces in the center of the panorama, beyond which are the Shivwits Plateau and the volcanic region of Mount Dellenbaugh.

The end of the Grand Canyon is as different from the beginning as death is from birth. The canyon begins as a small notch incised on the Marble Platform and gradually grows to a depth of more than 5,000 feet (1,500 m) as it blossoms into the mature Grand Canyon, then ends abruptly at the Grand Wash Cliffs. Here the canyon is as much as 6,000 feet (1,800 m) deep and is carved into a complex landscape formed on rock sequences that are thicker here than they are in the east. The spectacular cliff-and-slope topography of myriad colors is replaced by the single cliff of thick gray limestones, capped by a wide terrace.

The end of the canyon occurs at the Grand Wash Cliffs, the coup de grace of the Grand Wash fault's 16,000-foot (4,900 m) displacement. West of the Grand Wash Cliffs the Grand Canyon ceases to exist. It is replaced by rolling hills carved out of sediments deposited upon the downthrown block of the Grand Wash fault.

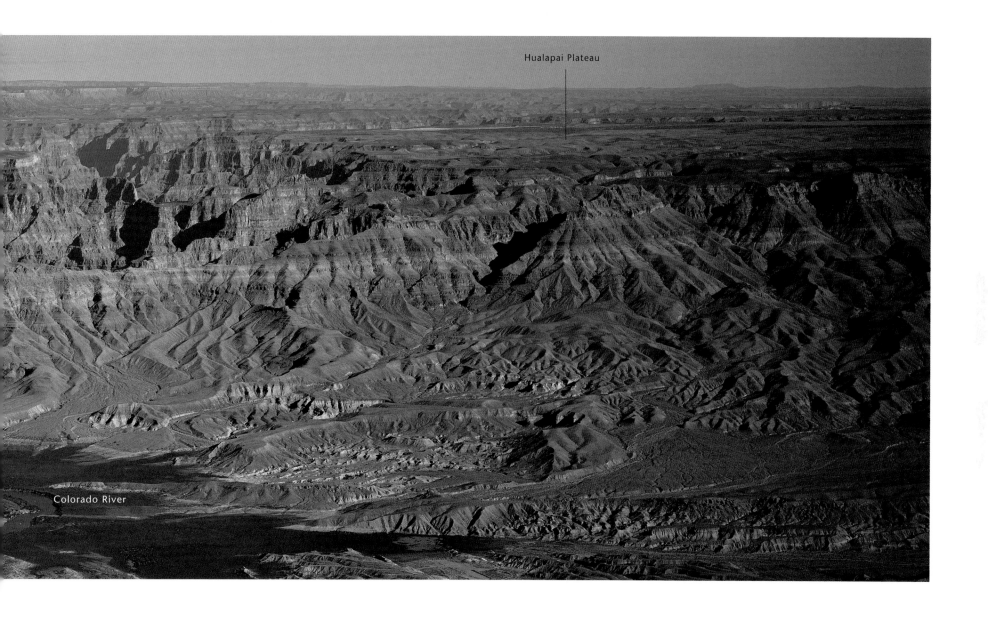
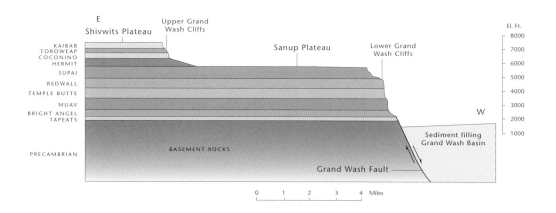

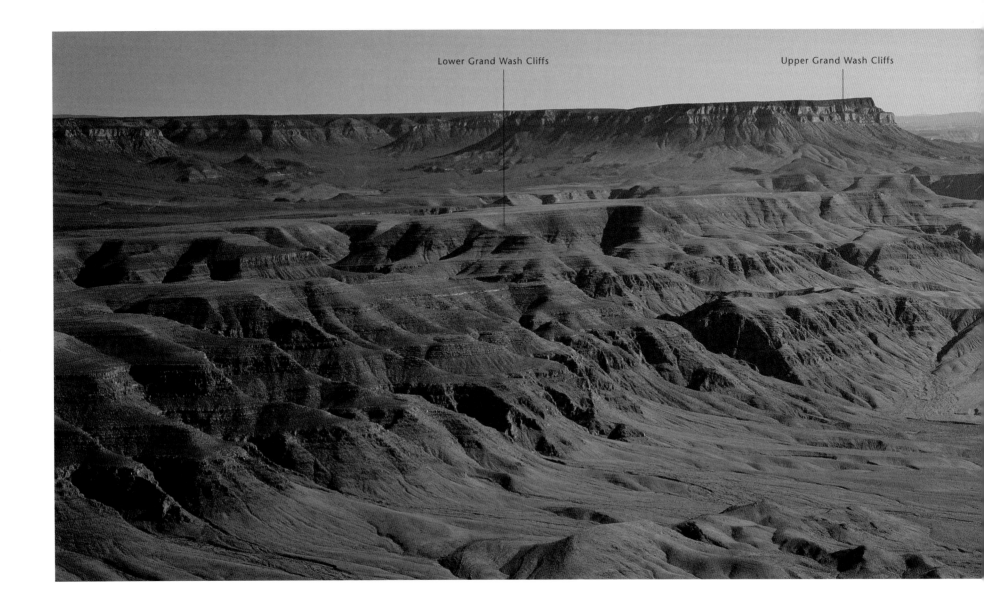

End of the Grand Canyon *View east*

The profile of the Grand Wash Cliffs is similar to that of the north wall of the Grand Canyon. Two major cliffs form the Grand Wash escarpment. The lower cliffs are formed by lower Paleozoic rocks extending from the Tapeats upward to the top of the Supai. On the north side of the river the Kaibab Formation caps the high Shivwits Plateau.

This view looks south from a point approximately ten miles (16 km) north of the river. Great thicknesses of sediment (possibly as much as 12,000 feet/3,700 m) derived largely from highlands to the west, lap upon the base of the Grand Wash Cliffs and are eroded into rolling hills.

Those who have experienced a float trip through the Grand Canyon to its conclusion know a little bit about the feelings expressed by John Wesley Powell below. For days you are hemmed within the confines of a deep, narrow canyon; then, suddenly, you are out in the open, free from the confines of the canyon's walls.

Grand Wash

To night [sic] we camp on the left bank, in a mesquite thicket. The relief from danger, and the joy of success, are great. When he who has been chained by wounds to a hospital cot, until his canvas tent seems like a dungeon cell . . . at last goes out into the open field, what a world he sees! How beautiful the sky; how bright the sunshine; what "floods of delirious music" pour from the throats of birds; how sweet the fragrance of earth and tree and blossom! The first hour of convalescent freedom seems rich recompense for all—pain, gloom, terror.

Something like this are the feelings we experience to night. Ever before us has been an unknown danger, heavier than immediate peril. Every waking hour passed in the Grand Cañon has been one of toil. . . .

The river rolls by us in silent majesty; the quiet of the camp is sweet; our joy is almost ecstasy. We sit till long after midnight, talking of the Grand Cañon, talking of home.

— J. W. Powell

Acknowledgments

I have benefited greatly from the numerous discussions with colleagues and students over the years. They are too numerous to mention individually but they know who they are and to them I extend my sincere gratitude. Stan Buess, Carl Bowman, Dick Young, George Billingsley, Tom Pittenger, Judy Bryan, Ellen Seeley, and Jim Heywood reviewed the manuscript and offered many helpful suggestions which I sincerely appreciate. I also extend my thanks to Bronze Black who worked so diligently on the art, design, and production of the book. Special thanks are due to Pam Frazier who worked closely with me throughout the development and editing phases and went far beyond the call of duty to make this book a success.

I am also grateful to my wife, Sally, who not only worked closely with me in editing and developing this book, but also in many others throughout the years. She had to stay at home tending the kids and running the house while I was out in the field doing geology. Without her support and encouragement I would never have been able to complete any of my projects.

Suggested Reading

Abbott, Lon, and Terri Cook. 2004. *Hiking the Grand Canyon's Geology.* Seattle: The Mountaineers Books.

Beus, Stanley S., and Michael Morales. 2003. *Grand Canyon Geology.* New York: Oxford University Press.

Duffield, Wendell, and Michael Collier. 1997. *Volcanoes of Northern Arizona: Sleeping Giants of the Grand Canyon Region.* Grand Canyon: Grand Canyon Association.

Hamblin, W. Kenneth. 2004. *Beyond the Visible Landscape: Aerial Panoramas of Utah's Geology.* Provo: Brigham Young University Geology Department.

Powell, James Lawrence. 2005. *Grand Canyon: Solving Earth's Grandest Puzzle.* New York: Pearson Education, Inc.

Price, L. Greer. 1999. *An Introduction to Grand Canyon Geology.* Grand Canyon: Grand Canyon Association.

Ranney, Wayne. 2005. *Carving Grand Canyon: Evidence, Theories, and Mystery.* Grand Canyon: Grand Canyon Association.

Sadler, Christa. 2005. *Life in Stone: Fossils of the Colorado Plateau.* Grand Canyon: Grand Canyon Association.

About the Author

Dr. Hamblin began studying the geology of the Grand Canyon in 1957 and has published numerous articles and books related to his research. His major interest has been the volcanic history and lava dams in the canyon's western region.

Dr. Hamblin earned his Ph.D. at the University of Michigan. Throughout his distinguished career Dr. Hamblin has taught at the University of Kansas, the University of Georgia, and Brigham Young University. In addition to his teaching and research in the Grand Canyon, he has participated in geologic studies of the Alps, Siberia, the Canadian Arctic, and the Great Rift Valley of East Africa. He has also been a guest lecturer in France, Switzerland, and South Africa.

Glossary

bar An offshore, submerged, elongate ridge of sand or gravel built on the sea floor by waves and currents.

barbed drainage A drainage system in which the tributary streams flows in the opposite direction to the main stream and then reverses its direction just as it joins the main stream. The pattern resembles a barb of fishhook.

basalt A dark-colored, fine-grained, mafic volcanic rock composed of plagioclase (over 50%) and pyroxene. Olivine may or may not be present.

basement complex A series of igneous and metamorphic rocks lying beneath the oldest stratified rocks of a region. In shields, the basement complex is exposed over large areas.

Basin and Range Province A section in the western United States characterized by north-south trending block mountains and adjacent sedimentary basins.

bed A layer of sediment 1 cm or more in thickness.

bedrock The continuous solid rock that underlies the regolith everywhere and is exposed locally at the surface. An exposure of bedrock is called an outcrop.

butte A somewhat isolated hill, usually capped with a resistant layer of rock and bordered by talus. A butte is an erosional remnant of a formerly more extensive slope.

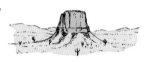

calcareous Rock containing a large concentration of calcium carbonate.

Cenozoic The era of geologic time from the end of the Mesozoic (65 million years ago) to the present.

Colorado Plateau A geologic province centered at the Four-Corners area of the western United States, which is characterized by horizontal layering of red Mesozoic strata.

columnar jointing A system of fractures that splits a rock body into long prisms or columns. It is characteristic of lava flows and shallow intrusive igneous flows.

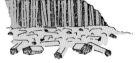

conglomerate A coarse-grained sedimentary rock composed of rounded fragments of pebbles, cobbles, or boulders.

consequent stream A stream flowing down a slope as a result of the inclination of that slope.

contact The surface which constitutes the junction of two rock bodies.

continental crust The type of crust underlying the continents, including the continental shelves.

cross-bedding Stratification inclined to the original horizontal surface upon which the sediment accumulated. It is produced by deposition on the slope of a dune or sand wave.

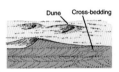

dendritic Pattern resembling the branching of a tree.

diabase An igneous rock similar to basalt but being composed of coarse, angular grains.

differential erosion Variation in the rate of erosion on different rock masses. As a result of differential erosion, resistant rocks form steep cliffs, whereas nonresistant rocks form gentle slopes.

dike A tabular intrusive rock that cuts across strata or other structural features of the surrounding rock.

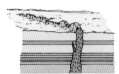

dip The angle between the horizontal plane and a structural surface (such as a bedding plane, a joint, a fault, foliation, or other planar feature).

downwarp A downward bend or subsidence of a part of Earth's crust.

down-dropped Collapse of a segment of the earth's crust as a result of stretching and release of tension.

entrenched meander A meander cut into the underlying rock as a result of regional uplift or lowering of the regional base level.

escarpment A cliff or very steep slope.

extrusive rock A rock that has solidified from lava (molten material) poured out onto the earth's surface by volcanic activity.

faceted spur A spur or ridge that has been beveled or truncated by faulting, erosion, or glaciation.

fault A surface along which a rock body has been broken and displaced.

flexure A bend or fold in a rock body.

floodplain The flat, occasionally flooded area bordering a stream

fold A warp or bend in a sequence of rock strata.

formation A large rock body of closely related rock types which is useful in geologic mapping and interpretation.

geologic column A diagram representing divisions of geologic time and the rock units formed during each major period.

geologic cross section A diagram showing the structure and arrangement of rocks as they would appear in a vertical plane below Earth's surface

Grand Staircase A series of cliffs and slopes ascending from the Grand Canyon to the high plateaus of Utah.

granite Coarse-grained igneous rock composed primarily of quartz and feldspar.

headward erosion Extension of a stream headward, up the regional slope of erosion

hogback A narrow, sharp ridge formed on steeply incline resistant rock.

igneous Rock formed by the cooling and solidification of molten minerals.

intrusion Injection of a magma into a preexisting rock. A body of rock resulting from the process of intrusion.

intrusive rock Igneous rock that, while it was fluid, penetrated into or between other rocks and solidified. It can later be exposed at Earth's surface after erosion of the overlying rock.

joint A fracture in a rock along which no appreciable displacement has occurred.

limestone A sedimentary rock composed mostly of calcium carbonate (CaCO3).

mafic Mineral or rock rich in magnesium and iron.

magma Molten rock, generally a silicate melt with suspended crystals and dissolved gasses.

mass movement The transfer of rock and soil downslope by direct action of gravity without a flowing medium (such as a river or glacial ice).

meander A broad, looping bend in a river.

mesa A flat-topped highland (mountain) capped by a resistant rock layer and edged with steep cliffs or slopes.

Mesozoic The era of geologic time from the end of the Paleozoic Era (225 million years ago) to the beginning of the Cenozoic Era (65 million years ago).

metamorphic rock Any rock formed from preexisting rocks by solid state recrystallization driven by changes in temperature and pressure and by chemical action of fluids.

metamorphism Alteration of the minerals and textures of a rock by changes in temperature and pressure and by a gain or loss of chemical compounds.

monocline A bend or fold in gently dipping horizontal strata.

outcrop An exposure of bedrock.

Paleozoic The era of geologic time from the end of the Precambrian (542 million years ago) to the beginning of the Mesozoic Era (225 million years ago).

physiographic map A map showing surface features of Earth.

plateau An extensive upland region.

Pleistocene The epoch of geologic time from the end of the Pliocene Epoch of the Tertiary Period (about 2 million years ago) to the beginning of the Holocene Epoch of the Quaternary Period (about 10,000 years ago). The major event during the Pleistocene was the expansion of continental glaciers in the Northern Hemisphere.

Precambrian The eon of geologic time beginning with the oldest rocks (formed approximately 3.8 billion years ago) and ending with the beginning of the Paleozoic Era (542 million years ago).

quartzite A sandstone recrystallized by metamorphism.

regolith A blanket of unconsolidated material that overlies solid rock.

rift valley A valley of regional extent formed by block faulting in which tensional stresses tend to pull the crust apart. The down-dropped block along divergent plate margins.

sandstone A sedimentary rock composed mostly of sand-sized particle, usually cemented by calcite, silica, or iron oxide.

scarp A cliff produced by faulting or erosion.

schist A metamorphic crystalline rock that can be split along approximately parallel lines due to its planar structure.

sedimentary environment A place where sediment is deposited and the physical, chemical, and biological conditions that exist there. Examples: rivers, deltas, lakes, and shallow marine shelves.

sedimentary rock Rock formed by the accumulation and consolidation of sediment.

shale A fine-grained clastic sedimentary rock formed by consolidation of clay and mud.

sill A tabular body of intrusive rock injected between layers of the enclosing rock.

silt Sedimentary material composed of fragments ranging in diameter from 1/265 to 1/16 mm. Silt particles are larger than clay particles but smaller than sand particles.

siltstone A fine-grained clastic sedimentary rock composed mostly of silt-sized particles.

slate A fine-grained metamorphic rock with a characteristic type of foliation (slaty cleavage), resulting from the parallel arrangement of microscopic platy materials, such as mica and chlorite.

slope retreat Progressive recession of a scarp or the side of a hill or mountain by mass movement and stream erosion.

sorting Separation of particles according to size, shape, or weight.

strata (plural of stratum) Layers of rock, usually sedimentary.

stratification The layered structure of sedimentary rock.

stream capture Diversion of the headwaters of one stream to another.

stream terrace One of a series of level surfaces in a stream valley representing the dissected remnants of an abandoned floodplain, stream bed, or valley floor produced in a previous stage of erosion or deposition.

strike The bearing (compass direction) or a horizontal line on a bedding plane, a fault plane, or some other planar structural feature.

strike valley A valley that is eroded parallel to the strike of the underlying nonresistant strata.

talus Rock fragments that accumulate in a pile at the base of a ridge or cliff.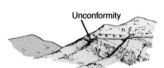

tectonics The branch of geology that deals with regional or global structures and deformational features of Earth.

terrace A nearly level surface bordering a steeper slope, such as a stream terrace or wave-cut terrace.

topography The shape and form of Earth's surface as expressed in elevations above or below sea level.

unconformity A discontinuity in the succession of rocks, containing a gap in the geologic record. A buried erosion surface. An unconformity in which the older strata dip at a different angle (generally steeper) than the younger strata.

upwarp An arched or uplifted segment of the crust.

volcanic neck The solidified magma that originally filled the vent or neck of an ancient volcano and has subsequently been exposed by erosion.

weathering The process by which rocks are chemically altered or physically broken into fragments as a result of exposure to atmospheric agents and the pressures and temperatures at or near Earth's surface, with little or no transportation of the loosened or altered materials.

Index

abrasion 35

ancient canyon 37

Arizona Strip 32

asymmetry of the canyon 16, 74

barbed drainage 43, 141

Basin and Range Province 14, 15, 26, 28–29, 35, 65, 141

Bass Limestone 76

Bright Angel Shale 19, 21, 24, 27, 38, 78, 81, 99, 126

Cardenas Basalt 19, 60–62, 64–65, 67, 73

cascade, lava 28, 110, 112, 114–117, 119

cave 21, 46–48

Coconino Plateau 16, 21, 28, 94–95

Coconino Sandstone 19, 21, 38, 54, 56, 58, 74, 78, 90, 92

Colorado Plateau 14–15, 141

consequent stream 32, 34

dam, lava 28, 111–127

Dellenbaugh, Mount 16–17, 26–29, 130, 136

delta 136

diabase sill 96–97

dike 20, 64, 82, 85, 87–88, 90, 121, 141

displacement 35, 63, 126, 136

downcutting 35, 143

down-dropping 35, 63, 141

Dox Formation 19, 60

drainage pattern 32, 43

Dutton, Captain C. E. 6, 8

elevation 16, 26–27, 30 , 54, 77, 119, 122; highest point 16; lowest point 16

entrenched meander 105, 141

erosion, headward 16, 28, 31–32, 38, 43, 56, 74, 94, 141; rate of 35

escarpment 44, 60, 123, 138, 141

Esplanade Platform 16, 19, 20–22, 24–25, 27, 28, 39, 41, 55, 90, 97, 99, 102–105, 106, 108–112, 114, 122–123, 127, 128, 130–132

fault 14, 16, 22–23, 26–29, 31, 35, 38, 55, 63, 82–83, 87, 126–127, 128, 130, 136–137, 141

float trip 7, 46, 67, 110, 138

geologic column 18, 141

Grand Staircase 32, 36–37, 104, 141

granite 20, 34, 39, 85, 87, 88, 126, 141

Hakatai Shale 19, 76, 82, 88, 96

Havasu Canyon 108, 120, 122–123; Creek 16, 28, 31, 122; Springs 122

headward erosion 16, 28, 31–32, 38, 43, 56, 74, 94, 141

Hermit Formation 19, 21, 24–27, 28, 36, 39, 48, 54, 58, 74, 78, 80, 99, 104–105, 129, 130

Hualapai Plateau 16, 26, 28–29, 132, 134–135, 137

igneous 39, 76, 85, 97, 141

Kaibab Formation 16, 18–19, 22, 26–27, 30, 32, 34, 43, 50, 52, 54, 60, 95, 99, 104, 106, 128, 138

Kanab Creek 16, 27–28, 32–33, 38, 104–105, 122; Plateau 25, 26, 29, 30, 32, 103

lateral variation 24–25

Little Colorado River 14, 16, 26, 31, 55, 64

map, geologic 22–23, 141

Marble Platform 16, 25, 26–27, 29, 31–33, 42–43, 44, 46, 50–54, 77, 136

mass movement 35, 142

Mesozoic 18–19, 22–23, 26, 37, 43, 44, 142

metamorphic 20, 22, 36–37, 39, 73, 76, 85, 87, 88, 99, 126, 142

monocline 16, 22, 26–27, 29, 30–31, 42–44, 50–56, 63, 70, 77, 142

Muav Limestone 19, 21, 22, 24, 28, 38, 80–81, 83, 97, 99, 106, 126, 129

nomenclature 18

Phantom Ranch 38, 83, 89

photography, panoramic 8

Powell, Major John Wesley 27, 44, 47, 85, 105, 138–139; Plateau 38–39

profile, canyon 24–25, 27–28, 34–37, 70, 76, 78, 90, 97, 104, 127, 132, 138

profile of equilibrium 34–35

Redwall Limestone 19, 21, 24, 38, 46, 48, 78, 80–81, 99, 104, 106, 129, 132

satellite imagery 16, 22, 42–43

schist 20, 39, 82, 85, 90, 142

sequence of rock layers 9, 18, 20, 27, 37, 43, 45, 50, 67

shaded relief map, digital 16

Shinumo Quartzite 87

Shivwits Plateau 26, 28–29, 30, 130–131, 136–137, 138

silt deposit 122

stripped surface 26, 32, 34, 43, 128

Supai Group 21, 24, 102, 104, 106, 129

Supergroup 19, 20, 22–23, 27, 36, 39, 52–53, 55, 56, 60–61, 63, 64–65, 67, 70–73, 76, 81, 83, 87, 88, 97

Surprise Canyon Formation 21

talus slope 105, 142

Tapeats Sandstone 19, 21, 27, 39, 52, 56, 67, 72–73, 76, 81, 85, 88, 90, 99, 126

Temple Butte Formation 19, 21, 24, 28, 106

Tonto Platform 20–23, 27, 39, 55, 74, 76, 78, 82, 90, 95, 99, 126, 128

Toroweap Formation 19, 21, 54, 91

tributary 16, 27, 31, 32, 35, 38, 58, 87, 94, 104, 110, 116, 122, 134

Trumbull, Mount 17, 29, 102, 110, 130–131

unconformity 20, 36–37, 39, 72–76, 79, 85, 87, 142

Uinkaret Plateau 16, 26, 28–31, 110–111, 112, 130

uplift 14, 16, 30–31, 32, 34–37, 43, 63, 70, 99

volcanic field 28, 31, 112, 130, 133

waterfall 28, 35, 110, 123